RELATIONSHIP ASPECT MARKETING

BUILDING CUSTOMER LOYALTY IN THE INTERNET AGE

JACK BURKE

SILVER LAKE PUBLISHING
LOS ANGELES, CALIFORNIA

Relationship Aspect Marketing
Building Customer Loyalty in the Internet Age
First edition
Copyright © 2001 by Jack Burke

Silver Lake Publishing
2025 Hyperion Avenue
Los Angeles, California 90027

For a list of other publications or for more information, please call
1.888.663.3091. In Alaska and Hawaii and outside of the United
States, please call 1.323.663.3082.

Burke, Jack
Relationship Aspect Marketing
Building Customer Loyalty in the Internet Age.
Includes index.
Pages: 320

ISBN: 1-56343-741-4
Printed in the United States of America.

ACKNOWLEDGMENTS

So many people have contributed to *Relationship Aspect Marketing* that acknowledging them all is an impossible task. These friends and colleagues keep me on the cutting edge of business today. They continually challenge and motivate me to keep an open mind and stretch beyond my own preconceived limits. To all of them—and you know who you are—I offer my sincere thanks.

There are some people who deserve specific recognition, however. Jim Walsh, the president of Silver Lake Publishing, who taught me so much when editing *Creating Customer Connections* and had the confidence to publish this book. Christina Schlank, my editor, has been absolutely fantastic. Paired up by Jim Walsh, we began from ground zero in developing a relationship while editing this book. Her help and advice have been immeasurable. Thank you, Christina.

Among my many friends and clients is a very special individual who is mentioned a number of times in the upcoming pages—Jim Cecil, president and founder of the James P. Cecil Co., Inc. in Bellevue, Washington. Cecil brought the concept of nurture marketing to the business world, and I owe him a debt of gratitude. On a blustery day outside the Chicago Fairmont Hotel in 1995, Jim and I began a wonderful friendship.

Over the years, Jim Cecil and I have shared thoughts on the importance of maintaining humanity in the workplace. Jim has proven to be a role model in maintaining integrity and value in every relationship, and he appreciates the unique human nature of every individual. We've truly challenged each

other to be the best we can be and I am forever grateful to count Jim among my friends.

And, a special thank you to Lee Loughnane, whose friendship has taught me the value of persistence in the pursuit of excellence and dedication to the honing of one's craft. But above all, I value him as a friend because he honestly confronts me when my thinking gets off-center, and encourages me to listen to his comments even when I don't want to hear them.

Finally, there is one person in this world who has taught me more about relationships than anyone else. Her capacity to care unconditionally for others in life has shown me how important relationships—personal and business—are to me as a human being. She can recall details of other people's lives and remember, for example, to inquire a year later about a friend's recovery from an illness or a trying time. Her secret to life is simple: she values people in an honest and meaningful way. She is my friend, my confidant, my partner and wife, Jo Ann.

Again, thanks to everyone. I feel blessed to have so many wonderful people with whom to share this journey called life.

ABOUT THE AUTHOR

Jack Burke is the president of Sound Marketing, Inc., a company specializing in audio and video productions to serve the marketing and communication needs of industry and government. His vision has positioned Sound Marketing as an innovative leader in communications for marketing, education and information resources.

Before founding Sound Marketing, Burke's corporate undertakings included management of the Hertz Rental Car Sales operation in North America. His commitment to employee training and customer service resulted in a major profit turnaround for Hertz. Burke learned that innovation requires an open mind that's capable of thinking outside the box. He believes that communication is the critical factor in long-term success for any business—a fact consistent with what he learned during his many years as a radio and television newscaster.

Burke has written hundreds of articles for various trade magazines; his commitment to communication as the critical element of all business relationships continues to be a central theme. The insight he gained from these writings formed the basis for his first book *Creating Customer Connections,* which was published in 1997. The following year, he contributed to the book *Best of Class* in the company of such others as Steven Covey, Tom Peters and Ken Blanchard.

Today, with the help of his wife and partner Jo Ann, he balances the ongoing management of Sound Marketing while serving as editor of the insurance industry's electronic newsletter *ProgramBusinessNews*. He's also

Relationship Aspect Marketing

a contributing consultant to Insurance Marketing & Management Services, host of several monthly audio programs for various industries and a keynote speaker at educational seminars.

Burke wrote *Relationship Aspect Marketing* to help businesses make sense of the ferocious onslaught of electronic change in today's marketplace in order to better serve customers and capitalize on new technological tools. He's also built a Web site dedicated to the concepts that you'll find in the upcoming pages. You may access the site at www.relationshipaspect.com.

TABLE OF CONTENTS

Introduction: What Is Relationship Aspect Marketing?

Too much of modern business is defined by transactions. The lawyers and investment bankers who serve business are paid to help make transactions happen, so it's no surprise that they talk about deals. But the problem goes beyond the Armani suits. Many of the best-known business consultants and writers come from the sales and marketing fields, so they tend to focus on closing the individual sale rather than building a business. This may be understandable—but it still leaves issues open. And, the business press is influenced heavily by lawyers, investment bankers and consultants. So, if you read business magazines or newspapers, you can easily come away thinking that all business is built around banner deals.

It's not. Business is built around *relationships*. And the most basic…most essential…business relationship is that between the party selling a product or service and the party buying that product or service.

That's what this book is about.

Relationships are contexts—frameworks—within which activities take place. While a single transaction may come or go, the relationship between the parties involved exists before and lasts long after. For example, Mr. Smith buys a 50-pound bag of quick-drying pre-mix from Acme Concrete. That's the transaction. If that's all business was about, everyone would be Bill Gates. But the transaction is only a very small part of a bigger and more complicated story. Did Mr. Smith choose Acme…or did he come to Acme as a last resort? Did Mr. Smith buy from Acme because

it's the cheapest source…or because he knows Acme provides great customer support…or because Acme carries a better grade of concrete? Did Mr. Smith pay cash or buy on credit? Most importantly, did Mr. Smith come away from the transaction satisfied that he got a good value for his money…or did he lug the 50-pound bag out to his truck, swearing he'd never buy from Acme again?

Whatever the service or product a business is selling, every business has its equivalent of a 50-pound bag of concrete. Do you know why your customers buy your concrete instead of your competition's?

If you're trying to build a lasting business, you need to do several things:

- understand the relationship that exists between you and your customers;

- ensure that relationship will work well—profitably—in your marketplace; and

- advance your relationships through sound sales, marketing and product development.

If you can do this, the individual sales—the transactions—will follow.

This book gives you tools for accomplishing all of these tasks. It helps you understand the relationship that exists between you and your customers. It gives you insight into gauging your position in a larger marketplace. And, lastly, it helps you advance this relationship. Relationship aspect marketing is not a project to be undertaken; it is a philosophical shift in the nature of how you run a business. It requires a constant commitment on the part of executive management—as well as the entire rank and file of a company. Together, a company must look past individual transactions, toward the larger framework of how and with whom it does business.

Business Relationships Mirror Personal Ones

Some people may wince when they see the phrase *relationship aspect marketing*. It may sound like another marketing buzzword. Or, as one

small business owner commented, "Relationships? Does it have to be that? I'm terrible at relationships."

I chose the word for a reason. You can't be terrible at relationships and build a small business. You have to be able to build them…and keep them. And, while personal relationships and business relationships aren't exactly the same, they are alike enough that common rules apply.

And to that complaining small business owner, I say: You probably work harder to maintain your business relationships than your personal ones.

Many small business owners and large corporate executives tell me they can remember the names of their clients easily, but are stumped when asked the names of their next-door neighbors.

Personal relationships are not a simple matter. A married couple, for example, doesn't always split workloads evenly; a couple doesn't usually frame issues in black and white or agree on things with a smile. Personal relationships require a commitment by both parties; part of the commitment requires compromise, sympathy and concessions. As any married couple can attest, this takes a lot of work—a lot of attention and constant input.

The initial excitement of a new romance is intoxicating; but the test of a relationship is coexistence the morning after…and after. A relationship's durability gets challenged every day—as does a business's.

If we dissect a successful long-term relationship of the spousal variety, we find some simple truths:

1) Each partner supports and encourages the other to succeed and to be happy.

2) Each partner makes concessions. They know that relationships mean compromise. No one can have it his or her way all the time.

3) Each partner makes an effort to avoid taking the other for granted. Both partners know that their role entails consideration and respect, looking out for the other's best interests and being thankful for the little niceties the other provides.

4) Sometimes a partner has to sacrifice his or her interests for the other. Both partners know that self-interest can destroy a meaningful relationship. Sometimes one must give up his or her wants for the greater good of the relationship.

5) They tackle problems together. They know that life can throw curve balls and that the power of two is exponentially greater than the power of one.

6) They share their joys and their sorrows. They acknowledge that no man is an island. They know that shared joys are doubled and shared sorrows halved.

7) They look for ways to surprise each other. They know that the relationship can become stale after the initial romance, so they look for ways to liven it up.

8) They express their feelings and show respect for the feelings of the other. They are cognizant to difficulties within a relationship, but are committed to working through problems.

9) They serve each other. They know that the overall health of the relationship depends upon their individual health (emotional, physical and spiritual). They position themselves to be of service to each other.

10) They explore opportunities together. They understand that exploring new ideas is exciting and, thus, they each take an active part in researching and developing plans for the future.

These 10 concepts might seem simplistic, but they are the elements of what it takes to grow and sustain a long-term relationship. Maintaining a relationship may be simple, but sustaining a good relationship is a more complex matter, dependant on a variety of subtle and not-so-subtle issues. Spouses—like customers—will sometimes leave a relationship explaining loosely that, "It wasn't any one thing that was wrong. It was a lot of little things. It just wasn't the same relationship it was at the beginning."

Although this person may be searching for a concrete reason for the failure, more often than not, both partners in the relationship probably took

it for granted. They stop paying attention to the fine points of the relationship—the "little things." Any party inattentive enough to let a relationship dissolve is at fault—and any party that notices its dissolution has a responsibility—to the relationship—to do something. That's the value that these 10 simple points bring to the relationship equation.

In a relationship, you need to pay enough attention to notice when a problem begins to surface. And, when it does, you need to take the initiative to stop the wear and tear. The same is true for business relationships, especially in today's tumultuous business world.

The Business Aspect

Some people think that the much-hyped "information economy" has changed the nature of business. And there is some evidence to support their belief. Not since the industrial revolution has there been such an upheaval in business. Companies without profits have had higher stock market valuations than the traditional companies that have been generating profits, building assets and issuing dividends for years.

More importantly—to my way of thinking—the explosion of information has shifted the power in business relationships from the seller of a thing to the buyer. It used to be that, if you have the capital and other resources to produce a widget, you could define your relationship with customers. You could set your price. You could provide the support you deemed necessary. If you didn't sell as much as you had planned, you could just modify your terms here and there until people bought.

Customers who were once dragged behind the corporate carts are now sitting in the driver's seat—because they can access goods and services from all over the country...and the world. Not everyone in business is clear on this change; some people aren't even aware of it.

This lack of clarity, as experienced by my friends and colleagues, convinced me to assemble the information and analysis that has become *Relationship Aspect Marketing*. This book serves, I hope, as a bridge from the past to the future. Through personal and shared experiences, my

goal is to minimize the fear and maximize the effectiveness of new technologies for my readers. As you read this book, keep this in mind:

- technology is a tool not the answer, and
- constant focus on the customer is critical to a company's survival.

In my last book, *Creating Customer Connections*, I stressed the importance of customer service as the critical key to success for any business. The customer must be the prime-motivating factor in every facet of a business, from marketing to selling, telephone procedures to training sessions and from daily operations to long-term planning. Achieving this customer orientation creates a nexus—a binding connection between you and your customer.

Today, not quite five years later, we also are faced with the added dilemma of ever-changing and expanding technology. Unfortunately, too many businesses rush into this world of technological opportunity like an unbridled horse, wearing blinders and galloping headlong into the unknown.

The propensity to trip and fall is great, and we shoot horses with broken legs to put them out of their misery.

Use Technology Intelligently

Several years ago, Ian Morrison, former president of the Institute for the Future and author of *The Second Curve* (a great study of the growth plateaus that bedevil businesses) told me: "By the year 2000, 99 percent of American business will be on the Internet—but only 3 percent will know why." His point had a dramatic impact on my thinking.

Too often business decisions are made according to a crowd mentality. Like lemmings, we follow the masses, and are driven forward before we know our destination. Nothing speaks more clearly to this than the wave of bad retail dot.com companies funded with frenzied venture capital in

Introduction: What Is Relationship Aspect Marketing?

late 1999 and early 2000. These foolish VC bets were proof of Morrison's prophesy. The bankers wanted to be in what they called the Internet's retail space. But they didn't know *why*. All they knew was that everyone else was pumping money into that marketplace.

With the benefit of hindsight, we must now ask ourselves: Are our actions solely reactions to advances in technology? Do we do any proactive planning and goal-setting when it comes to our use of technology? Do we only presume to know what our customers expect from technological wonders? In other words, do we know *why* we are doing what we do?

Amazon.com deserves credit—and maybe even a strong stock market valuation—because it was the first retail entity that reached a critical mass of consumers via the Internet. But does this trailblazing effort mean that consumers want hundreds of niche retail variations of Amazon.com?

Greedy start-ups and their VC moneymen answered *yes* to this question. And, in late 2000 and early 2001, many of them went belly-up. Why? Because consumers answered *no* to the same question—as the collapse of Pets.com, eToys.com and scores of other ventures attest.

These followers fixated on Internet commerce—the technology tool—instead of the underlying businesses.

In conversations with business owners throughout the world, I find a mixed assortment of feelings about technology. Some embrace it with open arms, others dread its approach. Some see technology as a way to grow their business into the future, others as an onslaught of new competition. Some see it as a new way of life, others as a prelude to their funeral.

I view technology as a wondrous opportunity with a major disclaimer. In and of itself, technology (whether it be the Internet, wireless communications or anything else) is nothing. Used as a tool to develop, enhance and nurture business relationships, it is substantial. The critical aspect is *relationship*—thus, the title of this book.

Business owners and managers pay a lot of lip service to the importance of melding service and quality, but to a large degree, business has been

unable to realize this lofty goal. And technology, in some cases, makes this goal more elusive. Two long-time friends of mine have come as close as anyone to articulating the difficulties in attaining this goal.

Rick Morgan, publisher of *The Automated Agency Report*, a monthly newsletter dedicated to the technological advances impacting the insurance industry, sees the problem clearly. He says, "Automation has improved efficiency, but it hasn't delivered customer-defined quality service."

Author and marketing guru Jim Cecil articulated the issue this way: "The only asset of any value that a company will carry forward into the new millennium is the respect and loyalty of its customer base." But how do we incorporate what we know to be true into our everyday business practices?

We must, without any reservation, utilize technology to the benefit of our customers first. Then, and only then, can we look at how it benefits us. Too many companies use technology to simply process business that they already have without any regard to preserving or expanding that business.

Many still use automation solely to process invoices and maintain financial records. They have yet to tap into the real worth of their databases—using them to enhance marketing efforts. For these people, technology is merely a tool to process existing business. The thought of using it to enhance customer relationships or develop new ones is foreign to them.

There is a corporate Berlin Wall separating operations from marketing when it comes to automation. And I use the term *Berlin Wall* advisedly. The separation is just as artificial...and just as absurd.

A Willingness to Change

I own a company that develops and implements a rather specific part of client companies' marketing efforts—their telemarketing and phone-based customer service functions. Like most business owners, I've refined my notion of what we do over the years. Sometimes this refining has been difficult...even painful. But I've always tried to pay attention and respond to my marketplace.

As human beings—and business people—our thoughts and activities must constantly change, ever adapting to internal and external forces. In my own pursuit, many of my old beliefs that seemed right at one time have proved themselves ineffective or impractical. It is important not to cling to poor ideas out of pride or ignorance. This may sound obvious, but I assure you, this clinging happens more often than not.

I didn't always dump my old ideas outright; sometimes they just needed to be redefined or tweaked to keep up with changes in technology and changes in the marketplace. In many instances, technological advances (and in telephone voice systems, there have been many over the last 20 years) have not changed the concept, but simplified the process.

Command and Control Is Out, Nurture Is In

Speaking of change: I used to be a major proponent of the old command and control system of management, which was based on the military regimen—orders were delivered from the top down and obedience was imperative. During the days when the best business minds at Wharton and Harvard espoused MBO (management by objective), I referred to it as *MBI* (management by intimidation). The business world was very different then. Today's employees refuse to function under this style of management, forcing business to create a more empowering environment.

This radical shift was due in part to a tighter employment market, which left employers scrambling for qualified workers and employees in the driver's seat. The shift was also the result of generational differences.

Since World War II, the Boomers and the Gen X'ers have become more independent than their parents. Lifelong careers with one company are rare. We deify individual accomplishments rather than foster a team mentality. Our youngest workers utilize technology as second nature—technology which many of the bosses barely understand. Never before has a workforce been comprised of so many generations that are so different.

These changing dynamics have rewritten the rules of today's workplace. Businesses must engender nurturing and motivating atmospheres in which

employees can thrive, or risk losing the best workers to the competition. Owners, executives and managers must develop relationships that work to the benefit of employees, clients and the company.

When I still clung to the command and control mentality, I believed that business dictated the marketplace. Advertising saturation in print, radio and television was the driving force. Consumers, like sheep, could be driven to take action based on the strength of the advertising. Madison Avenue was in its heyday and this tactic worked…at the time.

Recent decades have witnessed a constant explosion in media, beginning with radio and print and then television and cable. AM radio bands more than doubled with the acceptance of FM frequencies; three basic television networks matured into several hundred cable networks; new magazines catering to every possible niche market cropped up overnight. . . and then came the Internet.

Rather than aiming at the mass public, media is now targeting specific categories and interests, which creates smaller audience pockets that demand advertising oriented to their unique interests. It's a simple case of supply and demand; with so many media sources now available, each is forced to find a unique niche in order to survive.

It is no longer easy to reach the bulk of the consumer market today. People can custom-design the communications media that most directly impacts their life and their interests. Consumers no longer move as sheep controled by a shepherd. Instead, they are more like the herding dogs nipping at the heels of business. Business owners have had to regroup and adjust to these changes.

Old Business Model	New Business Model
Company Driven	Customer Driven
Product Based	Need Based
Create Need	Determine Need
Advertise Product	Market Value
Reactive Service	Proactive Service

Marketers no longer can arbitrarily develop a new product and create a need through massive advertising that in turn drives the sales.

Connect with Your Customer

I've always believed in the power of professional sales personnel. Sales superstars can move mountains. However, the support provided to them has changed. Merchandising tricks and gimmicks, promotional incentives and giveaways once used effectively to bribe a sale no longer exist. Today, it is unimaginable that people once chose their banking partner on the basis of a free toaster. Many firms have adopted policies prohibiting employees from receiving incentives, and in some industries such activity has been outlawed by state or federal regulation. Regardless, the novelty has diminished as has the effectiveness of such marketing tools.

A more specific example: In the 1970s, the automotive industry moved mountains with rebates to offset the impact of the first energy crisis. Three hundred dollar rebates were enough to drive cars off dealer lots and into consumer driveways. The strategy was so effective that the industry over-utilized rebates to the point that, today, a rebate or financing incentive is *expected* as a standard portion of an automotive purchase. I am sure that this is not what the car manufacturers or dealers originally intended.

Some car companies, such as General Motors' Saturn division, have tried to change the rules. But they've had little success. Individual dealers have tried to move toward fixed pricing, but acceptance is slow. The successes of tomorrow will be those companies that support the sales effort with tools that focus on building and maintaining relationships with the client.

Successful businesses add value over and beyond the product or service being offered to the consumer. Most business people know this; but they don't always agree on *how* to add value.

To me, the solution seems obvious. As consumers increasingly dictate what they want, business has focused on what the consumers are saying and on how to react appropriately. Service is no longer relegated to an

"after-the-sale" mentality. Service is no longer the handling of claims, warranties and problems that occur after a product or service is sold.

Service stands in the forefront of every transaction. It dictates the attitude of the company, the expertise provided to the customer, the delivery of the product, the support required for its use and the resolution of problems when they arise. Every employee has to identify himself as a service provider to the customer. It is all about the customer.

In my own business, I realized that customer focus was not enough. There had to be more and the consumers were demanding more. By focusing on the customers, by seeking to learn their wants and desires, we had created expectations.

These customers continue to direct and drive business, and the business community must react and meet their expectations. We must give them what they want: a valued relationship.

Cultivating Lasting Relationships

Of course, the relationship aspect of business is not new. For example, years ago (in another line of work), I bought airport shuttle buses for subsequent lease to airport hotels, parking facilities and car rental facilities. I bought them from one company over others because of the warm and caring attitude of a single sales administrator.

Over several years of doing business with this woman, I never met her in person, but I looked for occasions to call and talk with her. She made me feel like a friend, not a client. She shared stories of her life and her activities. She anticipated information I might need and provided it. She was never dismayed when problems arose, she merely set about resolving them. In short, she had an innate talent for creating a relationship with her clients. I spent hundreds of thousands of dollars with her company because of that relationship.

This is the kind of relationship I strive to have with my clients. When I began taking stock of the phone calls I received as president of my own

company—a position that affords me constant contact with hundreds of people from various places and walks of life—I found that most of these calls didn't directly involve business. Some were calls for advice; others were for referrals. Some people called to share victories...or difficulties. Some just called to say hello. This surprised me at first. But, when I thought about it, I realized that my clients had become something more than merely functional business acquaintances. We'd developed more personal relationships; in some cases even became friends outside of business.

Today my company does not spend a single penny on advertising. All of our marketing is predicated on the relationships we have with our customers. Our letters and sales material reflect that relationship. Our new clients are primarily driven by referral and they are quickly assimilated into our family. In fact, most of these prospective clients generally say something like, "My friend Jim says you not only take care of all his business needs, but that you're a friend I can trust." Bottom line: People—customers—seek a relationship, not just a business transaction.

All of this brings us back to this book's title: *Relationship Aspect Marketing*. Business is not just about you, your product, or, even, servicing your customers; it's about *relationships.* And focusing on the relationship aspect is a formula for success. It's a partnership in which each partner is totally vested in the success of the other.

Relationship aspect marketing must be an integral part of every operation within your company. Everyone from the shipping and filing clerks to the sales staff, customer service personnel and management must know and accept that every action they take relates to a one-on-one relationship with your clientele. That's the relationship aspect.

It begins with the relationship a company has with its employee and continues through the relationships your employees have with your customers. It is reflected in every phase of your marketing and communications—one building upon the other. It's a caring voice on the telephone. Sales people positioned to be of service to clients. A Web site that provides clients with tools to simplify transactions and resources to assist them in their businesses. It is an attitude and a promise. It is the agreement be-

tween two people or two companies that can help each other to grow and prosper.

Technology Empowers Ideals

At first, relationship aspect marketing might seem idealistic. However, modern technology and the speed of communications have placed tremendous pressure on our lives and our time. As a result, we become nostalgic for the camaraderie of earlier years; the world that once existed between the small shop owner and his customer. In other words, we yearn for the simplicity and human interaction of a slower-paced world.

The trap is thinking that technology will solve the problems when, in reality, technology has significantly increased our stress. We assume that customer relationship management (CRM) software is the answer to all of our problems and that account management databases, 24-hour Web sites, automated phone directories and e-mail advertising will keep our customers happy. But we are wrong.

Technology is not the answer. Technology is merely a *tool* that can help you find the answer. Technology can assist in building and nurturing relationships. It is the tool that can enable you to communicate more frequently and more effectively with your customer base. It is the tool that can literally keep your doors open 24 hours a day. It is the tool that can bring detailed information to your clients when they need it. But it is a tool that is only as good as the human wielding it.

Said another way: If you have good customer relationships, you can survive technology problems—the wrong phone system or ineffective database management software. However, if you don't have good customer relationships, the best technology hardware won't do a thing for you.

This notion has some very real consequences. One of the hot rumors of early 2001 was that computer hardware giant Hewlett-Packard was going to acquire the accounting and consulting firm PriceWaterhouseCoopers. This deal would have seemed impossible a few years earlier. Why would HP—which makes great printers and computers—want to buy a consult-

ing firm? Because PriceWaterhouseCoopers had great relationships with corporate America, in many cases at a higher level of the organization than HP did.

Throughout this book you will find examples and instruction on how to use technology effectively and integrate the relationship aspect. To implement relationship aspect marketing successfully, you will need to look at the old and the new. You will need to take inventory of all your business practices. Discard the ineffective policies, systems and procedures that distance you from your clients and embrace that which can add value to the relationship. Some of the discards will include old ideas, but some may be new ones.

My company, for example, hasn't printed a brochure (a former mainstay of our marketing) in over five years; our Web site is our brochure. On the other hand, we have discarded relatively new (and expensive) automated phone systems because of bad reactions from customers.

Always be mindful of what your customers need, want, desire and expect from you. We've allowed our world to become very depersonalized. The goal of relationship aspect marketing is to humanize this depersonalized world. Develop and utilize the tools that enable you to engender healthy relationships with your clients and build your brand upon that relationship.

If you position customer relationships as your primary priority, then you can nurture those relationships with the assistance of technology. Success in the new millennium depends upon a blending of people, technology and service—that is, the relationship aspect.

A Few Words Before We Move On

As a concession to the changes that technology has already wrought, the style of this book is designed to provide you with information in quick, easy-to-digest bites. E-mail and the Internet have forced everyone to get to the point quickly and succinctly. Flowery phrases and expert word-smithing has given way to the old Dragnet idiom, "Just the facts, ma'am." While I still appreciate and enjoy the power of a well-turned phrase, each

chapter of this book reads quickly and provides pertinent nuggets of information that I hope will carry a message for you.

I hope each chapter helps you focus on critical lessons and/or learn effective tools to better serve your clientele. Since this topic covers nearly every facet of a business, it is grouped into four sections: *It Starts with Customer Service*; *Technology—Past, Present and Future*; *Employees Are Your Front Line*; and *Branding and Other Marketing Concepts*. The forward to each section defines the concept and is followed by a series of short chapters, which together, illustrate relationship aspect marketing as it applies to that particular topic.

Section One: It Starts with Customer Service

Even the healthiest relationship needs constant care and attention. Unfortunately, not every relationship is healthy. In business, as in romance, certain fatal problems kill relationships time and again. You can describe these fatal problems in various ways, but I think of them as:

- Greed;
- Fear; and
- Denial.

When these problems arise, you have to be able to recognize them…and do something about them. So, let's consider each in turn.

Don't Let Greed Get the Best of You

Relationship aspect marketing begins with a focus on the customer, then moves on to a focus on your interaction with that customer. As with any relationship, there's a lot of energy and money expended on getting the first date.

In business, that first date is the commitment to do new business together. Unfortunately, many of the people who are best at getting the new business are also the ones most likely to take the relationship for granted and turn roving eyes to new prospects. They look at more business in terms of finding the next new customer or opportunity.

Relationship Aspect Marketing

Most large companies recognize this and structure sales and customer service separately—often dedicating one group to prospecting for new customers and another to maintaining existing customers. But small and mid-sized companies usually don't have the staff to specialize like that. So, you have to be watchful that you keep the developmental and the maintenance functions balanced.

Many small business owners I've spoken with complain that they spend a lot of money to hire a seasoned sales manager…but that their best customers seem less happy, rather than more. The sales manager usually operates under a particular kind of greed. He's thinking about the next prospect; he wants broader action, rather than deeper. He fails to realize that loyal, existing customers are a goldmine yet to be tapped. And he's not the only one—for many sales managers, the greenest grass always appears to be in the next pasture.

Like the thoughtful husband who surprises his wife with flowers, you will create a lot of goodwill with your customers if you exert the same energy to retain their business as you do to win it. They will feel valued and attended to. The result? Loyalty. Loyal customers are more likely to purchase your product or service than those who haven't done business with you yet. They already like, trust and respect you—key factors in any business relationship. If you develop a new product or service, your existing customers are your most likely prospects at the lowest cost per sale. And your chances of success are better if they think well of you.

So, why are so many companies greedy for more new business?

I chalk it up to a kind of institutional corporate greed—more customers, more money. Although there is some truth in that notion, it doesn't hold true over the long haul. Especially if you end up ignoring proven customers in the search for new ones, this greed doesn't make sense from a logical perspective.

This tendency to take our clients for granted is a combination of old beliefs that have been burned into our minds (plus healthy doses of fear and denial—more on these in a moment).

In business, we are trained to believe that "a little bit more business is good and a lot more is better." So, we are constantly seeking to get more. But this is a fallacy. The quality of an account is much more important than the quantity of an order—or orders.

Most businesses can identify with the 80/20 rule: 80 percent of your revenue comes from 20 percent of your clients. The stunning flip side of this rule: 80 percent of your customers generate only 20 percent of your revenue.

And, in my experience, I've developed a corollary to the 80/20 rule: The customers in that 80 percent who generate the least revenue generally require more attention than the customers in the golden 20 percent.

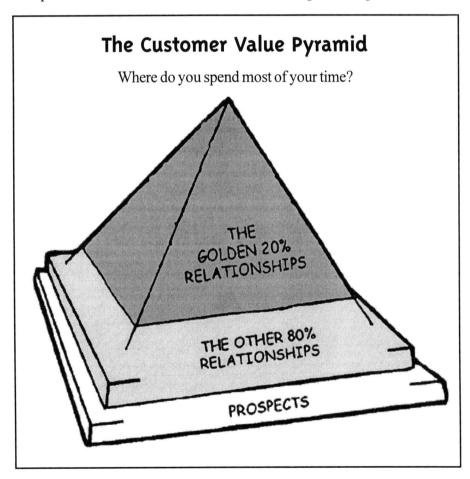

The Customer Value Pyramid

Where do you spend most of your time?

THE GOLDEN 20% RELATIONSHIPS

THE OTHER 80% RELATIONSHIPS

PROSPECTS

So, it would seem prudent to exert most of your effort serving that golden 20 percent. In addition, the better you know your top 20 percent, the easier it is to target comparable prospects that are likely to join your top 20 percent. After that, allocate some of your effort cultivating the other 80 percent. And, after that—only after that—spend time and energy searching for new customers (most of whom will end up in the 80 percent who need to be cultivated).

The 80/20 rule is a familiar standard for many business people. But it doesn't always mean as much to the aggressive sales and marketing people whose passion and energy you want—but need to direct carefully.

Another way to think of the same value equation is in a customer relationship pyramid. The golden 20 percent are the top of the pyramid—and make up three-fourths of its total mass. The other 80 percent are a narrow stage toward the bottom of the pyramid...and the prospects are a tiny slice along the bottom.

Ask your hard-charging marketers where they want to be.

Allocating your effort and resources in this way requires discipline. You need to train yourself and your staff to think in terms of the value of various customer relationships—rather than the greedy satisfaction of booking the next sale.

Fear Is Not an Option

Fear can be a major motivation for ignoring the customers closest to you and setting your sites on new customers. Someone who tends to be introverted might argue that fear keeps you at home, not out prospecting. I disagree. The fact is that many business people will do anything—including spend huge amounts of extra time and money—to avoid "going back to the well too many times." They are afraid to ask customers to buy more from them. They'd rather make the standard pitch to a new set of people, sending salespeople or direct mail pieces to the bottom of the pyramid—to the untested customers every time.

Why? Because it's easier to make the standard pitch over and over again. You've learned it well; you can do it smoothly. Plus, there is little chance that new prospects will ask for more than you want to give. This is the fear: If you cultivate relationships with customers, those customers will eventually start asking for things—modifications, improvements, new products, etc. I argue that this is a good thing, not a thing to fear.

Many sales people also fear contacting a customer after a sale. They are afraid that a problem may have surfaced since the product or service was delivered and that they will be asked to correct it, which may mean expending valuable time and resources. This too is nothing to fear. It is an opportunity to show your commitment to your customer and forge a stronger bond. This kind of fear is a variation of the old vaudeville joke about the man who didn't want to tell his wife he was choking because she might scold him. The reason you're in business is to hear what customers think about the product or service you're selling them. Don't be afraid of response. Ask for it. Beg for it. Pay for it, if you must.

Relationship aspect marketing is about more than asking customers to buy more widgets. It's about owing them information about new products and services, along with education about the things you have to offer. It's about creating the feeling of comfort and trust that allows a customer to call you and suggest a better way to work with her—which may be a better way to work with everyone. You can't let fear of more work or going back to the drawing board cloud this exchange.

Customers don't always know about every product or service you offer; you must meet not only their specific and current needs, but anticipate future ones and let them know about other things you offer. If you—the business owner or manager—are going to fear something, fear these words: *If I only knew that you provided that service or carried that product, I wouldn't have bought it elsewhere.* This statement is the greatest risk there is to your business.

A relationship mandates full disclosure. Make sure your clients know everything that you offer and remind them on a continual, but respectful,

basis. We all have too much to remember and we tend to forget—a lot! Fear that forgetfulness. Don't fear going back to the well.

Denial Is a River, in Business It Will Sink You

Denial is a major problem in business, as in personal lives. In business, we tend to deny that our marketplace is full of competitors. We deny that our customers are constantly being barraged by messages from the competition. We deny that we are not on the top of the customer's mind.

The truth is that customers really don't think about us, unless they are reminded or have a problem they know we can solve. We are not the priority we think we are—at least in our customers' minds. Yet we blindly deny this and proceed on the assumption that since they've bought from us in the past they love us. They would never leave us.

We have to break through this denial and acknowledge that out of sight *is* out of mind. Our neglected customers are like hundred-dollar bills lying on the ground in a crowded room. Everyone wants to snatch them up. Your competitors keep a watchful eye on all of your customers, looking for the opportunity to win them over—just as you're looking at their clientele in the same way.

Denial works against your efforts to build a business by blinding you to real risks that the marketplace poses. If you can convince yourself that your core business is an annuity—that it doesn't need effort or attention—you're more likely to drift from the top of the customer relationship pyramid down into the lower levels. And, as I've said before, and will again, you don't want to trade a dollar of business at the top of the customer relationship pyramid for a dollar of business at the bottom. (And you might not even want to trade a dollar at the top for two dollars at the bottom.) You don't want to spend time finding new business among the 80 percent of customers who generate little revenue (and demand a lot of attention) when you can spend time with the golden 20 percent.

As with greed and fear, the best way to battle the destructive results of denial is to be disciplined about it. Build a system by which you review

existing business. Solicit feedback. Schedule communications—meetings, if possible; correspondence, if necessary. Ask yourself as often as possible: Is my competition paying more attention to my clients than I am? Remember: Humans love attention and they are most likely to go to that place (or company) where they get the most attention.

Before there can be a relationship, there needs to be a courtship. In personal relationships, people often look back sentimentally on courtship. In fact, this is what many people think of when they hear the word *romance*. But there's a lot more going on in this process than necking.

During a courtship, two sides get to know one another. They test each other's limits and preferences. They gather information and make decisions about what they like, what they don't like…and what they can tolerate about each other. They decide whether or not to stay with the relationship. Through this process, they come to accept, like, love, respect and honor each other.

Successful business relationships aren't much different. From the initial courtship and excitement, the work of sustaining the relationship requires a significant commitment from both parties. They need to become vested partners. They need to know, like and respect each other.

Potential customers already know that your interest is probably getting into their checkbook. They know that you have products or services that you want to sell to them. That's a given. What they don't know is what else you bring to the table. Do you provide expertise? Do you provide defined services that are beyond the competition's? Do you offer particularly convenient hours of availability or inventory levels that enable immediate delivery? Do you offer support when they need it? Do you have a better warranty or guarantee? Do you offer training?

Whatever makes you unique, it's up to you to let the customer know. This sharing of information is the business courtship, and therein lies the rub of relationship aspect marketing. Have you taken the time to get to know your customers? What unique differences do they want? What availability do they expect? Do they care about immediate delivery? When do they want support from you?

Relationship Aspect Marketing

The answers to questions like these are the quintessential basis for relationship aspect marketing. You, as a businessperson, cannot assume that you know the answers without asking your customers. Once you do know, you can build your performance capabilities, your sales presentations, your advertising and your service policies into your overall marketing plan. You will be marketing to the relationship aspect based on concrete data supplied by your customers. Unless you have a crystal ball or are a mind reader, don't assume you know what your customers want without asking them. Fact-finding is integral to the entire process of the relationship. Companies must continually and constantly seek out customer input, while simultaneously keeping the customers informed about company efforts.

Thus, the first step in the process of relationship aspect marketing is a focus on the customer—based on knowledge. This knowledge includes what the customer expects, wants, needs and desires, as well as his or her knowledge of the value that you bring beyond the given product or service.

Chapter 1: Trouble Shooting Customer Service

Most of us have certain supposed truths ingrained from childhood including: *The greater the problem, the more you have to focus on it; No problem ever solves itself;* and *The harder you work, the more you'll make.* Sound familiar? If you have money problems, *tighten your belt, cut expenses and watch your budget.* Whatever the problem you face, *focus on it, develop a plan and stick to the plan.*

But these supposed truths don't always apply.

Consider an imaginary business. Sales and profits are down, so expenses have to be cut. What gets cut first? R&D? New product development? Maybe. Customer service? Probably. After all, customer service doesn't *produce* revenue. But this is one of those supposed truths that doesn't apply.

Rarely do you hear about a business cutting its sales force—though maybe you should. What the company needs to do is analyze its sales and marketing functions in the context of the customer value pyramid I've mentioned earlier. Where on that pyramid does each department...each individual...operate? If times are tough, pull back resources into the golden 20 percent. Budget for the rest very carefully.

Consider a less hypothetical example. I've done consulting work for the claims staff of a major insurance company. At one point, its payments for fraudulent claims had gotten high. This problem was hurting the whole company. The president directed the claims department to staff up and

concentrate on reducing the size of the problem. The claims manager staffed up, set up procedures to reduce bad claims and reported successful results. Payments for fraudulent claims were reduced by 50 percent in a short period. But customer service had been cut in the interim, and the company had suffered significant losses in its customer base.

After two years, that same manager was ordered to reduce claims staff because fraudulent claims were no longer a problem. For a while, the company was on top of claims; but, with the staff cut, the claims problems were likely to rise again. And this, combined with some burgeoning problems caused by depleted customer service resources, was posed to be devastating for the business. This kind of decision negatively impacted customers. We had to fight for more budget for customer service. To the company's credit, we got some more money and the crises were avoided. We were lucky. The market's timing worked for us...and the company's top brass was willing to listen to another way of thinking about offering customer value.

There's a good chance that you're reading this book because you have—or are worried that you're going to have—some sort of problem keeping customers...or converting them into reliable repeat business. This chapter is about dealing with those problems.

A Hard Truth: The Problem Is Usually *You*

I've learned over the years that the biggest part of any problem in my personal or business life is me! I can take an extremely minor problem and turn it into a mountain within my mind in no time at all. This complicated mental feat usually evolves this way: My mind begins by focusing on the problem, gradually projects various conclusions (none favorable) and then wakes me at 3 AM for further debate.

I've come to realize that focusing on the problem in this way results only in fear and anxiety. My mind is convinced that I am either going to lose something I have, or not get something I want. Ironically, and invariably, the conclusion is seldom played out according to the script written in my mind. Yet time and time again, the scenario replays itself.

Chapter 1: Trouble Shooting Customer Service

A wise man once gave me two pieces of advice and they have been guiding principles in my life ever since:

1) If you can distance yourself from the problem, the answer will always come; and

2) Replace the word "problem" with the word "opportunity."

Putting distance between you and a problem is an effective way to gain perspective on that problem. The way I usually do this is by focusing my energies elsewhere for a period of time. Ironically, the best way I know to achieve this is by helping someone else with his problems. Some say that getting away from the obsession and the fear allows you to get in touch with your intuition and solve problems more effectively.

The concept of finding opportunity in a problem was harder to implement. My mind wanted to disregard the possibility that by finding another approach to the problem, I might learn something far more valuable than simply solving the present problem. When I focused on a problem—whether it was a fight with my wife about something I'd said, or a disagreement with an irate customer about a faulty product—I tended to focus on the other person's misguided opinion. In my mind, my opinion was usually justified or rational.

As a result, I never saw the entire problem objectively. And, more importantly, I missed the lessons. I missed the fact that my wife does not respond well to me when I patronize her. And, therefore, I missed the chance to change my behavior. I missed the genius solution my customer had for fixing a faulty product. And, as a result, I missed the chance to fix a product that was probably causing other problems as well. The answers were there, but I was unable to hear them because I could only see the problem and not the opportunity.

I don't know all the *Why*s or *How*s, but I do know that these two principles have worked in my personal life many times over the years. It has helped me deal with family crises ranging from the tribulations of parenthood to divorce, schizophrenia and death.

Serve Your Customers Well

So, with these principles firmly in hand, I began to reclassify all my business problems as opportunities. For example, a few years back, Sound Marketing agreed to produce nearly 8,000 audio tapes per month for a client's membership. Shortly after filling the first order, we were deluged with complaints about bad tapes. Although testing of the tapes revealed that the tapes were fine, we didn't argue with the client. Instead, we provided it with a tape replacement request form for its members to fill out if they had received bad tapes.

When the forms came back, we noticed that most came from areas with cold weather and high humidity. Weather extremes and high humidity can create a multitude of problems with cassette tapes, especially if cassette players aren't regularly cleaned. Our solution? Turn the problem into an opportunity: The following month, Sound Marketing sent the client's members an advisory letter about cleaning their tape players with an offer to purchase a cleaner kit from us. The result: We sold thousands of cleaner kits, the complaints disappeared and we still serve the client today.

Faced with business problems in the past, my business reaction was quite similar to my personal reaction. I asked myself how I might resolve the problem without losing something I had, or not getting something I wanted. The focus was always on *my* needs or those of *my* business.

Today, regardless of the problem, I focus on how it impacts the customer, not the company. *What actions are in the best interests of the customer? How will the customer best be served?* By positioning our energy toward the customer, our company always wins. To borrow a concept from Abraham Lincoln, *We are a company of the people whom we serve.* This means thinking about the goods and services we provide from the perspective of the people buying them. You can do this in any of several ways. You can visit customers and simply observe how they use your product. Or, more simply, you can write or call them and *ask.* The question format doesn't have to be complicated or rigid. Just common-sense questions work well. "How does our product work for you?" "If there

were anything you could change about our product, what would it be?" "What are the two or three best parts of working with us? The two or three worst?"

A good customer service person should be able to slip a couple of these questions into most ordinary customer contacts. It continues to amaze me that so few companies make any concerted effort to ask customers what they think. This isn't a task for *Fortune 500* giants only. Every business with customers—which means every business—should ask.

This philosophy has served me well, and I seldom wake up at 3 AM these days to agonize over current problems. We must be doing something right; rather than complaints, today we have clients who bring us presents when they visit.

And saying "Thank You" is just as important. A couple of years ago, we sent out audio Thank You tapes to all of our clients. About a week later, a tape arrived in the mail from one of our clients that said, "No, we should be the ones thanking you for all the help you have given us over the years."

When I first started my own company, I adopted the staunch position that our customers were lucky to have a company like us. Everything was centered around the corporate ego, and I don't remember getting many presents—or praise. Today, I serve my customers. It's a total paradigm shift, a process of reinventing my reality. And, like anything else, it takes time and perfection is elusive.

Ask Yourself

1) *Always question old beliefs, they may be wrong.*

☐ Does cutting customer service increase profit? At what point will these cuts begin to cost customers? If you trimmed money out of customer service, where would you put it? Would you add it to the bottom line? To product development?

☐ Are problems caused by others or are they inherent to the process? How much does your customer service function end

up handling issues related to vendors, strategic partners or after-market service providers? What larger issues does this raise about your supply chain or service network?

☐ Is a short-term solution necessarily the long-term answer? In other words, does your customer service effort allow other parts of the enterprise to perform less well? Does customer service complain about cleaning up other people's messes?

2) *Redefine problems as opportunities to learn and grow.*

☐ Does resolving a problem serve the best interests of both the company and customer? Do you gain anything by refusing to seek out problems?

☐ Can a disgruntled customer be turned into a loyal advocate? How, specifically? Has this happened before? Can you use that experience as a case study for customer service staff?

3) *Offer action, not words.*

☐ What is your customer service policy? Do you have one?

☐ What kind of product or service decisions are frontline customer service staff allowed to make? Are these decisions enough to convert a disgruntled customer?

☐ What is the proportion of outgoing customer service calls—checking up on recent sales—to incoming calls—complaints or queries from customers?

☐ Has a customer ever complained about too much or the wrong kind of customer service? If so, what does that say about the relation between existing customer service efforts to customer expectations?

4) *Ask customers for feedback.*

☐ Does the product work for them? What would they change about the product—and the business relationship with you—if they could?

☐ What are the two or three best parts of working with you? The two or three worst?

Chapter 2:
Listen to Customers; They Want to Be Heard

Recently, luxury car manufacturer Jaguar Cars, Ltd. broke new ground in relationship marketing. Following a dealership bankruptcy in California's Orange County, Jaguar was embarrassingly absent in a very affluent market that loves luxury vehicles. In 1998, Jaguar began marketing a dealership that was not scheduled to open until the beginning of 2000.

Jaguar's goal was to pre-build a loyal customer base for this future dealership and the company spent a lot of money to do just that. Despite the lack of a functioning dealership, the dealership began sponsoring major charity and arts events, hosting parties and generally smothering the affluent residents with love and attention for two years.

Jaguar began soliciting feedback from the community about the proposed design of the new high-tech facility. Employees of Jaguar met often with the community in both formal and informal meetings, and its input continually altered the architectural design.

As a result of the preferences expressed by the community, the dealership was built in a mission style—instead of the original modern design—to blend in with the area's architecture. The willingness of Jaguar to adapt corporate desires to community feelings established Jaguar as a welcome and valuable asset to the community. Also based on consumer input, Jaguar developed a satellite boutique showroom and service drop-off for a nearby community as a convenience.

Relationship Aspect Marketing

Jaguar's commitment to the latest in point-of-purchase technology is also of particular interest. For example: To best serve this affluent and techno-savvy marketplace, Jaguar devised an interactive video wall that would allow customers to design a full-size image of their vehicle and build their dream car themselves, using a point and click option.

Ironically, despite its initial popularity, feedback from these future customers nixed the idea, despite the fact that some of these customers are the owners of high-tech companies. Apparently, Jaguar's potential customers did not want to look at computer images at a dealership; they wanted to kick tires of real cars! If Jaguar had not invested in pre-building customer relationships and soliciting early feedback, it would have invested in innovative, but useless—and costly—technology and architecture that the customers did not need, much less want.

So, as you investigate new technology to *better serve your customers*, do you take the time to find out what your customers think? Or are you wearing blinders, marching off into some fuzzy future, oblivious to the wants, needs and desires of your clients?

The model Jaguar followed is an old one: Listen to your customers. Your goals should be building relationships, developing ties within the community and soliciting the opinions of the potential customers. To achieve this:

1) Regularly seek *and use* consumer input;

2) Get to know your customers and their preferences;

3) Support local charities, schools and youth athletics;

4) Express your appreciation via birthday cards, special perks, etc.; and

5) Build trust by acting upon customer input.

Peel away everything from the telephone to the computer, and business still boils down to people doing business with people. So first find out what the people want before giving them what you think they want.

Ask Yourself

1) *Let your customers guide you.*

 ☐ Do you think you know what your customers want better than they do?

 ☐ Do your customers drive your business, or do you? This is an important distinction. If you stopped your marketing efforts, would customers still come?

 ☐ Directions make it easier to reach your destination. In terms of your customers and marketplace, what do "directions" mean?

2) *Ongoing customer contact pays big dividends, if it is valuable contact.*

 ☐ Is there a difference between quantity time and quality time? Can you give your customer service staff examples of each—based on real examples?

 ☐ Do you utilize customer contacts to gain more information about them? Does each customer contact involve some queries about how your product or service is used?

 ☐ Do you ask for customer input?

 ☐ How do you ask for this input? Written forms? Phone calls? In-person meetings?

3) *Technology is not designed to replace the human experience, but rather enhance it.*

 ☐ Would you prefer a real life experience or a virtual experience? How can you blend this to create an effective customer relationship?

 ☐ Does your automation attempt to *replace* humans or *enhance* the human experience? Too many customer service functions attempt to replace human interaction.

Relationship Aspect Marketing

- ☐ How can you use technology to *enhance* rather than replace?

- ☐ How can you structure the automated part of customer service to support the human part? In other words, can you use computers to ensure that people devote as much time as possible to assisting your customers?

- ☐ A computer can't replace the smell of a new car. But it can give a consumer a lot of information about the car—prices, options, specifications. What is the analogous change in your market?

- ☐ The latest in technology can't clean a dirty bathroom. How can you use it to empower frontline customer service staff to clean up messes?

- ☐ Will offering complete customer information online help?

- ☐ How about a program that determines the value of each sale?

- ☐ Can a smile be more valuable than efficiency? The information culture drives us all to objective measures of performance. How can you encourage *subjective* measures to customers?

CHAPTER 3:

ENCOURAGING CUSTOMERS TO SPEAK

A few years ago, Mann Theatres, a regional movie theater chain in the western United States contacted our company. At the time, theaters were being crushed by the competition and pressured to build bigger and bigger structures with increased technology for better sound and picture, added conveniences and different styles of seating. The Mann management team was in a quandary. Should they react to the competition? Should they make a quantum leap into new technology? Should they continue building bigger and bigger theatres? The decisions and the choices were similar to those confronting just about any business today.

At an initial meeting with senior management, the team asked my opinion as to what actions would have the greatest impact with moviegoers. "I haven't the faintest idea!" I blurted out. "What do your customers say?" "We're not sure," was the response. This set the tone for the remainder of the meeting. We discussed various ways to find out what the public wanted from a theater. We all agreed that focus groups were too limited; but we felt that the necessary survey would be too lengthy to attract any participants. Still, we needed to get inside the heads of the customers.

Discover What Your Customers Want

Using Los Angeles as a beta-test site, we implemented a strategy that combined the best of a focus group and a survey approach. From four

separate theaters, we collected about a thousand names of people who might be interested in participating in a fact-finding event. Each person on the list was contacted by telephone to discern age, marital status, movie attendance history and willingness to give up an evening to participate. Using this information, we then honed this group down to 100 people that we felt provided a broad spectrum of the movie-going public.

Simultaneously, we jointly developed a 30-page questionnaire that mind-mapped the process of attending a movie—starting with the initial thought that maybe it would be nice to go to a movie, and ending with the act of actually entering a theater.

Nobody wants to sit down for a couple of hours and work his way through a ponderous questionnaire. So we turned it into a party—treating the entire group to a sit-down dinner. After dinner, a professional moderator worked the group through the questions on an interactive basis with visual support.

At the conclusion, the participants were treated to 10 free movie passes and some complimentary promotional items. Based on a very enthusiastic response from the group, and prior to tabulating any results, Mann Theatres commissioned three more events in other geographical areas across the country. I must admit that I was anxiously awaiting the tabulations. The survey not only covered what we believed to be pertinent facets of movie attendance, but we had loaded it with a lot of technological *what if*s. What if you could buy your tickets over the Internet and print them out on your printer? What if you could pre-order your refreshments and have them delivered to your seat? What if…what if…what if?

We hoped to find out why the survey participants chose one theater over another, as well as what would impact that same decision in the future.

The key ingredient to their decision-making process: technology. Movie-goers expect the latest in audio and visual technology. As for refreshments, the group agreed that standing in line and making a decision from the visual and olfactory delights plays an integral part in the movie attendance process.

As informative as this feedback was, however, we had yet to reach a definitive answer as to why a person would choose one theater over another. Having the best technology and refreshments clearly wasn't enough. Something else was missing.

Well, the answer was soon forthcoming—and it was a "write-in." Over 75 percent of all respondees indicated that the cleanliness of the restrooms was a major factor in determining which theater they would visit. (The participants even wrote detailed comments about the size of the restrooms, number of stalls, distance from the screening rooms and maintenance—such as access to toilet paper.) Nothing in our survey addressed this particular issue, but it was so important to the participants that they took the time to actually write in special comments. Clean lobbies and clean auditoriums were the next most important factors.

In other words, *all things being equal, the cleanest theater wins!*

Defensive People Cling to Bad Ideas

In conjunction with a two-day management meeting, I was asked to report our findings to Mann senior management, including every theater manager in the chain. Prefacing my comments by saying that we now knew the secret to beating the competition, I quietly reported the data and reinforced the importance of cleanliness.

Some of the theater managers nodded in agreement, others silently looked at me as if I were crazy and a few took umbrage. One manager stood up and said, "I already have a staff person charged with inspecting the restrooms every half hour, and I'm not going to increase my labor expense in that regard!"

How quick we are to defend our positions.

Faced with facts, we often jump to defensive conclusions that harden our position against change. I pointed out to the manager that no one expected him to increase his labor expense. The solution could be as simple as providing the restroom checker with a sign-off checklist. Or since ev-

ery employee probably uses a restroom at least once during his shift, that could be construed as numerous additional restroom checks if it were built into everyone's job description. This particular manager's theater averaged nearly 24 employees per shift, which could dramatically impact restroom cleanliness.

Employees Are the Key

Prior to one of these sessions in Denver, I visited each Mann theater in the area to better know the lay of the land. I can't resist telling you about one exceptional ticket-taker I encountered. I approached him to ask if the manager was on hand, explaining that I would like to walk through the theater. Not wanting to leave his post, he asked a coworker at the candy counter to get the manager.

While I was waiting, a family gave him their tickets. Dad proceeded to the refreshment counter while the rest of the family headed toward the screening room. Loaded with several boxes of overflowing popcorn and other items, the father began to cross the lobby. "Hold on a minute," the young ticket-taker called, "Let me help you with that."

I watched as he approached the man, lightened his load and helped him to the screening room. I was amazed at the courtesy this young man displayed. When he returned to his post, I went up and complemented him on the wonderful customer service he had just exhibited. "Oh, you got it wrong," he quickly replied. "I really wasn't doing that to help him, I was doing it for me."

"What do you mean?" I asked.

"Well, I saw him juggling all that stuff and I knew he was going to drop popcorn all across the lobby. Since I'm the one who has to clean the lobby, it was easier to help him carry it than to clean up the mess."

I was amused—and, at first, slightly bemused—by his response. However, I immediately saw the truth in what he said. Despite his somewhat self-serving motivation, this employee truly cared about his job. That car-

ing attitude translated into concern for the customer. His actions definitely made an impression on me, as I'm sure they did on the customer.

The point is: If a company asks for customer input, it must respond with caring performance. Hiring conscientious and caring employees is one effective way to do this.

Ask Yourself

1) *Don't assume that you know what your customers want.*

 ☐ Sometimes we stand too close to the trees to see the forest. Does your process for answering customer service calls keep you from seeing marketplace trends because you're so busy answering questions?

 ☐ Assumptions can be misleading. Does your current process for answering calls conform to out-of-date notions of who your customers are and what they want?

 ☐ Have you ever misjudged a customer's need or want? Does your existing process rely on your judgment of customers' needs rather than giving customers the chance to speak for themselves? How can you give customers a better chance to speak to you?

2) *If you ask your customers what they want, they will tell you.*

 ☐ Do you give customers a forum in which they feel free—and comfortable—to speak their mind.

 ☐ Can you do this as part of your ordinary customer service?

 ☐ Or do you need to make a separate effort to gather this input?

 ☐ Can you use a series of questions to dig beneath the surface of a customer's mind?

Relationship Aspect Marketing

□ Who should ask the questions: Sales staff making follow-up calls? Customer service staff helping customers?

□ Are you willing to hear the answers? If you get useful input, do you have a method by which you can communicate the results with senior management? And implement changes?

(See Appendix Seventeen for a sample report that customer service/marketing can use to convey survey results.)

Chapter 4:
Customers Put You First
if You Put Them First

Many of my insights as a business owner are derived from my personal experience as a customer. That said, here's a story of two retail consumer giants: Minneapolis-based Best Buy Company, Inc. and Richmond-based Circuit City Stores, Inc.

My wife and I have finally reached a point in our lives where our children are grown and out of the house. Because of this and because we were in an environmentally friendly mood, we decided to purchase a new, smaller, energy-efficient freezer to replace the big freezer in the garage, which was a waste of space and energy. The subsequent process proved to be an interesting one.

First, I turned to the Internet to research various makes of small freezers, price ranges and benefits. There are many good sites on the Web that provide up-to-date information on freezer technology and data comparison. My research helped me to conclude that freezers are similar in features and pricing. So, we headed out to buy a basic freezer under $300.

A Painful Lesson in Retailing

Our first stop, which we anticipated to be our only stop, was Best Buy. (It was the closest to our home.) We entered the store, walked to the major appliance section and quickly found several small freezers from which to choose. A young clerk approached us and asked if he could be of assis-

tance. We pointed out the unit we wanted and walked over to his computer station to take care of the transaction. The young man first verified availability and explained that delivery could be arranged for three days hence. We agreed and he proceeded to enter into his computer all the necessary data, such as name, address, phone and directions to our house for the delivery truck. As this took place, I reached for my checkbook to pay for the freezer.

Much to my surprise, the clerk said, "Oh, I can't take your money. Go over to the other side of the building where you see the finance sign."

"I'm not financing this," I retorted. "I just want to pay for it."

"Well, you have to do that at the finance sign," he explained.

Perturbed, but still agreeable, I went over to stand in line at the finance window. There were several people ahead of me, but it didn't look too bad. That is until I realized that the couple at the window was literally filling out an application to finance a purchase.

I asked a nearby employee if I really needed to stand in the finance line to simply pay for a purchase. He responded that if delivery was involved it had to be handled at the finance window. After five more minutes of waiting in a line that had yet to progress, I took the paperwork back to the sales clerk in major appliances and said, "Cancel the sale. I don't have time to stand in line at the finance counter." He had no response.

We then drove about a mile farther to Circuit City and repeated the process. This time another young clerk took us to his computer station, verified availability and asked if we would like delivery the following day. I was feeling pretty good, I already saved two days of waiting for delivery. I was feeling even better; I had saved $5 in delivery fees. He then asked for my phone number and up came all my pertinent information, which he verified. (I was feeling great by now, as this saved the inconvenience of relaying all the necessary personal information.) Interestingly, I had made many purchases at both stores prior to this, but only Circuit City had the information on file for access.

As the computer tallied all the information and pricing, he asked, "How would you like to pay for this?" I wrote out a check, he took it, gave me a receipt and indicated that the delivery company would call that evening with an approximate delivery time.

My wife and I returned home, laughing that we would probably still be standing in line at Best Buy for the privilege of spending more money. (The monetary savings were strictly in the delivery charge; both freezers were comparably priced.)

Make the Process Easy or Lose the Customer

Bearing in mind that price is not usually an issue anymore—the nature of competition and the Internet have leveled pricing in most cases—what were the impressions that each store left in the mind of the consumer (in this case, me)?

Circuit City simplified the purchasing process by allowing the clerk to assist us with our purchase at his own computer/register. Best Buy did not. And why not? Is the company afraid to empower its employees to process payments? If so, what does that say to the employee? Is the finance counter simply a ploy to talk the customer into financing? (That thought reared its ugly head in the mind of this consumer as a method by which they could increase the profitability per sale.) Are Best Buy's computer stations incapable of processing payment? (With today's technology that would be a sad state of affairs.) Is it a case of operational inefficiency? (This is often true when internal efficiency takes precedent over customer satisfaction.)

I have to assume that Circuit City acknowledges that speed and convenience are critical to the customer relationship; Best Buy does not. Understanding your customer is the most basic aspect of any business relationship.

In today's hectic and harried world, most marketers have been quick to realize that consumers want *one-stop shopping convenience*. We see it

everywhere from the Big Box Stores of the world to shopping malls to automobile complexes.

That being the case, why would any retailer force customers into *two-stop purchasing* within it's own walls?

Ask Yourself

1) *The easier the transaction, the happier the customer.*

☐ Every sane person prefers quick and easy to slow and arduous. Are you constantly looking for ways to make your customers' experience quick and easy?

☐ Does your customer service function have a standard way of communicating with finance, inventory management and product development to shape customer response?

☐ Could streamlined marketing and customer service also increase general productivity?

☐ How can a smooth process of finding and keeping customers impact the *inside* aspects of your business?

☐ What does this mean for the overall structure of your operations?

2) *Speed is no longer a benefit, it is an entitlement.*

☐ Can an entitlement be construed as a benefit? What are the differences between the two—from a customer's perspective?

☐ Have customers increased or decreased their demands for immediate service? Do they put a real value on 24-hour service, real-time response or other current concepts?

☐ All things being equal, do you think customers will choose the slower vendor? Will they choose slow if it's cheap? Will they choose slow if it's easy?

3) *Efficiency must be customer-focused.*

☐ Can internal efficiency cause inefficiency at the customer level? This gets back to the question of structure.

☐ Is your business set up to reflect customer needs? Or is it inclined to turn a deaf ear?

☐ Does your existing customer service function utilize known customer data when making a transaction? This is a recurring question throughout our review of customer service functions. A customer's history and profile is essential to supporting a customer effectively.

☐ Does "once and done" apply to customer purchases? Generally speaking, the higher the unit sale price, the less true this statement is. If you're selling high-end products or services, you're going to need to offer considerable customer support. Are you ready?

Relationship Aspect Marketing

Chapter 5:

A Little Bit Extra Goes a Long Way

Lagniappe (*LAN-yap*) is a small, unexpected gift presented by a storeowner to a customer with his purchase. It is a frequently used word in Cajun country and—used generally—means "a little bit extra." A baker's dozen, or 13 for the price of 12, is an example of lagniappe. Customers appreciate a little bit extra—whether it's added product, service, education, training or simply a personal touch.

The concept of lagniappe was made clear to me when one of our auxiliary hard drives crashed. (And this time I was on the receiving end.)

I first called our computer consultant who agreed that the hard drive was bad and suggested that this would be a good time to replace it with more memory. Consulting his calendar, he said he could come out in about 10 days, install a bigger hard drive and update other elements in our system. I was preparing to leave town for a trip, so I said I'd call when I returned to schedule an appointment.

Later that same day, I was surfing the Internet and decided to pay a visit to Milpitas, Calif.-based Quantum Corp., the manufacturer of the hard drive that had gone bad. As I glanced over its homepage, I noticed an icon for warranty status. Curious, I clicked on it and was transported to a page asking for the serial number of my unit. I input the information, and a new page popped up with our company name, the date of purchase, warranty end date (10 months in the future) and current replacement cost ($0). I e-mailed the necessary information for a warranty claim, and re-

ceived an acknowledgment of receipt and a statement that I would be contacted within 48 hours. I did not want to wait 48 hours, so I called their toll-free number and within less than a minute I was talking with a customer service representative. I complemented her on the warranty status segment of their Web site, explained that I didn't want to wait 48 hours for a reply and described the problem.

She agreed that the drive was bad, excused herself for a minute and quickly returned with a warranty replacement authorization. "Now you get to make a choice," she said. "You can send the old drive back to us and then we will send you a new one [this is pretty much standard procedure], or we will send it out now, next-day air, if you will guarantee the return of the old one with a credit card deposit." Impressed, I guaranteed the return of the old drive and the replacement was delivered the next morning.

The only problem arose when I asked if the value of the replacement drive could be credited toward a bigger drive. Without missing a beat she said that that was a fairly common request and that it made sense. However, current policy did not allow that. She was quick to point out, however, that the claims department had a request in process to change the policy and she hoped that it would be different in the future.

What happened here?

First, and most important, Quantum put the needs of its customers before its warranty expense controls. Few companies offer a warranty status checkpoint on their Web site. In fact, I know of many companies that mimic the Armed Forces policy: *Don't ask, don't tell*. By placing the status check on their Web site, Quantum quietly positioned itself as a company of integrity.

Granted the company's return policy leaves it open to more warranty claims (like mine), but I am sure they have reaped the benefits of such a policy in increased business. After all, do you think I would look anywhere else for another hard drive? And, needless to say, my computer consultant lost my business…at least this time.

Ask Yourself

1) *Customer focus provides long-term benefits that far out-weigh any short-term costs.*

 ☐ Is a current customer more likely to buy from you than a prospect is?

 ☐ Can you build repeat or referral sales into a larger part of your business?

 ☐ What does it cost for you to find and sell to a prospect?

 ☐ Would it be beneficial to let your customers know how much you value them? In other words, would sending information and appreciation messages be worth the cost?

 ☐ How much repeat business would it take to pay for this kind of mailing or phone campaign?

 ☐ Are you willing to spend money to build loyalty?

 ☐ How much—in specific dollars—is a repeat sale worth?

2) *Great service builds tremendous loyalty.*

 ☐ Does your service policy cater to the needs of the company or the customer?

 ☐ Do you poll customers regularly for what they think about your service?

 ☐ Is service available when customers need it?

 ☐ Can service be the deciding factor in a purchase decision?

 ☐ Can you explain this to your customer service staff as a case study or example?

3) *Web sites need to offer substantive value.*

 ☐ Few people actively seek out commercials. How can your Web site offer enough to a customer that she seeks it out?

Relationship Aspect Marketing

☐ Does your Web site offer any information on your company and products? Is this information useful? Is it easy to access?

☐ Would customers value educational and service resources? How much would it cost you to provide these things online? How quickly could you recoup this investment?

Chapter 6:

Share Knowledge and Information

Surrounding good product with quality service at competitive rates is not enough for a business to survive. Today's consumer demands excellent products, superb service in every facet of an operation, and—at the very least—competitive prices. And being able to deliver these things is still not enough. You must bring added value to the equation in the form of knowledge, expertise and resources.

Whether they're speaking from podiums or being quoted in magazine articles, the experts tell us to add value to our business relationships in order to overcome competition and price. Yet few experts tell us exactly what value to add.

One day, I received a package from Interactive Business Information Systems, Inc., (www.ibisinc.com), a computer solutions provider that is partnered with both computer giant Microsoft Corp. and Great Plains Software, Inc., a leading provider of e-business accounting solutions. This package, which was sent to all their clients, prospects and vendors is a definitive example of providing added value to a business relationship.

The cover letter began with a quotation from Bill Gates:

> I have a simple but strong belief. The most meaningful way to differentiate your company from your competition, the best way to put distance between you and the crowd, is to do an outstanding job with information. How you gather, manage and use information will determine whether you win or lose.

Relationship Aspect Marketing

Explaining that this quotation came from Gates's book *Business @ the Speed of Thought*, IBIS president Andy Vabulas went on to say,

> …because of the enormous impact this book is making, we had copies sent to our board and our management team. The response was so positive, we decided to share it with our employees, our clients and our alliances. I have enclosed a newly condensed summary, and if you would like a personal copy of the full edition just reply below and we will send it with our best wishes.

The enclosure was a nicely bound, 14-page condensed version of Bill Gates's book.

This was not an inexpensive mailing and the offer of the complete book significantly upped the overall ante. Yet, even if everyone took them up on the free book, the cost per employee, client and alliance would be about the price of a nice lunch. What company would begrudge spending that on any employee, client or alliance?

Any company could do something like this, yet few do. That's what makes it so impressive. This company is as high-tech as you can get, yet it hasn't lost sight of the personal touch.

How many times have you read a good business book and recommended it to a client? Imagine if you had taken that one step further and actually bought the book and sent it to that client. The same could apply to a magazine article, or a taped recording of a speaker who impressed you at a conference. That's the extra mile, the extra step, the added value that differentiates the superstars in any business.

Silicon Valley's Oracle Corp., a leading supplier of software for information management, has spent a lot of money to help its clients and prospects to become more successful in their business. Their approach began with a direct mail invitation to participate in a strategic teleseminar for sales and marketing executives. It was being offered on two separate days. The teleseminar featured a live, interactive interview with Patricia Seybold, author of *Customers.com: How to Create a Profitable Strat-*

egy for the Internet and Beyond. After sending in my R.S.V.P, I received two phone calls and one e-mail from Oracle with information related to the teleseminar and reminding me of the day and time I had selected.

On the appointed day, I dialed the toll-free access number and spent 90 minutes listening to an enlightening discussion of e-commerce. I kept waiting, particularly during interactive response to questions about the program, for Oracle's commercial. It never came!

During the audience Q&A, I asked the interviewer—an Oracle representative—why they were going to this expense. His response was that by helping to increase the knowledge and expertise of the business public, everyone would win—including Oracle.

I am not an Oracle customer, but I am impressed by their commitment to developing and enhancing present and future relationships. From the direct mail invitation to the calls, e-mail and teleseminar itself, there was no blatant advertising. In fact, Oracle's role was dramatically downplayed, which, ironically, has made me remember Oracle's contributions all the more.

How Does This Apply to You?

You may wonder what a big-budget software company's campaign has to do with your business. Creative business owners and management can do the same thing Oracle did for its clients and prospects. And it doesn't need to be extravagant or expensive.

For instance, any company could schedule a teleseminar using its local phone company or AT&T Alliance Conference Calling. Invite your top 10 clients to hear an interview or presentation by an expert within your industry. (Your lawyer, accountant or insurance agent might be able to provide some suggestions.)

After the presentation, open up the discussion for questions and answers. Some of your clients may put the call on a speakerphone and ask other

key employees to sit in on the call. On a do-it-yourself basis, the phone line charges for an hour might equal about $30 per client—about the same as a lunch and less than a round of golf. For a little more, you could arrange professional hosting and even record the session for additional distribution.

The company that shares knowledge as a value-added service builds relationships. It not only survives, it flourishes.

Ask Yourself

1) *People want to feel appreciated; a sense of value creates a sense of appreciation.*

 ☐ How can you express a value exchange to customers—the value you offer and the value you feel for them?

 ☐ What are some ways you can express appreciation to your customers?

 ☐ Can you do specific things to create—or reinforce—a sense of value in your business relationships?

 ☐ Do your prospects feel appreciated before you make the sale? Or do you count on product use or ongoing service to create the sense of value?

2) *Creativity adds to perceived value.*

 ☐ Are people more likely to appreciate a creative effort than traditional service?

 ☐ What are the best aspects of traditional service? How can those be kept while newer, more creative service is developed?

 ☐ Do you ever conduct creative brainstorming sessions with either staff or customers? If you could do this—or do it again— what questions would you ask?

☐ Does creativity indicate a sense of positive motivation and energy? Or can it get lost in innovation for innovation's sake? How can you channel creativity so that it generates value?

3) *Added value simply means taking an extra step.*

☐ What does value mean, in the context of your product or service?

☐ How can notions of value be improved or expanded?

☐ Which would your customers appreciate more, a box of candy or a list of new products? A free TV or a day of technical training? A 10 percent discount or an extended service agreement?

☐ What do these references tell you about your customer's sense of value?

☐ When you find something of value, are you willing to share it with your new clients? Do they expect you to act as a resource—something or someone who finds value—they can use repeatedly?

4) *Technology can bring informative value to relationships.*

☐ Is it better to give or to teach? How does this distinction reflect the nature of your business?

☐ Do your clients consider your Web site an information resource? If information isn't considered very valuable by your customers, how can you *create* a sense of value in it?

☐ What technologies can immediately be used as information tools? Are these technologies a visible part of your product or service? Or are they an invisible part of other value your customers seek? (One fallacy that fueled the dot.com bust was thinking that people would value Web sites as tools themselves. Most don't. Most think of Web sites as invisible tools for conveying information or access.

Relationship Aspect Marketing

5) *Understated marketing can be very powerful.*

☐ Would you rather ask customers to buy or have them ask you to sell? In other words, is your sales and service approach introverted or extroverted?

☐ What does this mean for the way you set up customer service?

☐ Which is more powerful: attraction or promotion? Are you spending your resources in the right direction?

☐ Is your customer service function designed to attract sales?

6) *Even when offering a valuable resource, show appreciation to participants.*

☐ Does common courtesy have a place in business today?

☐ Do you consider your client's time as an equal value to your contributions?

☐ What can your customer service staff do to convey respect to your customers? Avoid jargon? Offer preferred status? Communicate regularly?

☐ Are you thankful for opportunities to be of service to your customers?

☐ How can you enable your customer service staff to *show* this thankfulness as well as say it?

CHAPTER 7:
BENEFITS CAN BECOME ENTITLEMENTS

I once wrote an article on the topic of speed as the newest consumer entitlement. First published in the newsletter *Executive Excellence*, and later included in the book *Best of Class*, the message is still pertinent today—perhaps even more so.

I trace the germination of my thoughts on entitlement to a past Christmas. Project Outreach is a holiday tradition in our household. Each year we assist our local church in gathering food, toys and money for distribution to families living in hotels in L.A.'s downtown Skid Row. On the Saturday before Christmas, we join many others in celebrating Christmas with about 350 of these families.

Delivery day is always one of heartfelt joy as we are greeted at the hotel room doors by glistening eyes full of hope and anticipation. Aside from the overwhelming sense that we help people who really needed it, there is always hope because each year the faces are new. These hotels are only a transitory stop for a family trying to regroup and recover.

This particular year was different from other Christmases. First, many of the faces were the same as the year before; upward mobility had stalled. Second, the attitude had changed. Gone were the warm embraces and grateful greetings. I was puzzled over the change. As I discussed this phenomena with others, the truth unfolded: Our gifts had become their entitlement. What a difference a year can make.

This isn't a treatise on sociology. I tell the story to exemplify how quickly a benefit or a gift can become an entitlement.

Consumers Expect Speed

In the business world of the past, companies that cared about their future aimed to satisfy their customers. Today, customers expect to be satisfied; satisfaction has become an entitlement. Good service and professionalism, once considered value-added benefits in the sales equation, are now entitlements. Expectations have grown exponentially as these entitlements have taken a firm grip on the hearts of consumers. It's not enough to just satisfy a customer's needs. In fact, even complete satisfaction isn't enough anymore. You now have to wow your clients by totally exceeding their expectations.

One of the newest entitlements, one that is becoming critical, is speed. As a December 23, 1994 article on the front page of the *Wall Street Journal* warned, "Time is money. Time waits for no man. The unforgiving minute."

Recently, I left the counter of a restaurant in frustration because five minutes elapsed without a greeting, menu, cup of coffee or even a near miss with a waitress. I ended up at a fast food joint. I had really wanted a more elaborate—not to mention, nutritious—dinner, but the first restaurant failed to acknowledge my entitlement to speedy service. The establishment lost my business.

Major hotel chains increasingly recognize this need for speed. Hyatt and others, for instance, are adding convenience-restaurants to serve the eat-and-run mentality of today's business travelers. Just look at the coffee carts that abound in lobbies today. Even room service has become too slow for most travelers.

Not too long ago, I watched in awe as the fax machine sent a document on to its destination. Today, I watch, impatiently, as it takes 30 seconds to process a page; e-mail is instantaneous. Perceptions change quickly. In the past, researching a paper meant more than an occasional trip to the

library. Today, that inconvenience is unacceptable. Research means a modem connection to the electronic libraries on the information highway.

This perceived entitlement to speed has gradually spread to other technologies that have not sped up. The telephone is a perfect example. Speed-dialing aside, it still takes about the same amount of time to make the connection and the spacing between the rings remains static. Yet, if the phone is not picked up by the second or third ring, I no longer tolerate the wait. Often I'll hang up and redial, assuming that I must have dialed the wrong number. After all no one would let a telephone go unanswered beyond the third ring.

Speed is no longer an option for a successful business. Automation has provided the tools by which we can meet the entitlement to speed. Remember, every journey begins with the first step. You aren't necessarily going to get your speed quotient up overnight.

Ask Yourself

1) *Speedy service acknowledges the customer's value.*

 ☐ Slow service might lead your customers to think you don't care about them. What can you do to make sure all service calls are answered quickly? And exactly how quick is *quickly*? Twenty-four hours? Seventy-two? Two?

 ☐ How quickly does a customer expect you to return a phone call?

 ☐ If you value someone, do you go out of your way to show it? Do you include a log of response time on customer calls? Do you add a field to your customer service program that allows for a short description of customer history?

2) *Lack of speed kills!*

 ☐ Customers avoid places with lengthy or delayed service. If you are a low-cost provider of a commodity, good or service, you might be able to get away with slow service. But

even that's not so true anymore. And most businesses aren't low-cost commodity suppliers.

- ☐ Do you position yourself as a high-end or value-added supplier? If you do, you have to provide timely service.

- ☐ Do your customers compare your speed with the speed of other businesses? Value-added suppliers will use better service to justify higher prices.

- ☐ Do you do this? Do your competitors? If so, do you—or do they—deliver?

- ☐ Do you use the fax as much as you used to before e-mail?

- ☐ How has technology put pressure on response time?

- ☐ What technology tools do you make available to frontline customer service staff?

3) *Monitor customer perceptions; they change quickly.*

- ☐ Is your customer service function equipped with outdated tools?

- ☐ Does your customer service staff have to justify expenditures because it's not a revenue-generating function?

- ☐ How can you use technology to show that customer service generates repeat sales—and critical revenue?

- ☐ Has the pace of consumer change increased since the introduction of the Internet?

- ☐ How many customers communicate by e-mail?

- ☐ How many have supply chain software in place?

- ☐ Have they asked you to participate in these programs?

- ☐ Have instantaneous Internet order confirmations made the marketing/sales/service cycle much shorter?

- ☐ What does this mean for customer service?

CHAPTER 8:

CONNECTING THROUGH CUSTOMER SERVICE

In any relationship, there has to be a sense of connection between the various parties. Among the several definitions of the word *connection* is the phrase *an arrangement to advance interests of another.* In a business sense, this means that if we connect with our clients, we put their interests before ours. In other words, we assume a position of service to them—as opposed to a position whereby they serve us.

Another interesting word used to define connection is *intimacy*, which has been broken down by some as "in-to-me-see." In order to be intimate with our clients, we must be willing to look at the world through their eyes. And when we look through their eyes, we see the needs that they expect us to meet.

This brings to mind the various methods by which we attempt to measure our relationships through surveys and questionnaires. Whatever the format—postcards and letters, Web site surveys, telephone calls or personal encounters—there are two obvious drawbacks to asking for input from your customers:

1) We tend to filter the replies through our own reality or "eyes." And, our interpretation is often vastly different from the intended comment from the client. This is a normal self-serving aspect of human nature.

2) We tend to seek "atta-boys," as opposed to the truth. This is because it is easier to hear and to respond to praise than it is

to criticism. Regardless of well-founded intentions, human nature encourages us to look for positive feedback, as opposed to criticism. Positive feedback promotes past accomplishments; criticism promotes positive change.

Both of these drawbacks can be circumvented through impartial, third-party analysis. When it comes to large, mass-mailing surveys, you have to remove yourself from the process in order to obtain objective feedback. If you, as a business owner or manager, are currently undertaking in-house surveys, save your money. The results are worthless unless you are looking for an advertising gimmick.

However, you can, and should, conduct informal surveys of your customers. This entails calling or sending a personal note to a small number of customers on a regular basis—say once a month—to ask them how they think you are doing and whether they have any comments. The advantages: This form of surveying is free, and a personal call or note is intimate enough that your customers may actually take the time to offer some constructive feedback.

The Dangers of Soliciting Feedback

Joel Folkman, in the book *Turning Feedback into Change*, identifies 31 principles related to the gathering of feedback.[1] The first two outline the danger of which I speak:

> Folkman's Principle #1: Asking others for input increases their expectations that you will change in a positive way.

> Folkman's Principle #2: If you receive feedback, but do not change for the better, you will be perceived more negatively than if you had not received feedback.

[1] *Turning Feedback into Change: 31 Principles for Managing Personal Development through Feedback*, Joe Folkman, Novations Group, Inc./Executive Excellence, 1996.

Feedback, when ignored, poses a danger to any business. (It reminds me of the old maxim that *no good deed goes unpunished.*) Moreover, outsourcing the process does not eliminate the problem. If you are not willing to change, don't solicit feedback—it will sink your ship.

Ask Yourself

1) *Feedback is critical to success.*

 ☐ How can you make customer feedback a built-in aspect of your service function?

 ☐ Loyal customers have a vested self-interest in your success. How can you create a sense of loyalty in your customers?

 ☐ What do they value in your relationship: Price, credit, service?

 ☐ How can you emphasize this value in every contact?

 ☐ Does soliciting feedback help you to better serve your customers?

 ☐ Can you use it to impress existing value on your customers?

2) *Don't seek feedback unless you're willing to change.*

 ☐ A survey made but not analyzed and acted upon is useless. Are you ready to commit to a feedback process?

 ☐ The solicitation of feedback establishes expectations. You have to be ready to use the feedback you collect in some concrete way that lets the customer know the feedback has been heard. How will you let them know? (See Appendix Sixteen for a sample letter that can be used to respond to customers who have provided feedback.)

3) *Third-party objectivity adds value to the analysis.*

 ☐ Can you maintain objectivity when soliciting feedback? Self-interest can distort the results of feedback. Can you take precautions internally to prevent this from happening?

Business Plans to Game Plans

- ☐ What can you do to make sure that you remain open to unexpected—or unwanted—responses?

- ☐ How can you assure internal groups that criticism can be constructive?

- ☐ How can you convey to your staff that truthful criticism is more valuable than positive endorsements?

CHAPTER 9:

HOW YOU HANDLE

COMPLAINTS...

Each time you connect with an individual in a business setting, you can create a positive impact or a negative one. When selling services, business owners ardently strive to make a positive impact to get the deal. But, what about after the fact, when a complaint or a claim arises? Complaints are a perfect example of a problem that can be an opportunity. Handle the complaint well and you've begun the process of building a customer relationship.

Let's take a look at three scenarios that I personally experienced—and that demonstrate how a company can keep valuable customers (like me).

Scenario 1 — Delta Airlines

After a particularly bad experience—departure delays, a direct flight changing to a flight with connections and lost baggage at both ends of the trip—with Delta Airlines on a trip to New Orleans, I wrote a letter to the company venting my frustration (the company had no e-mail feature on its Web site).

The company responded quickly in writing. Delta acknowledged their fault—the only finger-pointing was at themselves—and problems they were currently trying to overcome. Then, by way of apology, they sent me $300 worth of travel credits toward upcoming trips.

Result: *I was impressed by the speed and sincerity with which they handled the complaint and will continue to use their services. And, backing up their apology with a monetary olive branch didn't hurt. Of course, this was savvy on their part—providing the coupons helped to ensure that I would use their airline again. And I will.*

Scenario 2 — Sheraton

On that same trip, I experienced less-than-favorable service at a major hotel chain. The Sheraton New Orleans provided a room with a non-functioning television, no hot water, no phone jacks for a modem hook-up and poor room service.

Following my stay, I e-mailed a complaint to their corporate headquarters. A representative from the company first responded by e-mail to thank me for taking the time to write, apologized for the inconveniences and assured me that the responsible department heads were notified. Shortly thereafter, via snail-mail, another letter of apology arrived. The company accepted full blame and offered two free nights at their facility.

Result: *Again, I was impressed by the expediency and courtesy of their reply and will continue to use their services.*

Scenario 3 — Superior Insurance Companies of Atlanta

The third problem took nearly five weeks to resolve.

My 1967 classic Thunderbird was clobbered from behind at a stop sign and totaled. During the first month, there was no settlement offer from the other driver's insurance company, and only one written communication— a letter advising me that any additional storage fees incurred would be at my expense unless I allowed them to tow the car to one of their storage areas.

After daily faxes, letters and phone calls on my part, I finally received a callback from their claims processor. "I don't have anything to tell you since we aren't prepared to make an offer," he said. When I questioned the delays, I was told by the same processor, "Oh, we're right on schedule." *On schedule for whom*, I wondered.

Thirty-three days after filing the claim, I received a settlement call—and a whole lot more—from their assistant vice president of claims. To my amazement, the insurance company settled for the amount I had suggested three weeks earlier. Then the claims guy asked if I had time to hear "his side of the story."

We both agreed that 10 days of the delay was caused by the accident reporting system utilized by the California Highway Patrol. Apparently, once the highway patrol takes a report, it can take up to two weeks before the report is available and then you have to go to the investigating office and purchase a copy. Despite television depictions of highly-automated police forces, their accident reporting system is technologically antique. Everything is done by hand.

The insurance company's own internal problems led to further delay. The claims agent explained that I was assigned a fairly new claims processor who still needed some training in people skills, or as he put it, "the ability to creatively work outside the box of the rules."

Consumers should not have to depend on the luck of the draw, unless the company is engaged in premeditated suicide. New employees must receive proper training before they are put on the firing line. And, management must closely supervise employees until they have gained enough experience to understand the boundaries of their empowerment.

This brings us to one of the greatest problems in business (and a pet peeve of mine): Companies will spend hundreds of thousands of dollars on technical training—but squeeze every penny when it comes to training employees in the area of people skills. Yet, these customer service people are our direct interface with the public.

Relationship Aspect Marketing

Apparently, the insurance company also experienced a technology short-fall within the organization that further added to the delay. When a fax is routed to their central fax server, such as a request for appraisal, the system does not confirm that the fax has been either sent or received. The claims rep added that they were working on resolving that problem, but in my case, it meant that they incorrectly assumed that the appraiser had been notified. Still, even the most rudimentary fax machine prints out confirmations. Why would a company accept anything less from their automated vendor?

Finally, as I pointed out, the insurance company's claim process lacked in direct communication with the claimant. My company has had basic automated letter processes for years. Yet, this major company had no procedure or process. Simply acknowledging the filing of a claim with a basic outline of the process helps establish reasonable expectations in the mind of the claimant. If you are a company without automated claims communications, you are probably spending more than necessary on settling claims. Why? Setting proper expectations and providing speedy processing results in lower dollars per settlement.

To the rep's credit, he did not try to place blame, and accepted complete responsibility for the delay; he immediately sent a check to resolve the claim.

Result: *Despite a diligent telephone call and letter of apology, the overall process left a strong negative feeling about this particular insurance company. As a victim of their client, rather than a client per se, I feel lucky that they are not my insurer; if they were, I would quickly find a new insurer with which to place my insurance.*

Conversely, when I filed a claim against AAA after being hit by one of its insureds, I was treated like a four-star general. They expressed concern, arranged direct billing for a rental vehicle, expeditiously handled the adjuster's report, followed up on the work at the body shop and impressed me with their claims processing.

Result: *I consider AAA a potential source of insurance.*

Problems, properly handled, are actually opportunities to build loyalty, sometimes even a fierce loyalty. How do you measure up?

Ask Yourself

1) *Respect the complaint.*

 - ☐ What is your approach to handling complaints? Do you let customers vent? Fix the specific problems? Or look for issues that the marketplace wants addressed?

 - ☐ Can you train customer service staff to listen for useful complaints?

 - ☐ If you can't, how can you structure a process for forwarding complaints to the front management people?

2) *Speedy replies mitigate the intensity of complaints.*

 - ☐ When does a customer want a complaint resolved—now or later?

 - ☐ Does your frontline customer service staff understand that prompt acknowledgment of a complaint can minimize the cost of resolving it?

3) *Effective resolutions to complaints can enhance relationships.*

 - ☐ Would you rather have a customer talk about a problem or how well it was resolved?

 - ☐ Could prompt handling of a complaint increase the potential loyalty and retention factors?

Relationship Aspect Marketing

CHAPTER 10:
USE TECHNOLOGY TO MEET CUSTOMER NEEDS

One of my hobbies is restoring old cars. The problem is that I also like to drive them, which means I exceed the limited mileage restrictions for typical classic car insurers. So, I insure them on my regular auto policy handled by an agent who is also a close friend. Unfortunately, my insurance company doesn't like to insure specialty vehicles and we typically get into an elongated argument over *stated value*. Eventually, the company wears me down and I accept its version of my car's worth.

This had further complicated the frustrating claims process mentioned in the previous chapter. The driver who hit me only carried California's minimum liability requirements—$5,000. Due to my insurer's stated value on the car (less than half the *appraised value*), I was unable to file a claim for an underinsured driver. I was forced to absorb the loss.

As a result, I decided that I would not agree to anything less than the appraised value of my 1969 Marquis convertible. After six weeks of continuing negotiation, letters and appeals, my insurer's final offer was only a stated value equivalent to 60 percent of the appraised value. My agent, an independent broker who represents numerous companies, investigated other available coverages. None could match the price and required two insuring companies and loss of all multiple-car discounts.

In the interim, I receive an AARP/Hartford mailing that offered a 10-minute quote on my car insurance. Noticing a classic/antique category on the application, I went to Hartford's Web site for an online quote.

Technology Helps Meet Customers' Needs

As I filled out the online application form, I followed the instructions to "click here" if my vehicle was not listed. It wasn't. I was then asked if I wanted to continue on the telephone with a service representative. I indicated that I did and was transferred to an interactive phone page. I keyed in my phone number, hit send and my phone rang immediately. A computer voice indicated that this was my requested callback from Hartford and that a service representative would be with me shortly. Within 30 seconds a live person was on the phone with me.

I explained that the Internet application did not list my car, and she verified my name and American Association of Retired Persons (AARP) number. (She also asked permission to call me by my first name, which I thought was a nice touch.) Upon punching my AARP identification into her computer, the rep said, "I notice that we've currently got a quotation in process on your business insurance. (I had requested a quotation from Hartford on business insurance based on an earlier AARP/Hartford mailing.) Would you like that same department to work up your automotive quote? There may be some multiple policy pricing advantages." Now that was service!

To make a long story short, Hartford was more than willing to match the stated value with my independent appraisal on the Marquis and the rep asked if I wanted to wait for a quote over the phone. I said yes.

"Don't be surprised at the amount," the rep said, "most companies only quote a six-month premium, we quote a twelve month premium and guarantee it." Then she quoted me a premium more than $200 lower than my Mercury premium for nearly identical coverage. (Also, Hartford's rental reimbursement was $5 per day less than Mercury's.)

The rep asked if she could write the policy now. I told her that I preferred to see the written quote first. (After all, I needed time to figure out how to explain all of this to my agent.) She complied and added, "Why don't I include a homeowners application with it? I'm sure there are some additional savings if we insure your vehicles, your business and your home."

Chapter 10: Use Technology to Meet Customer Needs

Out of loyalty to my relationship with my agent, I gave him one last chance to meet our insurance requirements—which the insurer did (though at a slightly higher cost). My current insurer retained my business based on my desire to maintain the relationship with my agent, along with the convenience of maintaining status quo. But my hat goes off to Hartford for having a Web site that combines effective use of the latest technological tools, speed and the human touch.

Hartford's automation enabled its telephone representative to see that I had requested other quotations and tie it all together in a cross-selling attempt. Her access to knowledge is what impressed me. It customized the call.

Whether your call approach is mass-customized or personalized, catering to the unique needs of your customers is critical to the sales process. It tells the customer that they are important to your business. A company with excellent personnel and a small circle of clients can do this without automation—they know the clientele that well; but most companies need automation to accomplish this. Whether it is an integrated database that every department within the company can access or a screen pop-up system that recognizes inbound telephone calls and automatically pulls account information, customers appreciate your ability to service them quickly and accurately.

Furthermore, Hartford's ability to leverage relationship marketing through alliances with other groups is excellent. By aligning itself with AARP, Hartford is able to build relationships with new or potential clients upon the pre-existing relationship between these people and AARP. This is a powerful position for any company. Here, AARP endorses and, in effect, validates the company in the consumer's mind. In the end, the consumer and the two companies win.

But my current insurer also lost some business because I am no longer a good ambassador for them. Because of Hartford's excellent performance, I have recommended the company to many friends and have written articles about them in various magazines catering to classic car owners.

Relationship Aspect Marketing

Hartford has positioned itself as a company willing to earn your business; My insurer has only retained mine by default.

Ask Yourself

1) *Technology is most effective when combined with the human touch.*

 ☐ Do your company letters lack the human touch and are they, as a result, ineffective?

 ☐ Do you organize your efforts to take advantage of the human touch?

 ☐ Do you combine Internet technology with live customer service?

2) *Address your customer's needs, not your wants.*

 ☐ Does your automation allow for variances in customer needs? (This is a critical application of technology—it allows for detailed customization. Look for ways that your customer service software allows you to send out letters or fliers designed for specific customer groups. Customization works on many levels—not just marketing pieces.)

 ☐ Do you sell what you want to sell or what your customer needs to buy?

 ☐ Are employees empowered to deal with exceptions to rules or guidelines? How are they empowered—specifically?

3) *Adaptability is a critical component for future success.*

 ☐ Do you have a process in place to keep track of customization and the trends it might suggest?

 ☐ Do you have a process in place to measure the repeat business that comes from customized contacts? (Customization allows individual customers or groups of customers to have specific experiences of your product or business. This usually breeds loyalty.)

CHAPTER 11:

APPRECIATION...AND COMPASSION

Modern technology and efficient processing should not preclude true customer service. All too often, we get caught up in the advances of our technology—forgetting that it is only a tool to assist us in serving the customer.

The Agoura Animal Clinic practices what I preach. We can all learn some lessons from this veterinary practice. For over 14 years, this clinic served the needs of our dog, Mac. During those years, we watched the clinic become highly automated with records, reminder letters, invoicing, etc. They have everything automated and in their database.

After many years of loyal friendship, Mac started getting sick. It was clear to everyone in our family that he was miserable...and nearing his end. We contacted the clinic to make arrangements. The clinic handled the event with care and sensitivity, while carefully logging all the data into its computer system. A short time later, we picked up Mac's ashes and assumed that our business with the clinic was over.

However, this was not the case. A week or so passed when we received some mail from the clinic. *Perhaps a final bill*, I thought. Instead, I found a full page, handwritten letter from the attending doctor offering the sympathy of the entire staff at the clinic. This sensitive letter talked about the joy Mac had brought to our life and reinforced our decision to euthanize Mac. In closing, the doctor noted that he was available if we needed to talk during this difficult time.

I thought: *Here is the human touch in an automated world. This is what makes everything work for both businesses and customers.* But the story isn't over yet.

A few weeks later, we received a letter from the University of California-Davis informing us that the clinic had made a financial donation to the school's Companion Animal Memorial Fund in memory of Mac. (Evidently, one of the veterinarians at the clinic, who had graduated from the veterinary school at UC Davis, adopted the idea for the donations.)

This is more than a nice story about a caring business, it serves as an example of how we—as business owners and managers—should all be dealing with our clients.

Find Solutions to Your Client's Problems

Every business expects to face problems of one nature or another—delivery delays, unkept promises, warranty issues, installation, etc. These are serious problems to business owners and managers, but they also have a direct impact on our clients. When we manage to efficiently resolve problems, we often feel that everything is fine and we turn our attention to more pressing concerns.

After a problem is solved, how much compassion does your company show your client? Do you send a standardized survey letter asking if your performance met their expectations? If you do, don't pat yourself on the back just yet! My local service station does that after my car has been repaired.

Providing solutions to your customers' problems at critical moments can truly nurture a relationship if handled in a caring, sensitive manner. For instance, do you or your staff ever take the time to hand write a letter of apology after an error has been made? If not, why not? Try it sometime, you'll be surprised at the results.

If yours is a service industry, and a client has suffered a personal loss—perhaps someone has passed away or there is a major illness or injury—

have you ever made a corporate donation to a charity on behalf of your client? If not, why not?

Make Your Customers Feel Appreciated

As the Agoura Animal Clinic taught me—and, I hope, you—compassion and sympathy foster lifelong relationships. I know that any pets in the Burke household will be patients of this clinic—even though our home is now farther away. Wouldn't you like your clients to go out of their way to remain loyal to you?

Never underestimate the power of compassion. Empathy and sympathy have a distinct place in business. As the Golden Rule states, *Do unto others as you would have them do unto you.* We all like to feel special, appreciated and recognized. Take the time and make the effort to extend those warm fuzzies to your clients.

Think of your favorite fancy restaurant. Does the owner or maitre d' try hard to please you when you arrive and make your experience a memorable one? Successful business owners know that customers return to those places where they feel most comfortable.

Consider these questions:

1) How often do you express your appreciation to your customers?

2) In what ways do you express that appreciation—letters, calls, e-mails, gifts, cards, visits, business referrals, testimonials?

3) Do you promptly apologize when things go awry?

4) What form does the apology take and do you accept full responsibility for the problem?

5) Do you allow yourself to act from your heart?

6) Do you know your customers well enough to know when they are experiencing problems?

7) If a customer is experiencing difficulties in his life, do you take the time and make the effort to offer assistance, or send condolences?

8) Do you truly like your customers?

9) Do you take time to listen to your customers and react appropriately?

10) Do you view your customers as you hope they view you?

These are hard questions. They reflect simple human emotions that are so often overlooked in the business world. Business should be boiled down to one human interacting with another, instead of one transaction following another. Again, the soul of a business resides in relationships. And the human touch is a remarkable tool in building long-term, mutually beneficial relationships.

Ask Yourself

1) *Treat others as you would like to be treated.*

☐ How does the Golden Rules of life apply to your business?

☐ Have you ever tried to walk a mile in your customer's shoes? More literally, have you ever spent a day at a key customer's business?

☐ Do you have a specific understanding of how the customer uses your product?

2) *Look for innovative ways to be compassionate.*

☐ Could a personal visit, a handwritten letter or flowers convey your concern for a customer?

☐ What is your most effective way of showing attention and a focus on the customer?

☐ Does compassion bring with it an effort to alleviate suffering?

☐ What does "suffering" mean in your business context?

☐ Have you experienced suffering at your business? If so, what was the impact?

Chapter 12:
Better Technology Doesn't Make a Winner

In reviewing the relationships Sound Marketing has with our vendors, I've found that the more high-tech the company, the less of a personal relationship we have with that company.

Let's look at two companies that serve our needs. Company A is high-tech, Company B isn't. Company A has a personal relationship with us, Company B doesn't. We spend from $60,000 to $75,000 annually with Company A, about $250 with Company B.

Unbeknownst to one, our account with them is in jeopardy.

Company A is fully automated and Internet accessible. Rarely do we talk to an inside sales person. We usually place five to six orders a month, averaging $1,200 each, by fax, or occasionally, electronically via their Web site. Within two days an invoice/order confirmation is sent by mail. The order typically arrives by the fourth working day. Each quarter we receive an updated catalog. Everything is handled automatically. There is seldom a problem.

Once, during a UPS strike, we called about an invoice we had not yet received—though the order had been delivered. A manager at Company A had been sitting on the invoice, because he was uncomfortable with billing us the $850 air freight charge (even though I had authorized air delivery). After a short conversation, he suggested that we split the costs since the strike was out of both our control.

Good service, good use of technology, quality product and fair prices…yet they might lose our account. Good isn't good enough anymore. They have no special relationship with us. We have never received a thank you letter, a Christmas card or a proactively placed phone call. One time I was going to be in their city in Texas for a convention and sent them a note saying, *I'll be in town and would love to meet someone from your company— maybe even see your facility. Give me a call.* There was no response. Our company is merely an account number to them. They give us everything we need, but they don't give us what we want most: a relationship.

Develop Relationships with Your Customers

Speaking strictly for myself, I find a sense of security in knowing the people with whom I do business. I like to match the face with the voice. I feel that two people who know each other will be more responsive. Many of today's business transactions have been commoditized. To break out of that commodity price mold, businesses must be sensitive to the opportunities presented by the human needs of their customers. All things being equal in price, product and service, my business goes to the company that exerts the effort to develop and encourage a relationship.

Lately, I've been courted by one of Company A's competitors and already know three of its employees by name. I wonder who'll be getting my business this time next year?

Company B, on the other hand, doesn't have a Web site and you have to call your orders in to their sales department. They specialize in foil embossed *Thank You* stickers and we only place one or two orders a year. Throughout the year we receive wonderfully creative packages and samples of new offerings—always addressed personally and always with a nice letter thanking us for our continued business. These packages also include information about their employees and business—a personal connection. During the holiday season, we also receive a card.

When you call in an order, Company B's database contains our entire ordering history. They ask how business is, and a few days later we receive a thank you letter, order confirmation and proof sheet. About four

weeks later our stickers arrive. Several days after that we are sent an invoice with another letter of thanks.

Company B has built its business on relationships. Their database and billing systems are designed to enhance the relationship while effectively meeting its needs for automation. Not the highest of technology, but perhaps the most effective in protecting their greatest asset—its customers.

There are many printing companies out there that do embossed stickers, but we won't be changing vendors. We like Company B. It makes us feel valued.

Ask Yourself

1) *The personal touch goes a long way in today's world.*

 ☐ How can you mix the customized focus of a handwritten letter with the efficiency of a form letter?

 ☐ Might the growth of wireless communication devices indicate a need to be connected to others?

 ☐ Do you make it a priority to visit your key customers at their place of business occasionally? Do you encourage them to visit your offices?

2) *Has technology ever forced you into the trap of thinking that objective efficiency—and things like "zero defect" processes—are the only measure customers use?*

 ☐ What does "feel welcome" mean in your business? Despite all of the modern world's technical advances, people still do business where they are made to feel welcome.

3) *People like to do business with other people.*

 ☐ Does emotion enter into a purchase decision in your business? If so, how does it impact the customer's decision-making process?

 ☐ Is emotion always the enemy of reason?

Relationship Aspect Marketing

☐ Have you ever paid more for a product because of the sales person? Why?

Section Two:

Technology—Past, Present and Future

Any talk of the Internet and its influence on the way business is done inevitably brings up images of the dot.com mania that swept through management—and investment—circles during the late 1990s. People believed the Internet would create a market unto itself where billions could be made by simply getting on board early.

Of course, this was not true. But a number of stock promoters and venture capital investors made a lot of money, pushing Internet stocks of dubious value. Most of these shaky investments have been washed out of the market. Talk of a new business model, that doesn't include profits, is history. Income needs to exceed expenses, just as it always has.

The Internet is a marketing tool—not a market. Like the telephone or the television, it offers a new and better way to communicate with the people and businesses who will buy what you have to sell. And, unlike other forms of mass media, the Internet is interactive. The marketplace can talk back to you when you talk to it.

This kind of interaction is an essential part of relationship aspect marketing. That's why I believe strongly in using the Internet to communicate with customers. Some people wondered why, given my early belief in the Net, I didn't raise a bunch of venture capital money and start a dot.com selling cars or insurance or gardening equipment.

Relationship Aspect Marketing

The answer: You can't count on the Internet—or any technology—to create new businesses. The best technology can do is give you better ways to do the business you're already building.

The manic enthusiasm for the Internet made for more than a few false starts. Initially, the World Wide Web seemed destined to become the abandoned highway of virtual billboards. (Somewhat akin to the home shopping networks on television, there is a limited market of people who truly enjoy spending their time looking at advertisements.) Then, auctions and bidding were going to be the model for online sales. Later, free content was going to be what the Internet would be about…and you'd have to give away information in order to get close to the online transaction. And, though the best content still isn't free, this later model is closer to what has finally emerged.

Though retailer Amazon.com remains the number one retail site on the Internet—in spite of the fact that it has yet to turn a profit—more and more people are finding value in the Internet as a resource for information and a support tool for business-to-business endeavors. The Internet is a way to increase productivity and cut expenses.

To do this, businesses must design their Web sites to meet the demands of their customers. For some, that means educational resources, interactive support and service, 24-hour accessibility and order placements. For others it means self-service access to account files, interconnectivity with other companies, cooperative purchasing power for groups, one-stop convenience for multiple activities in the financial services arena and quick availability of comparative analysis for purchase decisions.

Every market, every company, every industry and every individual differs. The challenge is to determine what your clientele wants from your company so that you can provide it as a value-added benefit to the relationship. When you give clients what they want, they will come to you. If you don't, they won't.

The problem is that most businesses view the Internet in black and white. It's either good or bad. The naysayers cry out that the Internet will mark the death of their business. Why? They fear the competition.

Many insurance agents, for instance, were convinced that consumers would forsake agents and purchase insurance directly over the Internet. Granted a certain percentage will, but the vast majority still prefers the comfort of an agent who guides and advises them through the process.

Car dealers were hit twice. They worried about eroding profits as consumers gained easy access to the dealer's wholesale prices. Then there was concern about consumers buying vehicles directly over the Internet, cutting them out of the deal altogether. Most of these fears have given way—today, only 4 percent of cars are bought online. It seems people still like to kick the tires when they buy a vehicle.

As for price awareness, it is nothing new. Astute buyers have had access to dealer cost long before the Internet; it's just a little more universal now. In fact, rather than fighting cost disclosures, the National Auto Dealers Association has begun posting dealer cost figures on its own Web site. What car dealers have to learn, as do many other industries, is that consumers are demanding more than low prices—they want to see the additional value brought to the transaction by the dealership. Value, not price, is becoming the discriminator in many purchase decisions.

Value is something that is created over time. True value doesn't come out of a quick-hit deal. It comes out of consistently delivering a good product or service for a fair price. It comes from knowing your customer well enough to have a meaningful give-and-take about what you offer…and under what terms you offer it.

That's relationship aspect marketing.

The Internet Creates a Level Playing Field

An important part of any customer relationship is managing expectations. When all things are considered, this ability is one of the key things that you get out of working hard to develop and maintain relationship aspect marketing.

Relationship Aspect Marketing

I recently gave a keynote address to a group of insurance agency owners from throughout the United States.

Prior to taking the podium, one agency owner who had heard me before approached and told me that he still wasn't on the Internet. He reasoned that his rural agency was 100 miles from nowhere and he couldn't see any need for going on the Internet. His customers were too people-oriented to get involved with all this electronic hubbub.

Knowing he was proud of his refusal to go online, I simply asked him how many of his clients were farmers. He estimated more than half. I then pointed out that farmers were among the very first to lay claim to the value of the Internet. Due to their geographical isolation, the Internet brought them together, provided access to their suppliers and connected them with the informational resources necessary to running a successful farm.

Still not convinced by my argument, the rural agent agreed to look into it and talk with some of his clients. By the end of the conference, he told me that he had made a commitment to invest in a Web site upon his return home. His clients had confirmed that they wanted him to have an Internet presence.

While some have wasted valuable time paralyzed by fear of the Internet, others have embraced it. For the first time, small businesses can be on a level playing field with the bigger players. Companies whose distribution was once limited by the geographical area in which they sold can now conduct business on a national, and even international scale. And companies of all sizes have equal access to information resources for the first time. The Internet represents opportunity if it is properly utilized.

As I write this book, there has been a popular television commercial for an Internet company running that depicts people standing in a parking lot at three in the morning. They're puzzled and confused because the store is closed. The Internet provides access to your business when the customers want it—at *their* convenience unlike most brick and mortar establishments. Your clients can enter your virtual door 24 hours a day. The ques-

tion is whether they will find what they need when they get there. If not, you may lose customers to a competitor whose Web site meets their expectations.

Common Misconceptions

In relationship aspect marketing, the Internet must enhance the value you offer customers. A common misconception: A business can't provide what the customer wants because the competition would find out. One business owner I know said he couldn't put the contact names of his employees on the Web site because the competition would try to steal them away in a tight job market. I define those thoughts as delusional paranoia. Face it, your competition probably knows more about you than your customers do. A company cannot operate effectively if it is paralyzed by fear of the competition.

Other common misconceptions include the idea that the posting of prices might scare away the customer; and that the competition will find out. If the price scares away the customer, then let that customer depart before you invest time, energy and money in someone who isn't buying. The competition already knows your prices. A company's failure to post prices on its Web site is just bad business.

When it comes to the Internet, as with any other facet of your operation, concentrate on your customer—not your competition. Your goal is to give customers the information they need to make intelligent decisions. Today's consumers understand the power of information and they demand it. In turn, they appreciate those companies that acknowledge this reality and generally give their business to those companies that respect their right to that information. Companies that hide information or, worse yet, refuse to give it, instantly propel themselves into the consumer category of a slippery used car salesman. An instant lack of trust develops, and trust is the foundation of any good relationship. Remember: You must earn the right to serve your customers.

Design User-Friendly Technology

The key to relationship aspect marketing is making all communication—
and, especially, your Internet Web site—easy to use. This includes easy
manipulation of the site for the user; search engines must be accurate and
speedy. Web visitors do not want to wait two minutes for a search engine
that provides answers that are out of context or inappropriate to their
request. Speed and accuracy are absolute necessities.

Don't engineer convoluted sites that take a dozen clicks to get to a desti-
nation and are nearly impossible to get back to the start. Every link in a
Web site should be accessible by no more than three or four clicks and
every page should offer a return to home page.

Retail giants spend years developing friendly layouts for their stores, prop-
erly grouping merchandise and creating special interest areas. Then they
continually tweak the layout in response to customer input. Web sites,
retail or otherwise, should be no different. Whether you are developing
your initial site, refining an existing site or totally restructuring, do it through
the eyes of your consumers. Know what they will be looking to accom-
plish on the site and how easy it will be to do that. Focus on the custom-
ers' desires—not your corporate ego.

Web sites can also be effective tools in gathering information about your
customers. The more you know about your customers, the more solid
your relationship foundation. Design and use your Web site to continually
gather more and more information from your clients. This enables you to
customize your marketing to the individual.

Relationships are personal, so don't be afraid to get personal. With knowl-
edge about client age, lifestyle, size and brand preferences, clothing retail-
ers can target unique personalized messages to those most likely to pur-
chase certain items. Financial institutions can market services applicable
to specific life requirements and occasions. Upselling or cross-selling prod-
ucts and services that are specific to the needs of an individual or group
increases client loyalty as well as profits. The more someone buys from
you, the greater the likelihood he will remain your client.

Choose Technology Carefully

Along with Web sites, the Internet has given us e-mail—a newer and faster way of communication. By comparison, faxes seem inordinately slow as they take 30 seconds to process a page that can be e-mailed within a few seconds. When it comes to the relationship aspect, this is one of the most useful communications tools ever developed. It provides instant, documented communication as needed. And it allows the recipients to reply at their convenience.

Technology has changed expectations. Today's customers are more knowledgeable and demanding than they were five years ago. So, you may feel the need to give every sales rep a Palm Pilot or laptop computer, or equip your offices with a high-tech phone system. Making technology decisions is often one of the hardest things a small or mid-sized business has to do. It's easy to get seduced by the latest gadgets and the speed or productivity gains they promise. On this point, I have a warning: Don't fall into the trap of thinking that anything old is bad.

Be it the Internet, a faster and smaller computer or the latest software program, newer is not necessarily better. The latest innovation is not the magical elixir that solves all problems.

Yet time and time again, we neglect the old for the new. A carpenter may have invested in the newest, most powerful saw on the market; yet it is of no value without a hammer to nail the pieces together.

Throughout this book I continually refer to the fact that technology is not the answer, it is merely a tool. Craftsmen use many tools to create a finished product. Likewise, relationship aspect marketing requires the use of all tools at your disposal.

Technology Is a Tool, Not the Answer

A lot has been written and said about the effect of technology on business, as well as on customer prospecting and development. Technology, gener-

Relationship Aspect Marketing

ally, and the Internet, specifically, are wonderful tools for customer development and relationship building. They change the focus of marketing from selling to giving information. This means it's easier to have a detailed and thorough courtship process with a potential customer.

You can move away from hard-sell tactics (like the old-style car salesman asking, "What can I do to get you into this Edsel?") to soft-sell tactics (like the new-style car salesman who offers technical data on a new model and then welcomes you to come back when you want more information or to make a decision). And—after the sale has been made—the new-style salesman welcomes you to come back for more information, to get your car serviced…and eventually to buy another car.

High-end car dealers have sold this way for years, merging the sale of a Mercedes or Rolls into a package of product and service. Only in the 1990s did middle-market car dealers (led by General Motors' Saturn division) begin to use this model. Today, when you buy a car, the package can encompass everything necessary to maintain the vehicle for five years after the warranty has expired, including normal maintenance. Some manufacturers even bundle car insurance with the purchase price.

This is relationship aspect marketing.

Controversy and contention have always surrounded technological advances. Some of the historical doomsday sentiments have included:

- The Industrial Revolution marks the end of small business.
- The telephone will drastically reduce in-person human interaction.
- The television will be the death knell for reading.
- Computers will reduce our ability to think.
- The Internet will put newspapers out of business.
- The electronic age signals the end of civilization.

Although there is a kernel of truth in most of these observations, they all discount the human element. Although the Industrial Age sprouted factories that drew millions of workers away from the farms and small business, the entrepreneurial spirit maintained a lively wellspring of independently owned and operated businesses. And the Information Age has only increased entrepreneurial opportunity. (Think of the garage where Steve Jobs started out.)

The telephone may have reduced the need to go next door to share gossip, but we quickly adopted it as a means to expand our interaction with others. (Ask any teenager about the value of a telephone to a relationship.)

Television has drawn some away from books that stimulate the imagination, and decreased some family interaction. Yet it has brought the world into our living rooms. Book publishers can still make a go of it because parents, schools and libraries promote reading. And, family interaction and discussions today can now cover a wider breadth of topics due—in part—to television.

Computers have not deterred our ability to think. In reality, they have freed us from so many mind-numbing chores that productivity has increased dramatically and our minds are freed to pursue loftier thoughts than balancing a checkbook.

And so, the totality of the electronic age has not marked the end of civilization. However, one could argue that a degree of depersonalization has occurred in direct proportion to the hours spent in front of the computer, the increase in home-based businesses and the growing tendency toward telecommuting.

Personalize Your Technology

As a reaction to this, we demand more personalization in our business encounters and seek more and different opportunities and places to commingle with each other. This new breed of the electronic age is adamant

about maintaining human contact, and is finding it in places as disparate as coffee houses and church revival meetings.

Today's technology is a double-edged sword. On one hand it can be a tremendously effective tool for developing long-term relationships, on the other it can be a totally devastating force of alienation. It definitely is not a magic pill in either case. The key, as in all relationships, is to find out what the other party wants.

On a personal level, technology has drawn families closer together. Parents and siblings, who once limited their phone calls for budgetary aspects to one a week or even less frequently, are now able to maintain continual communication on a daily basis.

On this past Thanksgiving day, my youngest sister e-mailed pictures of her Thanksgiving festivities so that we could vicariously share the holiday with them from 2,000 miles away. My daughter continually keeps us updated with text and pictures on our grandchildren's growth and activities from 3,000 miles away. My wife's concerns about the welfare of her elderly parents is diminished with twice-daily e-mail letters. My electronic guru of a daughter even set up a private central site where family members can post single messages to be read by all.

E-mail can be just as beneficial to business relationships. From broadcasting e-mail newsletters to your entire client base to the forwarding of specific articles of interest to a single customer, it enables us to keep in touch. Communication is a cornerstone of any relationship. As a business family, the Internet can bring you closer together.

The Internet can be an invaluable enhancement to the relationships you have with your customers if you focus the technology on your customer. Concentrate on meeting your customers' needs and they will meet yours. Concentrate on using technology for the courtship and sharing information that will migrate the customer relationship to its greatest profitability.

Don't Take Old Technology for Granted

The telephone remains a fundamental tool of any trade, yet it is often the most neglected. The telephone, like the Internet, is a doorway to your business. Professional service providers can spend thousands of dollars to create a welcoming ambience in their lobby areas, and retailers spend as much or more in signage and entry as well.

Fully aware of the importance of initial entry into a business, companies seldom pay much attention to their telephonic lobby. Ironically, many companies process more people through this telephonic lobby than through the physical entry.

I'm constantly amazed at how many business owners abhor dealing with automated phone systems and menus, yet they subject their customers to the same process. If you don't like it, why think your customers are any different? Would a robotic voice through an impersonal speaker box have the same warmth as the physical greeter that welcomes you into a WalMart? Of course not, yet that is exactly what we do at our telephonic lobby—welcome our customers and entreat them to do business with us. Unless your business (e.g. Microsoft) handles an immense number of calls, there is no reason why your customers can't be telephonically welcomed by a warm and caring person.

One major credit card company actually advertises that calls are answered by real live people to distinguish itself from the competition. Even AT&T, the mother of automated phone systems, advertises that its information services are now answered by live operators. Call me old-fashioned but I like to have a real person answer the phone, greet me and direct me to the party I request. Why? Suppose the person I request is out of town or sick; the receptionist would know this and be able to direct my call without any further delay. Once I've proceeded past the telephone receptionist, voice mail messages are sufficient—provided that they're answered on a timely basis.

Relationship Aspect Marketing

The problem with telephones is found in the users, not the hardware. Telephone phobias—like Web phobias—are alive and well. Every employee should receive some basic training in telephone etiquette. Their voice and mannerisms represent your company. You wouldn't want sales people calling on your clients in torn jeans and stained sweatshirts, so you wouldn't want employees slurring their words and chewing gum while taking calls.

Telephone receptionists should receive advanced training. Far too many companies slot the newest employee into this critical position without training or experience. Do you really want the initial impression of your company to be imprinted upon the minds of your customers by an unskilled employee?

Good telephone receptionists are worth their weight in gold. They set the tone for the relationship and are a significant force in retaining that relationship. Many of the best receptionists actually develop their own relationships with clients, and these relationships are often more sustaining than relationships developed by your sales force. Hire telephone receptionists wisely, train them well and reinforce the impact they have on your business. As with any other employee, if you treat them well, they will do their job well.

The value of telephones can be further increased with the tools of telephony. Connected to your computer's database, caller signals can be identified and trigger their account information to surface on your computer screen as the phone is answered. Such systems are substantial time-savers that increase productivity and speed up the transactions for your customers.

Telephony also brings us to another of the older technologies—your computers and their databases. How accurate is the information in your customer database today? If customers could look at their accounts, would all the information be correct? Or, would they find names of people that no longer worked for them, incorrect area codes, old addresses, etc.

The newest trends in technology indicate a burgeoning movement toward customer access to their own files. This allows customers to perform numerous tasks at their own volition. Keep your database current. Informa-

tion about your customers is extremely important to the relationship aspect. Incorrect and outdated information creates serious ramifications to any relationship. It's right up there with calling your wife by your former girlfriend's name. It reflects a lack of attention that indicates the relationship is unimportant to you.

On the other side of the spectrum, one of the oldest technologies—paper and pen—is now positioned for unbelievable impact in relationship aspect marketing. As we are bombarded by media messages and electronic communications, few people take the time to pick up a pen and write a personal note. As a result, such notes stand out in the minds of your clients. Don't lose sight of this powerful tool. A few written words on any appropriate subject in a hand-addressed envelope with a real stamp will stand head and shoulders above the mass-produced bulk.

On the same tack, faxes remain a powerful method of communication that gain our immediate attention. Think about it. When you check your e-mail or the postal delivery, there are usually a number of items vying for your attention. We quickly scan items for initial interest, dooming most to the trash can or the e-mail delete icon.

Faxes, on the other hand, are generally delivered to my desk as they arrive. As a result, I find that each fax has my undivided attention as it is handed to me. There is still a sense of urgency and importance connected with the fax. Avoid sending spam or unsolicited advertisements. They not only diminish the effectiveness of this tool, but they result in angry recipients.

It's bad enough when e-mail clogs up your mail server, but it's even worse when you've paid the toll-free charges for your fax for someone to send you a barrage of unwanted advertisements. Use it with discretion and always make sure that it offers a value that your clients want.

From the telephone to paper and pen, computers to fax machines, technologies of the past can add value to your present and future relationships. Similarly, the messages of relationship aspect marketing can be communicated via audio tape and CD, video tapes and DVD, business cards and

stationery, newsletters and advertisements, as well as through a personal visit.

The power of one human being directly interacting with another is still awesome. All the technology in the world cannot replace that human touch—it can only enhance it.

CHAPTER 13:

ASK *WHY* INSTEAD OF *WHY NOT?*

To reinvent an old phrase, *The only things certain in life are death, taxes and evolving technology.* Too many of us look at the new technological advances and simply say, "Why not?" The question we should be asking instead is "Why?"

Technology Exists to Serve You

At the 2000 Los Angeles Car Show, I had the opportunity to see up close some of technological advances that have been made to our personal transportation units. Many of the vehicles are equipped with voice recognition technology that enables us to converse with our car, and vice versa. We have the technology to produce talking cars, but is this the direction to take with our research and development dollars? We *can* do it, but *should* we? As gasoline continues to pollute our air and its additives decimate our drinking water, should we devote our technology to developing talking cars—or environmentally-friendly transportation?

Many of us are so driven by what technology can do that we often fall victim to the latest techno-trends. We are like rudderless ships being battered by relentless storms upon the sea of technology. We are not using technology—technology is driving us.

The World Wide Web is a perfect example of how easy it is to get caught up in technology, without first understanding what value can be derived

from it. Like the highways of the 1950s, the Web is littered with meaningless billboards. Too many companies post Web sites because they can; but they often forget *Why* they should have one and *What* it should do.

Understand Technology's Limits

A good friend of mine has the misfortune to be one of those people who has never mastered the ability to manage his life. He's notoriously late, disorganized and lacking in the ability to make plans and deliver on them. To make matters worse, he's addicted to gadgets. The minute some new piece of electrical or mechanical machinery is released, he's got it. His mistake is that he is convinced each new item will help him arrive on time, make him better organized and, generally, solve all his problems. When faced with economic problems, he spent $2,500 on a new laptop to manage his finances. Forever missing appointments, he bought a PalmPilot to manage his time. Unfortunately, my friend's difficulties are intrinsic to him, regardless of the tools at his disposal.

It's the same in a business environment—coming up with a technological answer doesn't always fix the problem. For example: A business owner looks at a room filled with stressed-out office workers and thinks, *They've got too much to do. It's taking too much time to process the work. There's got to be an answer.* Several months later, after a compelling sales pitch at a convention on the wonders of paper-free living, the owner returns and installs a paper-free, scanning device, thinking it will solve the problem. The staff is invigorated and motivated—for a few weeks—until the stress returns.

The problem: With every timesaving device developed, a hundred new tasks await to fill the void. For example, when washing machines were first made available, they were statistically proven to save users up to 20 hours per week. But, how many people today can account for those 20 hours of free time?

Now, I'm a proponent of electronic filing, scanning and paper-free environments. However, such technology is not the answer—it is merely a

tool. The business owner should have first looked at work flow, job descriptions and management for the source of the problem. Had he addressed the problem first, the paper-free system would not have been seen as a solution, but as a beneficial adjunct to the solution.

The canard is technology itself. So before you jump on the next techno-trend, ask yourself: *Why? What will it do for me? How will it better enable me to serve my clients? Where does it fit into the workplace environment?*

Ask Yourself

1) *Don't expect technology to solve your problems.*

- ☐ What kind of tool—if any—do you use to keep track of meetings and appointments? A book? A human assistant? A PalmPilot?

- ☐ How effective is this tool? How easily does it integrate with your colleagues or staff? How well does it integrate with outsiders—clients, customers or partners?

- ☐ Will a computer enable you to write better?

- ☐ Do you use your computer like a fancy typewriter? Simply turning out letters, memos and e-mail you sent to others?

- ☐ Can you share documents as you develop them?

- ☐ How well does your accounting system work with your planning and project maintenance functions?

- ☐ Can you use it to provide real time financial information on costs and profitability?

2) *Fix the root problem, not the surface problem.*

- ☐ How technically savvy are you? Is your staff?

- ☐ If a computer has problems or a program doesn't work, can you troubleshoot and solve the problem? Or do you have to wait for an IT person?

☐ Can you educate an employee with an existing computer station? Or, do you need new hardware and software to do this?

☐ Does voice mail merely concentrate too many calls with too few personnel?

☐ Can you use your phone system to spread calls evenly around your staff?

☐ Would electronic filing fix a work flow overload? (Programs that combine computer programs with phone systems are expensive, but allow many companies to avoid marketing, sales, or customer service bottle necks.)

3) *Time is like closet space, there's never enough.*

☐ Are you basking in the extra time afforded by time-saving devices? Or do you feel pressed to accomplish even more with new tools?

☐ If you are reachable more often, do more decisions come to you—decisions that someone else could or should make?

☐ Do you expect more from your employees with each new technology?

☐ How do you track and measure increases in productivity?

☐ Does technology dictate the job or does the job dictate the technology? In other words, do job descriptions in your firm include expected technology skills? Or do you hire people or vendors to fix specific technology problems or fill technology needs?

CHAPTER 14:

INTEGRATING E-COMMERCE

Everything seems to be preceded by an "e" these days. It started with the word *e-mail* to help us differentiate between electronic correspondence and traditional "snail" mail. Like a weed, the letter has made its way into every category: *e*-business, *e*-commerce, *e*-retail, *e*-marketing, *e*-this and *e*-that. Although the simple addition of *e* has added a new dimension to language, its use can cause some counterproductive thinking in people dealing with customer service matters.

Akin to religious separatism, the e-mentality preaches exclusivity that has kindled a new kind of snobbery among business professionals. Despite the stock market reckoning, dot.com elitists still tend to view archaic business models with disdain. You may see it within your own business. The brash young ministers of electronic divisions seldom interact favorably with old-guard management. Battle lines are drawn. The e-contingent claims that the traditional models of business will fail unless the company adapts to modern principles. Meanwhile, the traditionalists reply that historical policies and procedures have tenure. Rather than working together for the common good, both sides battle each other to defend their turf.

What, specifically, do these differences mean? Although it may sound like a cliché, younger marketers tend to believe in aggressive, information-based campaigns. Precisely customized promotions aimed at tightly-defined groups. Ironically, their opinions about products are often more lax; they may argue "ship it now and fix it later." But there is a kernel of rela-

tionship aspect marketing in this attitude—they want to hold onto customers through many stages of a product.

Older marketers may recoil from this approach, calling it arrogant or reckless. The traditional marketing approach doesn't put so much emphasis on speed. And it's not so comfortable with partially developed products or services. These people may argue that they're more committed to quality and steady performance—and there's some truth to that. (Although the implied contrast to younger marketers—they don't care about quality—is an oversimplification.) The reality is that each side brings much value to the table. Together, both models of business can bring about much success.

Stop Differentiating Business from E-Business

Preparing a business plan is a good example of the basic dysfunction. A business plan to most people in the electronic world is the template by which they raise investment funds. A business plan to a traditional businessperson is the game plan by which revenues are realized, expenses are controled and profits are attained.

Companies in the Internet age need to stop differentiating between business and e-business. They are one and the same. For example, most everyone has visited a car dealership at one time or another. And, if you have, you know that business is usually comprised of new car sales, used car sales, service, parts and body shop. Each department contributes to the whole. Each department is integrally interconnected with the others. The welfare of each unit is predicated on the performance of each department. Think of traditional business and "e-business" in the same way. They are mutually dependent parts of the same unit.

New technology, deflation in the stock market and decimation of a segment of the dot.com industry shows that traditional business planning is needed in the New Economy. All businesses need to plan for revenue generation (from their market, not investors), expense control and profitability. This historical model has proven itself in all types of business over

time. E-business is no different. Management becomes the moderator of a team effort focusing on a common goal, rather than a referee of a fight.

Even old-guard companies recognize the importance of integrating e-business and traditional business practices. Jack Welch helped his company, General Electric, to do just that—even as he prepared to retire. Welch had a greater vision for the Internet than most. He envisioned the Internet as more than a sales platform. He saw the totality of possibility—especially when it came to planning for the control of expenses. In the management of travel expenses alone, this massive conglomeration saved $40 million between August 1999 and August 2000. Not a mean feat during a time of escalating travel costs. Utilizing electronic tools, Welch's goal was a $12 billion reduction in overall expense. That was 25 percent of expenditures in selling, general and administrative costs savings that would flow to the company's bottom line.

Impacted areas, other than travel, include electronic purchasing from suppliers, processing of orders from the distribution network, using the Web—rather than call centers—to disseminate information, reduction of sales staff, etc.

Additionally, GE is linking and leveraging all of its various operations so suppliers can do business with all of their entities using a more holistic approach. And GE's strategy benefits consumers, too. GE Capital developed a loan processing program, which is projected to slash processing time by over 80 percent. Consumers get the speed they demand, while this financial arm expects to save over $12 million per year.

Technology is not an end to itself, but an integral tool for the growth and success of a business entity. Both the traditionalists and the electronic types must be given free and equal reins, rather than constraints.

Integrate New Technology

Once a company achieves this kind of integration, and develops a new organizational structure, it can proceed to the e-planning process—developing an electronic strategy that best fits both the company and the

customer. This strategy, or plan, can then be integrated into the general business plan for the company.

Planning is critical at every stage of business development, whether an organization is creating a first Web site, envisioning a business-to-business strategy with vendors or simply implementing company-wide e-mail. Regardless of the stage, the process begins with planning.

For instance, a new employees wants to set up e-mail. Sounds simple enough, right? But do you want the e-mail to be through your own domain name, such as mary@ourcompany.com, or are you going to use a national service like America Online? Would the choice affect your customers'—or employees'—image of you? How will you name the accounts? Last name, first initial; first initial, last name; first name, last initial?

Some companies have resisted the informality that's a central part of Internet culture. They ask employees to use more formal versions of their names for e-mail (MaryJohnson@ourcompany.com). The impulse is understandable; Internet culture can get a little excessive (BloodyMary@ourcompany.com or *?!#Mary@ourcompany.com). But I encourage companies I work with to embrace the informality, at least among people dealing with customers. Mary@ourcompany.com seems more accessible than MJohnson@ourcompany.com.

Get Started on an E-Plan

So if something as simple as e-mail needs planning, imagine the energy that must go into Web development, business-to-business development strategy with vendors and implementation of communication modules for your clients. Here are a few suggestions to consider when it comes to planning your Internet future:

1) Establish an e-planning team staffed with representatives from all departments including: finance, sales, marketing, service, production, fulfillment, shipping and technology. Integration of e-planning with traditional functions is key.

2) The e-planning team should be headed by the corporate leader. The leader provides the grand vision that sets the overall goals

for the company. As a visionary, the leader embraces input from everyone on the team and sets the tone, character and passion that drives the team.

3) The e-team should select a technology leader or champion who is invested and knowledgeable in internal automation, as well as Internet technology. (Although many companies have separated these two functions, the two will blend. Standard Internet browsers are already interfacing with most management systems and programs for interfacing with intranet and Internet activity.)

4) Consider a consumer advocate for your team; this person should not be an employee. Many companies feel that customer service management can represent the customer, but they can't due to vested self-interest. I recommend asking one of your most valued clients to participate as a member of your e-planning team or board—at least on a limited basis.

5) Nurture communication and understanding among team members and departments. Like a family, everyone is interrelated. Technology must understand sales, marketing, service, finance, production and shipping issues. Likewise, every department must stay apprised of technology's impact on their fiefdom.

6) Encourage electronic research, but don't limit it to your own industry. Generally, each team member is aware of, and recognizes, benchmark companies that are role models within a specific area of operation. Find out what they do, how they do it and determine what might be applicable to your operation.

Using approaches such as these, a company can develop a well-rounded planning team and proceed with the business of planning an effective electronic strategy. Always remember to focus your planning on the customer and then build your plan to meet that focus. If a company focuses first on profits or sales, it tends to force the customer into a predetermined mold.

In the old model, the company drives the business. It develops the product, markets it to a real or created need and reaps the profit. The product

is literally driven into the hands of the customers by sheer force of marketing and advertising.

In today's new model for business, the customer drives the process. The company that focuses on the customer will design a plan and structure to profitably support a customer's needs, wants and expectations. The result is a relationship that breeds customer loyalty.

Ask Yourself

1) *E-planning should foster inclusiveness among employees, not exclusiveness.*

 ☐ Do your IT people form cliques within your organization?

 ☐ Does your e-planning team recognize the value of all functions within the business? Does the team solicit help from these other functions?

 ☐ Can non-technically oriented people offer new insight into potential technology applications?

2) *E-planning teams should include at least one member representing the clients.*

 ☐ If technology is focusing on the customer, shouldn't you ask for customer input?

 ☐ Do you consider your customers as partners? If so, could a customer have a different perspective than the company that might improve your business?

3) *Build your electronic strategy to focus on your customer.*

 ☐ Do you first ask what a strategy does for the customer or for the business?

 ☐ Does your strategy include free information or resources for the benefit of the customer?

 ☐ Does your automation make things easier for you or for the customer?

 ☐ Are you more interested in internal accounting or simplified customer transactions?

CHAPTER 15: E-MAIL AND INTERNET ISSUES

Advances in technology often play havoc with management.

Take the telephone, for instance. It has become the quintessential lobby for most businesses. Customer contact, orders, marketing and service all take place over the phone. When a telephone line goes down, businesses panic as everything grinds to a halt. Yet the telephone also became, and remains, a managerial headache when it comes to employees.

How can you effectively monitor and control the personal use of the telephone on an employee's desk? What type and amount of personal use is acceptable? If a parent needs to check on a sick child, is that permitted? What about calls to arrange baby-sitting for a social activity? What about those expensive 900 numbers?

And there are additional problems with hourly workers in a factory. Should they have access to a pay phone? If they leave their workplace to make a call, should the time away be docked from their paycheck? If a spouse calls in an emergency, should they be permitted to take the call in the supervisor's office? How do you know it's really an emergency?

While management continues to wrestle with these problems, the Internet renewed the debate with a vengeance.

The solution seems simple. Set the rules and discipline anyone who violates them. Yet such autocratic behavior on the part of management can lead to morale problems. And if there is bad morale among employees, customer problems are just around the corner. Remember, happy employees make for happy customers—and vice versa.

Business needs rules. A world without rules leads to chaos and anarchy. And employees don't want anarchy any more than management does. If Mary spends three hours a day playing computer games, Jane is going to get very upset because, as a conscientious employee, she's covering the additional work. If Jane complains to Mary, Mary may become defensive and escalate problems. Should a customer happen to contact one of them during these problems, the customer suffers—and everyone loses.

So, What Is a Manager to Do?

Proper behavior is most effectively established when everyone knows the reasons behind the rules, accepts them as valuable and realistic and participates in establishing the penalties for disregarding or breaking them.

Here are some thoughts for developing effective electronic policies and procedures for Internet use:

1) Define Personal Versus Company Activities. Most people agree that the use of the Internet should be restricted to company business. Yet others point out that even personal Web use can be educational and can help employees become more comfortable with the technology and resources. Company policy in reference to Internet use is likely to vary from location to location and from discussion to discussion.

 To put the point bluntly, you probably don't mind that your employees look at a competitor's or vendor's Web site. You probably *want* them to go to client's Web sites and industry association sites. But you don't want them on pornography or gambling sites. Your network administrator or IT people can restrict access to specific sites or sites with particular words in their names—but these restrictions are only hurdles, not complete barriers. You have to give your people adherent instructions...and incentivize them to comply.

 It's important to define "personal" versus "business" use and communicate that policy clearly to employees.

Some of the key questions to address before issuing any Internet guidelines are: Should access to the Internet be available to all employees? Should management provide individual passwords or codes for access? If so, what would be the process of gaining approval for such access? What are the penalties for violation of the guidelines?

2) E-mail. E-mail must also be considered in the formation of policies and procedures. All communication impacts the image of a company. As with printed stationery, you might consider a standard signature to be placed on all outgoing e-mail. Or, better yet, create an electronic stationery template for employees to use. As simplistic as it might sound, even basic letter-writing skills might be included: the use of a salutation, spelling and grammar checks, proper closings, etc.

Some businesses may also find other safeguards necessary, such as policies that prohibit contacting the media without involving public relations personnel, divulging of trade secrets, criticizing the competition—or the company itself, or anything that might expose the company to undue risk. Remember, the electronic world is not private.

Probably the biggest e-mail issue is privacy—specifically, how much an employee can expect when sending or receiving e-mail. In short, the best policy is—usually—to state plainly that any e-mail sent or received on office machines should not be assumed to be confidential—and that it may be read by company employees. Tell people this when you hire them—and repeat it any time you make any announcement involving the computer network or e-mail.

3) Copyrighted Material. The use of copyrighted material is a potential exposure to any company. Copyright issues range from illegal distribution of software in violation of licensing agreements to copying and distributing copyrighted material—music, pictures, etc.—found on the Internet. The company should state clearly that *all* unauthorized use of copyrighted material—the company's own or anyone else's—is against policy and may lead to disciplinary action including termination.

4) Viruses. This is more relevant today and can have extremely costly ramifications. Does the company have adequate software to detect viruses? Are employees required to use detection procedures for e-mail attachments or file downloads?

5) Mandating Severe Penalties. Certain activities should mandate disciplinary action. These include: electronically distributing harassing messages of a sexual nature; distributing messages that defame or discriminate against any person on the basis of religion, racial or disability status; using company equipment for hacking, slander, sending chain letters or electronic stalking. Some people may be worried about free speech issues raised by these guidelines. Generally speaking, you are free to restrict how your equipment is used.

6) Internet Free Time. Today's employment market is tough. Companies are bending over backward to recruit and retain good employees. To entice talented, youthful employees, who have grown up in the digital world, some companies are using their computer technology as an added inducement. Employees are given specific non-work hours (early morning, evenings, weekends) when they can use the computers for playing games and other high-tech endeavors. Some companies even offer large screen monitors for such activity, further enticing new recruits. Policies and procedures do not preclude creativity—but the general rules of etiquette and professionalism should apply to *all* activities.

These suggestions serve as a starting point. Each company has its own unique needs and concerns. Management should review the team recommendations and meet with the team to finalize the guidelines. Once the guidelines are finalized, don't just hand them down to the employees. Conduct implementation meetings so that all employees feel they have a stake and a say in how the new guidelines are carried out.

Remember that the first line of any company is its employees. How you treat your employees dictates how they will treat your clients and pro-

spective customers. Empowered, involved employees make for long-term, satisfied clients.

Ask Yourself

1) *Dictatorial management is not effective.*

 ☐ The difference between rules and guidelines has become a critical one to modern business. Which is more likely to be followed: rules that are mandated or agreed to by consensus?

 ☐ Can you earn loyalty—from employees and customers—without inviting anarchy? That's the challenge of management.

2) *Involve employees when developing policies.*

 ☐ How can you best include your employees when deciding upon e-policies?

 ☐ Does your staff appreciate the necessity for operational guidelines? How can you emphasize their importance?

3) *Employees that understand the reasoning behind guidelines are more apt to follow them.*

 ☐ Does understanding a policy lend itself toward behavioral acceptance? How can you foster that understanding in your organization?

 ☐ How can you keep your employees involved in the implementation of their own policies?

 ☐ Does your company educate employees on policies?

Relationship Aspect Marketing

CHAPTER 16:

E-SERVICE IS A 24-HOUR THING

Humane treatment and exceptional service by such companies as Microsoft must have lulled me into complacency. I was beginning to believe that most companies—Internet or otherwise—actually gave a damn about their customers.

Once again, old truths fail the test of our new economy. Remember when small retail outlets justified their existence and their pricing by offering greater personalized service than the big box stores? Apparently, that doesn't apply in the electronic world. The big guys, despite governmental intrusion, have become experts in the service game. The smaller companies, however, have not—at least not in the new technology world.

Among the small companies that haven't yet been able to compete with the big guys when it comes to techno-service is a software company whose products I have purchased on occasion. The company, Cheney, Washington-based software product manufacturer Williams & Macias, Inc., produces a trademarked software program called StickyBusiness, which enables you to design and print preformatted labels on Macintosh computers. I ordered the program from our label supplier; because, allegedly, it is superior to a similar program by Brea, Calif.-based Avery Dennison, one of the leading suppliers of office products.

When the program arrived, I registered online and prepared to install it. To my frustration, the installation disk was unreadable by my computer, as well as other Macintosh computers at the office. I didn't figure this to be a major problem. I would simply call, advise them that the disk was unread-

able, provide the serial number and be directed to download it from the company's Web site. It seemed simple—until I picked up the phone.

The automated menu gave four options. The first three directed me to send a fax, leave a message or go to the Web site—where there was no chance of talking with a human being. The fourth, categorized as *other*, repeated the same information and added that their phone lines were only open between 8 a.m. and 12 p.m. It was already after noon, so I was out of luck.

The following morning, a customer service representative called. Within two minutes I had an answer to my problem. As I had suspected, I only needed to be directed to a specific URL on their Web site to download a working version, which I did. The service person also sent me a new disk.

Despite the fact that the company solved the problem, it missed the mark. There was no apology or explanation as to why the company could only be reached for four hours of the day. There was no apology for my having to sit on an unusable piece of software for a day. Was my problem resolved? Yes. Were my ruffled feathers smoothed? No.

I may sound unreasonable.... What is a day, after all? But, I was on a tight deadline to get out a mailing to a group of customers and the delay was going to cost me. In today's market, a day can make the difference between selling to a customer and losing him to the competition.

9-to-5 Just Doesn't Cut It Anymore

Handled differently, the software company could have made me feel valued by acknowledging my frustration, extending an apology and providing some rational explanation for the delay. Since it didn't do any of these things, I probably will not seek it out for future purchases—unless I have no other choice. It was simply not accessible when I needed support

The days of 9-to-5 accessibility are long gone for any business that purports to service the customer. Whether it is the 24 hour-a-day nature of the Internet, dual income households with unbelievable time constraints or

a general increase in the pace of our lives, accessibility—like speed—has become a customer entitlement. Successful businesses must make themselves available when they are needed by their customers.

Some companies try to legitimize inconvenient hours for human-to-human contact on the basis of their Internet presence. Unfortunately, the capability of their Web sites seldom match up to the needs of their clients. A good analogy is a hardware store that operates from 9-to-5 Monday through Friday, and closes on the weekends. Unless that store has exclusive distribution for high-demand products, it will fail. The hours of operation do not match the hours when working people require purchases from the store.

Everyone accepts the fact that business must match products and services to the needs and desires of the clientele. Businesses must also match hours of operation with their consumers' availability. Sometimes availability is the greatest service.

Ask Yourself

1) *Use technology to serve clients, not hide from them.*

 ☐ Do you use telephone voice mail to "screen" your calls? (Some people think "screening" calls is a sign of status. In marketing or customer service, it's a sign of evasion.)

 ☐ Does your Web site make it easy for customers to reach you directly?

 ☐ Do you blame the computer for problems? (Remember: Computer problems are usually the result of bad input.)

2) *Problems are opportunities to apologize.*

 ☐ Do your customers expect perfection or integrity? (This is a critical distinction.)

 ☐ Does your corporate ego allow you to recognize and claim errors as your own? (What kind of irate comeback can a person have to the words, "I'm sorry?")

Relationship Aspect Marketing

3) *Surface problems often indicate core deficiencies.*

☐ Do you spot clean a problem when it surfaces or do you take a deeper look at how and why the problem started?

☐ If a product has a tendency to malfunction, do you replace individual units or fix the cause?

☐ If you sell for eight hours a day, will your customers be satisfied with service for four hours?

☐ What kind of balance does your company need between selling and servicing?

CHAPTER 17:
SURVEYS NEED TO BE DONE CAREFULLY

Surveys and questionnaires—used carefully—are great tools. But there are some major problems with the way that most of these tools are used. I do not consider most surveys or questionnaires to be worth the value of the paper on which they're printed. Most are written to elicit a positive response. Most companies are afraid to ask the hard questions. Yet, it is precisely the answers to such hard questions that a company needs to know.

The saving grace is that most questionnaires leave some space to write additional comments. (Remember the Mann Theatre experience I wrote about in the earlier chapter?) Whether the company pays any attention to them is another question; but, in my opinion, much valuable information can be gleaned from side comments in this section of a survey.

The following is a real life example of the problems with surveys.

My youngest daughter needed car insurance and asked me for help. She lives 400 miles away, so I didn't want to bother my local agent. Instead, I decided to give a well-known, online insurance brokerage a try. Let's just say, I did not find InsWeb's slogan: *Where you and your insurance really click*, to be an accurate expression of my experience.

I failed in my first two attempts to properly fill out the online application for her. And, with each error I was sent back to a new application to start from the beginning. On my third attempt, I succeeded; of course, that was about 20 minutes later.

The initial quotes seemed pretty high and I wasn't about to accept any of the offers. Several hours later I received an e-mail offer from the company that was lower, but I wasn't impressed enough to buy. The following day, the company bettered its offer. I asked to be contacted by an agent.

The agent, a very pleasant young man, called and took detailed information over the phone. However, due to a prior violation on my daughter's driving record, he said he'd have to do some research and call me back with a firm quotation in an hour or two—which turned out to be two days. Although his final quotation was reasonable, he was too late. He failed to live up to my expectations (which he helped set).

In the interim, I called my personal agent and asked him to write the policy for my daughter, even though she was out of the area. It took all of about 10 minutes for him to find the right coverage at the right price and fax over the paperwork.

A Perfect Example of an Inept Survey

About 25 days later, I received an electronic Customer Survey Form. The survey is a perfect example of survey ineptitude. The survey asked the following 10 questions:

1) How would you describe your experience of shopping for auto insurance on the InsWeb Web site?

 Answer choices ranged from very positive to not sure, with no space allocated to provide an explanation.

2) What did you like *best* about the InsWeb Web service?

 Respondents were directed to select two answers.

3) When you were presented with a listing of carriers on InsWeb, which best describes how you submitted your information to the participating carriers?

 The answer choices ranged from "all the carriers presented" to "all but the current carrier" and everything in between. The right answer for me: "I don't remember."

4) You requested a quote and/or coverage from the following companies. How long after you requested information from these carriers and agents did you receive it?

 The form listed two carriers, twice each. I don't remember requesting anything from either of them.

5) How would you rate the overall quality of the service you received from InsWeb carriers?

 Answer choices ranged from excellent to disappointing, but there was no opportunity to cite reasons.

6) What is the likelihood that you will purchase insurance from one of the companies presented to you on InsWeb?

 Finally, a good question. But 25 days after the quote? Answer choices ranged from very likely to will not purchase, with additional blank space provided to indicate from whom you would purchase the insurance.

7) What features would increase the likelihood that you would purchase insurance through InsWeb?

 Not a bad question, but the answer choices were limited. There was nothing about how to make the Web site application easier to use and nothing about why you wouldn't purchase from the company.

8) How much would you have to save in annual premium costs in order to change carriers?

 Answer choices ranged from less than $50 to more than $500, but the question is a waste of time and presupposes that price is the only issue.

9) How likely are you to recommend the InsWeb service to others shopping for insurance?

 Finally a question that I could answer truthfully—but again, no opportunity to cite a reason for my answer and no space to list a referral if I wanted to give one.

10) How did you hear about InsWeb?

This was the most solid of all the questions and provided an opportunity for the company to gather information critical to future marketing—if they looked at it.

The Answers Are Only as Good as the Questions

The last segment offered the opportunity to write additional comments or concerns—a positive sign. Many electronic surveys do not offer a comment area.

The point is that vague or inept questions followed by preordained answers will not help any company get a handle on what its customers want or need. This survey and others like it don't ask the tough questions such as: *Were you unhappy with the experience? If so, please note the reasons for your dissatisfaction. What didn't you like about our service? Why did you visit our Web site? Did you expect more than what you found? If so, what?*

I did take the time to fill out the survey and provided as much negativity as I could under the circumstances, but most people faced with such a survey would not take the time to fill it out. I never even received an electronic, *thank you for your time*. In fact, no one has ever followed up with questions about my negative answers, and there was never any attempt to placate me.

This is the fatal error. Surveys imply that your company cares what the respondent thinks, which means that you must follow up with the client or prospect, and make him feel that his time has been well spent.

Remember, surveys create expectations. If you can't address those expectations, if you are not willing to change, save your time and your money. If you can't develop a good survey and support it operationally, you are better off with no survey at all.

Ask Yourself

1) *Surveys are only as good as the questions.*

 ☐ If you are doing surveys—electronic or paper—are you willing to ask the tough questions and pay attention to the answers?

 ☐ Do you make the person being questioned feel that he is a vested partner in your company?

 ☐ Do the questions you ask reflect the needs of our customers?

 ☐ Are you sensitive to the possibility that certain questions may be offensive to some customers?

 ☐ Do you review the questions with trusted employees before customers receive them?

 ☐ Are questions oriented to just those who bought, or to those who didn't buy as well?

 ☐ Do you have the means to survey prospects who haven't bought? Does it make sense to do this?

2) *Don't ask a question unless you're willing to hear the answer.*

 ☐ Before you begin a survey, are you prepared to process and respond to negative answers?

 ☐ Can a business learn from a negative response?

 ☐ Should your company survey allow for responses beyond the formatted answers?

 ☐ Are your surveys designed to elicit truthful responses or to receive praise?

 ☐ Are you looking for responses that indicate areas which need improvement?

3) *Share survey results with customers and employees and act on your findings.*

 ☐ Do you objectively share all responses with your employees?

Relationship Aspect Marketing

☐ Do you objectively share all responses with your customers?

☐ Do you thank the participant?

☐ Do you let him know what the survey reveals and what actions are being taken to affect change?

☐ If there are problems with doing this, how can they be overcome?

☐ Do you have a plan of action based on survey results?

Chapter 18:

Building a Good Web Site

Fear was a big obstacle for me when it came to developing our Web site (www.soundmarketing.com). In fact, I was paralyzed by fear. I wanted to design and manage our site internally—to allow immediate and constant updating. But the prospect of being responsible for keeping track of all the data and properly managing the continual process of inserting new material in-house seemed overwhelming.

I've since overcome my fear and am convinced that Franklin Delano Roosevelt had it right when he told Depression era Americans: "The only thing we have to fear is fear itself."

I began my education in conquering my fears of Web design with one of many excellent what-you-see-is-what-you-get software programs for Web development—Microsoft's Front Page. I first attempted to go through the tutorial, but I found it overly simplistic and never actually made it through the program. The secret, I discovered, was to sit down, manual at my side, and actually begin to implement the design of our Web site. (I had planned it all out on paper first.)

Once I began, my comfort level grew and my fears were put to rest. I suppose I should mention that I cheated a bit at the end; I hired a consultant for a couple of hours to fine-tune the work I had done and to teach me the shortcuts for such things as speedy loading of graphics. The total time investment on my part was only a couple of days.

I saved a significant amount of money in start-up costs and I continue to save because we can do updates in-house without paying a specialist every time. However, larger businesses, such as those needing a shopping cart capability, may need expert help.

I have found that many others share aspects of my Web-phobia. Ironically, I've forgotten my fears and I wonder—not so empathetically—why people are so intimidated by the concept of building their own Web site.

Tried and True Tips for a Better Web Site

After much research and countless conversations with business owners and Web experts, I've distilled a few suggestions about Web sites that may be of benefit. (Some of these ideas are in use on my Web site; others will be implemented during the next renovation.)

1) Design a *contact* directory that lists the name, title and e-mail hyperlink for each employee. This, of course, assumes that each of your employees has his own personal e-mail, which, I might add, is a proven morale booster. I also recommend connecting employees to the Internet. It still puzzles me why so many businesses refuse to provide Internet access to all their employees. The most common fear is that they might visit undesirable sites or play around on the Internet. Connectivity is the true value of the Internet and the means by which companies can improve productivity. Failure to connect your employees, both internally and externally, is a great disservice to your business. As for concerns about abuse, this is a management issue. (See Chapter 17 for more on e-policies and procedures.

2) Provide a constantly changing value-added enticement. You need to give people a reason to return to your site—merely offering a billboard menu of your services falls short. The easiest way is to offer articles that contain pertinent information for your market. If you do not wish to create the material yourself, many publications allow you to reproduce their material as long as you credit the source.

An example: Emily Huling, owner of Selling Strategies, Inc., goes beyond articles—her site offers free tools that anyone can use. One of the most successful tools: Lost Account Letter. The letter can be used as a template by any company. Visitors can download the sample letter at the Web site www.sellingstrategies.com. The secret is to find out what your clients and prospects find valuable, and use it to entice them to your site.

3) Develop a *Meet Our Friends* page that hyperlinks to the Web sites of clients, vendors and friends. This should be negotiated to a mutual benefit; that is, the linked site provides a hyperlink to you on their Web page.

4) Expand the *Meet Our Friends* concept with value-added discounts. Most of your clients would be very willing to offer a special discount to your other clients and employees. Remember: The more you help your clients, the more loyalty you inspire in them. (Of course, it is wise to consult the client before promising such discounts on his behalf.)

5) Offer personal pages for your employees. This is not as difficult—or expensive—as it sounds. Each employee is given the responsibility for his own page, which is good techno-training, and enables him to share the important things in his life with your clients. It's amazing how pictures of family, details on hobbies, information on organizations and charities and other personal data can provide a bridge for your clients and employees to develop lasting relationships. Plus, your employees urge others to see their pages—which drives more traffic to your site.

6) Design a virtual library. Most agencies have developed an extensive library of training and educational materials. Inventory what you have available in print, audio and video, then list it under your virtual library. Clients can e-mail their request and borrow the material on a first-come, first-serve basis. This establishes you as a valuable resource.

7) Conduct contests! Here's a fun way to get your clients and prospects familiar with what your site offers. For example,

hide in a word or phrase somewhere within your site and offer a modest prize (lunch for two at a nice restaurant) to the first five people who find the hidden word.

8) Post your newsletters. If you send out periodic newsletters, post them on your Web site. This is a great way to expand your readership—at a low cost. Such postings may also lead another organization to approach you to reprint one of your articles on their site.

9) Establish a community bulletin board. From owners to receptionists, employees are usually pretty involved within their community. Offer charities and other such organizations free space to publicize their events on your Web site. They'll appreciate the gesture and drive more traffic to your site.

10) Add a Web site signature to all your e-mail. Most e-mail programs allow you to customize a closing *signature* that is added to all outgoing e-mail (see Appendix 10 for a sample e-mail signature). Why not close every e-mail with an invitation to visit your Web site and make the site address a hyperlink.

Above all, don't let Web phobia lead you to pay more for your site than necessary. Try to accomplish it on your own. And, having done at least some of it yourself, I promise you'll be more confident when other technological battles arise. Anything is better than nothing. The only *wrong* thing you can do is *nothing*.

Ask Yourself

1) *Overcome your fears by taking action, one step at a time.*

☐ Businesses—like individuals—have fears. A business fears are simply more general and institutional. What are your business's institutional fears?

☐ How have your business's institutional fears impacted decisions—made or unmade—within the last few months?

☐ How can you avoid repeating mistakes shaped by institutional fears?

2) *Don't be held captive by fear.*

☐ Has fear-based inaction effected your business? How?

☐ If you fail to change are you maintaining the status quo or slipping backward? (This is an important distinction. Most business people think inaction means security. This is a fallacy that has killed many businesses.)

☐ Have most of your projected fears proven to be accurate or inaccurate?

3) *Push your employees past their fears.*

☐ Are you willing to take a chance to overcome a fear?

☐ How far are you willing to go?

☐ What form will it take?

☐ Are your employees more likely to gain knowledge and productivity from a new resource? (In many cases, this will mean new technology.)

☐ Would you ban telephones because they are abused? Would you ban Internet access because it is abused? The means for monitoring use of each are relatively cheap and readily available.

Relationship Aspect Marketing

CHAPTER 19:

IF YOU BUILD IT, THEY MAY NOT COME

Imagine the Empire State Building as a library with every room, hallway, nook and cranny filled with books. Now imagine a librarian who can only assist you with books located in one room of the library. That's what the Internet is like today. Recent estimates suggest that search engines such as Yahoo! and Excite only provide access to about 16 percent of the content on the Internet. The Internet is growing faster than the search engines can accommodate.

So where does that put you, the proud new owner of a Web site?

Despite all the innovations of the Internet, you need traditional advertising and marketing to steer people to your Web site. Every piece of paper from letterhead and business cards, to invoices and return mail addresses should incorporate your Web site address.

Fax cover sheets should have your Web site address, as well as other pertinent marketing information about your business. Every article you write for public relations purposes should contain your site address. Every e-mail should have a signature segment that has your Web site address, and a hyperlink to your site. Every advertisement you purchase from mail decks and newspapers, to radio, television, billboards and mail fliers should promote your site address. Direct mail, newsletters, Yellow Page ads, promotional giveaways—everything that promotes your business should also promote your Web site.

Build hyperlink alliances. Friends, associates, vendors and clients are all viable sources for mutual promotion of Web sites. Offer a *Connections* page on your Web site, to put visitors in touch with your cyberalliances; they, in turn, should be doing the same for you. Some allies, such as Amazon.com, even pay to have these hyperlinks by offering commissions on any sales made to customers who arrive through your hyperlink.

Be Wary of Paying for Internet Advertising!

From Madison Avenue to the business next door, no one seems to have a good handle on effective Internet advertising. By this I mean the banners and ads that you can purchase on portals such as Yahoo!

Unlike other media, such ads have to grab your attention and convey their message in a nanosecond. And most surfers are immune to such electronic entreaties. We are in a stage of trial and error that requires constant testing and evaluation. I suggest you let other businesses waste their money in this testing phase.

Rather than paying for Internet advertising, think of creative ways to get exposure for free. Here are a few that have proven to work for my company:

1) Send press releases about your Web site to your local media and trade magazines on a regular basis. Provide them with a synopsis of a new feature, article or benefit on the site, explaining that readers can access the site for the complete version.

2) Network, network, network. Everyone with a Web site is looking for ways to build traffic. Talk with your clients, friends, peers and acquaintances about "rubbing each other's back." *I'll promote your site on mine with a hyperlink, if you'll promote mine on yours.*

3) Imbed your Web site's URL into the graphics of your company logo and make it available for posting on other Web sites when co-promoting each other.

4) Create e-mail newsletters to send to clients and prospects (stay within legal parameters). Rather than posting an entire article, just write a brief synopsis with a hyperlink to your Web site for the complete story.

5) Promote your Web address on everything from business cards to stationery to fax covers.

6) Hire someone to program your Web site into the "high-priority" category in search engines. This is one aspect of Internet marketing that is worth the investment.

These are just a few ways to market your Web site cheaply. (The last suggestion will cost you, but it's well worth it.). Some creative brainstorming should uncover many more.

Recently, a number of the major Internet players have cut back on their Internet advertising, choosing more traditional advertising media. It's not that Internet advertising is ineffective, it's just that results are still questionable. Still, I'm sure that the future holds advancement in Internet advertising, so don't discount it, don't forsake it, but be wary of it.

While you're waiting for the Internet to get up to speed in the advertising sector, you can concentrate on keeping the business you already have interested and coming back for more. With the first wave of dot.com mania subsided, some common sense things about internet marketing have emerged. Chief among these: It's important to keep new material on a Web site fresh.

Once You Get Them You Have to Keep Them

Your electronic counter has just registered another visitor to your Web site. Is this visitor a one-time fly-by, or is this a repeat visitor?

Remember: Presentation is important, but content is critical! Too many Web sites are merely billboards—electronic braggarts shouting to the masses: Here I am. Look at me. I am wonderful. Give me your money.

Relationship Aspect Marketing

I remember growing up in the 1950s and being in awe of the billboards that dotted our highways land. After time, their messages were lost and confused amongst the clutter. Legislation has dramatically lowered the number of billboards that blur our driving vision. As a result, today's messages are more apt to be noticed and appreciated.

The Internet has created a whole new marketing avenue for advertisers. We're in a stage of Internet advertising that's analogous to the explosion of the billboards in the 1950s and 1960s. Many messages are getting lost.

Experts say we are bombarded by 3,000 to 5,000 ads a day. I believe that is a significantly low estimate, especially among those who spend any time on the Internet. Just sitting here in my office, I am bombarded by over 100 messages—with my computer turned off. Equipment brand names, advertising logos on pens and cups, and ads in open magazines are everywhere.

Don't allow your Web site to be another piece of clutter in a cluttered landscape. It must offer value to the visitor. It must offer entertainment or non-commercial information that the visitor can enjoy or use and it must be up-to-date—that is, if you make effective use of the Internet.

Let's use Soundmarketing's Web site as an example. Our home page lets you connect to information on our services. The site offers details about the service or product, as well as its price. (I abhor sites that give you everything but what you want—which is the price.)

Since most of the visitors to our site are business people, we offer an array of timely articles on a variety of topics designed to help a business improve its practices. The site also offers a connections page, listing friends, vendors and associates that we feel could also be of benefit to our visitors. Additionally, for those that know us or hope to know us better, our personal pages keep you up-to-date on our personal lives—our grandchildren, our pets and our hobbies. These pages add an important element of warmth to our electronic presence. After all, if you were talking to a client you would probably spend a little time talking about personal stuff, as well as business. That's what relationships are all about. So why not incorporate it into the company Web site?

Of course, this level of personal interaction is not appropriate for all businesses, but it works well for us. You must discover what works best for your company, but I recommend incorporating some amount of personal contact into your Web site, no matter how small.

Ask Yourself

1) *Use proven methods with new marketing technologies.*

 ☐ Do you view the Internet as an added advertising channel? Or do you see it as a cure-all to flagging sales?

 ☐ What specific needs and wants do your Internet users have that differ from your other customers?

 ☐ Are you meeting these needs and wants?

 ☐ How should you customize your sales and marketing products to Internet users?

 ☐ How can you follow up with non-Internet products to these customers?

2) *Web presence in and of itself means nothing.*

 ☐ How many people accidentally stumble into your site?

 ☐ Have you ever tried to find your Web site listing by using an Internet search engine? (If you can't find yourself using three of the biggest engines, your not listed enough.)

 ☐ How frequently would your telephone ring if no one knew the phone number? If people aren't aware of your Web site, how likely are they to visit it?

3) *Market, market, market your Web site.*

 ☐ Are you marketing your Web site?

 ☐ If so, by what means?

 ☐ Are you doing enough marketing?

 ☐ How do you know when you've done enough?

Relationship Aspect Marketing

4) *Content is critical to a successful Web site.*

□ The structure of a Web site is less important than how people use it. Is your Web site easy to use? How do you know?

□ Do you jam your Web site with too many ads?

□ How many ads do you have on your site?

□ Do they daw the eye away from the main body of the site?

□ Will visitors have trouble figuring out what your product or service is?

5) *The more the value, the greater the traffic.*

□ How can you market your Web site as having extra value?

□ How can you promote the value of your site by word of mouth?

□ How can you—like MSNBC and Hollywood.com have done—create a site with perceived value?

□ Have you ever recommended a Web site to someone else because it offered a unique value?

□ How can you replicate that experience for your own site?

6) *Get personal, it works.*

□ Do your customers know anything about your employees? About your locations? About other customers?

□ Does your Web site offer contact information for specific individuals or groups?

□ If employees and customers were featured on your Web site, do you think they would tell others about it?

CHAPTER 20: E-MAIL CAN BOOST MORALE

I've already stressed the importance of connecting employees to the Internet. As owners, managers and executives, we often wear blinders when it comes to our staff and employees. We seldom address the humdrum aspect of their daily duties. And even when we do, we rationalize: *Well that's the job and somebody's got to do it.*

As one who came up through the sales and marketing ranks in business, I recall, with a shudder, those infamous phone bank days. Making one call after another to our distributors all day long was like Chinese water torture. It stifled creativity and led to long, drawn-out yawns and droopy eyelids. But it was *part of the job and somebody had to do it.*

Today, many employees still have to deal with "phone bank days" every day. Customer service representatives, call center employees, claims processors—whatever the title, the job is to place calls proactively (marketing, prospecting, etc.) or reactively receive calls (sales, claims, service, etc.).

But there is good news for people in these jobs. Recent studies indicate that the Internet is a catalyst for change. In fact, according to an *InternetWeek* article, Web-enabled employees are finding more satisfaction in their jobs. The article quoted one telephone customer service representative who described a dull pre-Internet day of waiting for the phone to ring. Now Web-enabled, that same employee is excited about work and happy to use his writing and analytical skills.

Relationship Aspect Marketing

E-mail exercises dormant writing muscles, which many employees find empowering. It provides them with the opportunity to put their skills into action. Employees actually write their own response, as opposed to filling in the blanks on a template response letter.

Automation has expanded telephone-oriented positions into multifunctional support centers with Internet access, e-mail and faxes, along with the traditional telephones and snail mail. Computer resources, coupled with the Internet, enable employees to research, evaluate and determine the proper actions or solutions to nearly any situation (provided that management is wise enough to empower them and support their actions).

When I visited the Web site of a large insurance agency, I was disappointed that most of its pages were advertising billboards about the agency. I was impressed by its communications page, which listed every employee within the agency. In addition, each name was a direct e-mail hyperlink to that employee. Obviously, the company understands the value of immediate contact with the right person. I'm sure that the employees feel valued. Having their own e-mail account allows them to field calls and solve customer problems on their own.

Conversely, when I wanted to e-mail a person at a major support organization to the insurance industry, she sheepishly asked if I could mail or fax it, because she did not have a personal e-mail address. All company e-mail went to a central address and could only be accessed at one computer! Embarrassment is definitely not high on the top 10 list of morale-boosters.

If providing Web access for each employee can improve performance, increase job satisfaction, enhance the services provided to your clients, educate them in new business technology, improve your prospecting results and significantly augment your profits, can you afford not to do it?

In today's employment market, job satisfaction and high morale are valuable concepts. No company can afford to lose good employees to Web-enabled competitors. And losing clients because you aren't living up to their expectations in an automated world is unacceptable.

Ask Yourself

1) *Technology empowers and improves communication; communication boosts morale.*

 ☐ How can you integrate e-mail and similar communications tools into your daily routine?

 ☐ If a customer prefers e-mail communication, how can you assure the technical tools are in place to allow this?

 ☐ And, once the tools are in place, how can you let customers know what they can expect from communications with your staff?

 ☐ Is it beneficial for your employees to be as electronically knowledgeable as your customers? What do you need to do to keep your staff's skills sharp?

 ☐ How much will this cost—in time lost and money?

 ☐ How can you track the cost and effectiveness?

2) *Morale is key to employee retention.*

 ☐ Can poor morale disrupt productivity and performance?

 ☐ If so, what do these disruptions cost your company?

 ☐ And what can you spend to prevent that cost?

 ☐ Can limiting Internet access and e-mail privileges have an impact on morale?

3) *Happy employees make happy customers.*

 ☐ When customers know that an employee is not happy, what does this kind of negative impression cost you?

 ☐ How much is it worth to prevent the impression?

 ☐ Are your employees a reflection of your company? How?

 ☐ Are your employees likely to go the extra mile for the customer? And, if so, how much is that worth to your business?

Relationship Aspect Marketing

CHAPTER 21:

TECHNOLOGY OFFERS INCREASED INTIMACY

Remember when people complained alternately that e-mail was too impersonal or that it would make letter-writing a thing of the past? Well, people still complain about these things, and think that new technology distances people from one another. True, e-mail has changed the way we communicate—but it hasn't replaced traditional forms or made for a disconnected society.

The military, one of the Internet pioneers, is a perfect example of how e-mail can affect change. My brother-in-law is an Air Force Colonel who has served in administrative and managerial positions throughout his military career. During a visit while en route to a new assignment in Hawaii, he mentioned that e-mail has broken down the barriers between ranks—at least as far as communication. Apparently, in years past, telephone calls to senior officers were filtered through secretaries. You rarely talked with the officer on the first attempt. Written communication was slower and more ponderous.

"When I send an e-mail to a commanding officer, it goes right to his desk— no secretary, no assistant. Plus, he types his own reply and it's usually pretty quick," my brother-in-law said. "The downside is that it often diminishes the image of the office or the person sending the e-mail. When most communication was written, I might have a secretary retype a letter six times to make it right. Anything we sent out was representative of our office and it had to be perfect. Today, it's a lot looser. And it's amazing how many officers can't spell!"

E-Mail Opens Up a Wide New World

Business, like the military, is trying to find its way through the electronic maze that gives us direct access to people who might be difficult to reach otherwise, but leaves us wide open as to how we should present ourselves. And you can't hide behind an assistant's good grammar or use her as an excuse when an error finds its way into an e-mail memo you wrote.

Furthermore, despite the advantages of brevity, I still like a little chitchat about what's going on in my e-mail pal's life—business or otherwise. And I fall short in both categories at times. Sometimes I get so wrapped up in a fast response, I forget simple courtesy. Where's Amy Vanderbilt when we need her?

That being said, e-mail has genuinely drawn us closer. Teenagers, the inveterate usurpers of telephone time, were probably the first to realize the advantages of e-mail. They can talk to their friends all day and night and their parents aren't hollering that their allotted time on the phone is up. (I suppose, now parents holler that their e-mail-obsessed children need to get outside for some fresh air and sunshine.)

When my firstborn finally got out of the house and went away for college, I began to appreciate the wisdom of the young. E-mail is a convenient way to converse nearly every day, without logging hundreds of dollars in long distance phone charges. I became a believer the day I refused my daughter's request for a loan, and she slyly responded, "But look at all the money you would have been spending if we communicated by phone." It's hard to argue with that kind of logic.

The young aside, the group that represents a major growth segment for the Internet is seniors. Despite age, infirmity, driving restrictions or other disability, seniors can now join the rest of society on the information highway. My mother-in-law, intrigued by stories of the Internet, was a ready mark. Her youngest daughter introduced her to the free computers at the local library and signed her up for a free e-mail account with hotlink.com. Before we knew it, Mom was surfing the net and bulking up her e-mail address book on a daily-basis.

A few months later, she called for advice about buying a computer. Today, she and my wife are in contact nearly every day, even though they're 3,000 miles apart. She sends and receives electronic greeting cards, and spends a lot of time researching topics of interest on the Internet. It has added value to her life and enhanced her relationships with her daughters, and my wife no longer worries about her mother.

The Advantages of Going Cyber

These lessons apply to every facet of our electronic relationship building strategies. Although it will never replace a personal visit or occasional phone call, the Internet enhances and nurtures relationships. Consider some of the advantages to building relationships electronically:

1) E-mail is a quick and efficient way to remember your clients. An electronic birthday card, thank you card or thinking of you card brightens anyone's day and it's free.

2) Subscribing to electronic newsletters via e-mail is an excellent way to keep abreast of developments within your industry. This helps you maintain the expertise your clients expect.

3) You can utilize e-mail to pass on tidbits that can benefit your clients and prospects by either sending them as a document attachment or pasting them into the main body of an e-mail.

4) When handling a customer complaint, you can show your clients you are hard at work on their problem by using the carbon copy (cc) function on your e-mail to involve all relevant parties within your company.

5) You can keep in contact with potential clients by e-mail. This helps you learn what prospects actually need, want and desire. When you finally meet face-to-face, you've already begun the relationship building.

6) Use e-mail to confirm convenient times for telephone calls. The person you are calling will be more receptive to the call, and you won't interrupt any other calls.

7) E-mail is the fastest way to convey needed information or resources to a client or prospect.

The benefits of e-mail are an obvious addition to your communications arsenal. This brings us to another step in your e-mail implementation strategy: the process of collecting the e-mail addresses from all your clients and any new prospects.

Ensure that any information-gathering material asks for an e-mail address. This goes for order forms, reply-back forms, surveys, questionnaires—anything that requests a name, street address or phone number—should also request an e-mail address. Then the e-mail should be entered into an address book.

Ask Yourself

1) *Get personal with e-mail.*

☐ How do you use e-mail to show that you care?

☐ Do you pay more attention to a letter addressed to "Dear Mary" or "To Whom it May Concern?"

☐ How do you approach e-mail: like a spoken message or like a letter?

☐ How should your customer service staff treat e-mail?

2) *Communication breeds relationships.*

☐ How does the way you communicate indicate that you value someone?

☐ Is a simple checking up phone call or e-mail worth making to key customers? To every customer?

☐ Does it make sense for you to structure inside and outside sales or customer service functions? (Inside functions take calls; outside, of course, make calls.)

☐ Does this structure make sense for your business?

3) *Build your e-mail database.*

☐ Do you broadcast e-mail applications to contact many customers at once? Having done this, do you customize e-mails to address specific customers or groups?

☐ Is it as natural for you to ask for an e-mail address as a phone number?

☐ Can the quality of your address book impact your ability to communicate?

Relationship Aspect Marketing

CHAPTER 22:

HUMANIZE YOUR TECHNOLOGY

Are you using technology to attract, nurture, sustain and retain clients? Or is technology costing you customers? Maintaining the human touch in a depersonalized world is critical to success in any business.

A gentle wind is blowing across the country from boardrooms and small businesses, to schools, churches and everywhere in between. Call it a function of the millennium—a reaction to informational overload or a simple maturing of the populace. People are trying to reverse the effects of technology and get in touch with their human side. Years ago John Naisbitt called it "high tech/high touch."

In 1989, Stephen Covey rocked the business world with his best-selling book, *The 7 Habits of Highly Effective People*.[1] The book outlines specific learned habits that are common among those who are highly effective performers in business. Covey stressed basic competence and a human focus. More recently, Tom Riskas, former Vice President and Senior Consultant of the famed Covey Leadership Center, says that the Seven Habits aren't enough for people to be effective; they have to find balance and healing at their core essence.[2] Riskas acknowledges the self-improvement impact of the lessons contained within Covey's book, but feels that humans have a hidden agenda which requires addressing core issues or needs that goes far beyond adopting new habits.

[1]*The 7 Habits of Highly Effective People*, Stephen R. Covey, Simon & Schuster, 1989.

[2]*Working Beneath The Surface*, Thomas Riskas, Executive Excellence Publishing, 1997.

I maintain that our sense of humanity—the need for a human touch—is a critical issue that businesses need to keep in mind.

Today, clients want information and they want it fast. They want to be able to place their business at a time, and in a manner, most convenient to them. As for service, they want it when they need it—at their convenience, not that of the service provider. At the same time, they also demand and expect that you care about them as individuals. This is a tough combination.

A Human Voice Can Make All the Difference

Once, I needed some assistance on a particular Microsoft product. Because of the evening hour, I tried Microsoft's Web site for technical assistance. After an hour and a half, I gave up and decided to try again by phone the next day. It wasn't that the online service couldn't answer my question, but I was unable to figure out how to send my request.

Much like some automated phone menus, I found Microsoft's customer service menu to be confusing. I couldn't quite figure out how to get to the spot where I could send them my question. The Web site was definitely not friendly to *this* human.

Wary of the automated phone system (I'd been caught in the automated phone maze before), I placed the call the next morning, and, inevitably, was connected to the wrong person. But this technician transferred my call to the right department, where I listened to music while on hold for about two minutes.

Suddenly, a voice jumped on the line, "Jack, didn't they answer yet?" I was blown away. The technician had been monitoring the status of my call. He put me back on hold while he had the operator connect me immediately. The person who picked up my call apologized for my wait and delved into my problem.

As with most software issues, the answer was quick to come and easy to implement—all I needed was the direction. End result: I felt that the com-

pany valued me as a client and an individual. Technology will have glitches in service. But, in this case, the company had minimized the impact of my frustration.

I've been taking potshots at automated phone systems for years, and I still dislike them. However, Microsoft is an example of a company that uses technology well and uses it to its advantage, while integrating the human element to make up for any pitfalls in technology. That's the kind of company that will continue to get my business.

Microsoft has also made major improvements in its Web site in terms of processing service queries. It's now quite simple to access online support, identify the product in question and submit your answer. I've found that they generally reply within a day—but provide a phone number if you need immediate help. In either case, you're assigned a case number that follows the problem through its eventual resolution.

The caliber of Microsoft's service personnel continues to improve as well. Over the phone, one night, one of the company's technicians worked for a solid two hours to resolve a problem with a PowerPoint presentation. On the e-mail side, one service person worked assiduously for two weeks to diagnose and circumvent some difficulties with the HTML editor function of FrontPage. The company strives to make its services—phone and Internet—more user friendly and its personnel are committed to solving customer concerns.

Do Unto Others...

When I talk to business owners, I often ask them three questions and request that they put themselves in their customers' shoes when answering. (The following questions are directed at the use of automated phones, but they can be altered to apply to other technology.)

1) How many of you hate automated phone systems? And, how many of you are dismayed to find yourself back at the beginning of the system—minutes after you began? (Most people raise their hands in identification.)

2) Keeping question number one in mind, how many of you business owners and CEOs have automated answering systems? (Again, the same people tend to raise their hands.)

3) If you don't enjoy dealing with automated answering systems, do you really think your clients do? (At this point they begin staring at their shoes, rather than making eye contact with me.)

I prefer businesses that have a live operator offering me the choice of going into the automated system, or automated systems that immediately offer me the option of accessing a live operator by dialing 0.

I urge every business owner or manager to take a long—and close—look at the company's automated systems to determine if the human touch is present or missing.

Are you using technology to take care of your customer base—and maintain its loyalty?

Ask Yourself

1) *Proactive, customer-focused actions prove to your customers that you truly care about them.*

☐ Are your form letters and direct billing statements sensitive to the human recipient? Or, do they look, taste and feel like insensitive computer regurgitation?

☐ Do you take the time to personalize e-mail?

☐ Is your Web site an exercise in ego-gratification, or does it truly serve the needs of your prospects and clients?

☐ Is your telephone system user-friendly?

2) *If you don't like the way a technology works, your customers won't like it either.*

☐ Are databases being used for humanizing contacts, as well as client management?

☐ Do you use databases merely for internal accounting and processing invoices? Or, do you also use them to maintain client profile information for future marketing and ongoing communication (without customer relationship management software)?

Relationship Aspect Marketing

Chapter 23:

An Amazon in Every Respect

A book on electronic commerce and relationship marketing can't afford to exclude a chapter on the mother of all e-commerce: Amazon.com. I really wanted to avoid writing about this mega cyberbookstore simply because everyone writes about Amazon.com. Although I must admit, I long for the day that someone writes about them turning a profit.

My decision not to write about Amazon.com in this or any other book I write came to a screeching halt over a luncheon discussion with my wife. I had just collected the mail and commented that a package from Amazon had arrived for her. "Really?" she said, "I just ordered it yesterday and didn't request next day delivery." She went on to mention her surprise when she went to the company Web site the day before and, according to her, "As soon as I accessed it, the screen welcomed me by name."

This got me thinking: Don't we all love acknowledgment? Doesn't it feel good when we go into a store and the employees know us and welcome us by name? It adds value to the relationship and Amazon is managing to do this in spite of the technology-based business model.

My wife does not consider the computer to be her friend. But she found it easy to use the Amazon.com search engine to find a book. She couldn't remember the name, but knew the author and that the book was about the author's child. "That's not all," my wife gushed. "I had two e-mails from Amazon last night. One verified my order and the other indicated that the book had been shipped."

Technology Can Get Personal

Exceeding expectations is difficult today, yet Amazon.com has continually accomplished this with personal greetings, a user-friendly site, order verification, shipping announcements and speedy delivery. Its standard delivery takes five to seven days. (But it rarely takes that long.) Anything less than that exceeds their commitment and the customer's expectation. Finally, on opening the package, my wife got some lagniappe. Along with the book and the receipt were a complimentary Amazon.com Post-it pad and a bookmark—small, but effective, reminders that the company appreciates your business.

Amazon.com also mines the gold of its customer database. Based on the books that I have purchased, I occasionally receive e-mail messages from Amazon.com. (Wisely, it restrains from overwhelming customers with e-mail solicitations.) The message usually goes something like this:

Dear Mr. Burke,

Prior purchases that you have made indicate an interest in <subject>. A new book on that subject has just been released and we thought you might find it of interest. The book, <title>, is written by <author> and depicts <brief description of the book>. To learn more about this book, or to arrange delivery to you tomorrow, just click on <URL>.

Although this is automated marketing, it has a personal touch. The e-mail addresses me by name and covers topics of interest to me. This is the electronic equivalent of walking into a neighborhood bookstore where the owner says, *Hey, Jack, good to see you. I know you're interested in ancient history, so while you're here you might want to check out this new book.* Now these are not unheard of stories in the retail trade—unless you consider that this is about a virtual bookstore that no one can physically visit—a 100 percent electronic concern.

I think we can all learn some lessons from Amazon.com.

Ask Yourself

1) *Establish reasonable expectations, then exceed them.*

 □ Do you have the most effective process for meeting customer expectations—whether it's with delivery, speed, stock availability or troubleshooting?

 □ Might a customer doubt the validity of unbelievable promises that appear to be too good to be true (e.g. overnight delivery)?

 □ How do you guarantee promises?

 □ How do you exceed expectations?

2) *A small thank you can earn big dividends.*

 □ Do you have the tools in place to acknowledge the value of your customers on a regular basis?

 □ How can you communicate the importance of establishing customer loyalty to your customer service staff?

 □ How do you ensure the practice of courtesy and good manners among your employees?

3) *Know your customers and sell to their needs.*

 □ Are you constantly watching for ways to migrate existing customers to repeat status? Is your staff?

 □ Do you know your customers well enough to suggest something that they would like?

 □ Do customers tend to buy because you sell or because they need?

 □ Do you know the status of each of your key customers? Of each of your customers, period?

Relationship Aspect Marketing

CHAPTER 24:

BATTLING OVER PRICE ON THE INTERNET

The Internet has generated a truth that every business owner must learn to accept or he will perish: *Competitive pricing, based upon value, is a given.* Most businesses (designer original fashions excluded) cannot arbitrarily take advantage of the consumer with exorbitant pricing.

Consumers are savvy and expect you to be competitive. If you aren't, you're out of the race. It only takes a few quick strokes on a keyboard to research just about any purchase—including price ranges, and wholesale costs. The result: pricing on a level playing field.

Take for example, the consumer's ability to research wholesale pricing in the automotive industry. Who would have thought that the tire-kicking, deal-negotiating American pastime of purchasing automobiles would become so prominent on the Internet in such a short time? Consumers can now investigate makes and models, compare features and get factory invoice pricing to leverage their position in negotiating with a dealer—all over the Internet. In addition, consumers can purchase, finance and insure a vehicle at one-stop shopping Web sites. Unfortunately, you still have to go to the dealership to take delivery. . . . But that's changing, too.

For decades, dealer cost was a much speculated, but largely unknown, factor to the consumer. Dealers were so secretive that many sales personnel didn't even know the true cost of a vehicle. Enter the World Wide Web. Suddenly, prospective buyers can access myriad sites to find the dealer's cost of any vehicle.

Consumers Gain the Pricing Edge Online

Armed with cost printouts, car buyers descended upon the dealer. In April 2000, the National Auto Dealers Association announced that vehicle costs would be made available to the general public over its Web site. This venerable association of dealers had realized that there was no way to prevent the consumer from gaining access to pricing information. Therefore, dealers acknowledge the reality and provide the information themselves directly to the consumer.

Business owners who had managed to keep costs a secret shivered at the thought of such well-informed customers. However, the battle for automotive customers can now be waged based on the intrinsic value of the vehicle and the value that the dealership can bring to the table. The hope is that this will result in greater service to the customers. And, in turn, this value will be the deciding factor in a customer's purchase.

The electronic dichotomy remains. The Internet has, for the most part, removed price from the purchase equation because consumers can gain access to cost factors or, at least, compare retail prices. So if the question is price or value, I believe the answer is both. Prices have to be competitive to remain in the game. That being the case, value should make the difference. What each business needs to determine is the actual value they can apply to the equation. For some, it might be 24-hour service, for others technical expertise, geographical location or hours of operation.

A few weeks ago, a friend was researching the purchase of a new truck over the Internet. The Internet is a tremendous convenience for him as he lives in a rural area of Colorado. He knew the make and size of truck that he wanted, and he went to the Internet to check out the various options and determine the actual specifications.

Having built the truck on a virtual basis, he decided to attempt the purchase-negotiation process over the Internet as well. However, rather than going to one of the huge, generic car purchasing sites, he opted to check out dealers that were online. However, he encountered a few disturbing trends.

First, he discovered that most dealers are pretty slow in responding, either by e-mail or by phone. Second, when they do reply, they are literally tongue-tied. Think about it! The sales person knows that you're Internet savvy. That means you've most likely researched the car you are interested in and gained access to dealer cost figures.

In the mind of this salesperson, the only issue is how much over cost you're willing to pay—or perhaps you've got a trade-in that allows room for negotiation. What the sales person wants to do is get you to come into the dealership where emotions can surface, and then they have a chance to get you to pay more than you were prepared to. If they negotiate over the Internet, they assume that the customer is only interested in the price.

Price Is Not a Competitive Advantage

What both the dealer and the car buyer in this scenario have missed is that price is no longer the object. The Internet has destroyed price as a competitive advantage. Easy access to cost and pricing quotes for most retail industries has eliminated the issue of price in many business relationships. You are either competitive, or you are out of business.

However, this still leaves the dealership with other ways to differentiate itself. (Differentiation, on more than just price, determines tomorrow's winners.) For example, the dealer may provide free loaner vehicles when a car is in for service or actually pick up and deliver your car when it needs service. Some dealers offer special service waiting areas with activities for children and Internet connections for businesspeople with laptops. Others offer free oil changes for a year or two, a full tank of gas at delivery and free car washes on Saturdays. There are hundreds of ways a dealer can differentiate through service, accommodations, policies, etc.

But let's return to our original discussion. Why would a dealership have a sales person make the initial call on an Internet inquiry? Isn't it more effective to have contact come from a service manager, or a public affairs liaison?

Relationship Aspect Marketing

Imagine the customer's surprise when he receives a call from a service manager, instead.

"Hi, this is John Jones, service manager for ABC Ford, and I see that you've inquired about purchasing a car from us. Jennifer Sells, one of our sales executives, will contact you shortly about that, but first I wanted to contact you. You see, in the greater scheme of things, you might spend a few hours with Jennifer, but I hope you'll be relying on our service department for as long as you own your vehicle. So, before you talk with Jennifer, let me tell you a little bit about the many conveniences we offer to our customers...."

I don't know about you, but this type of initial contact would definitely put that dealership ahead of the rest in my mind. In addition, a public affairs specialist, or customer service representative, could approach the customer on a broader basis than a salesperson by talking about all the various departments and benefits a dealership has to offer. That way, when the sales person enters the picture, the prospect is already predisposed to do business at the dealership. The salesperson can concentrate on getting the appointment, model and option selection, finance options and all the other pertinent elements of the sale.

I use the auto industry as an example, but any company doing business over the Internet or, anywhere for that matter, can quickly devise strategies that will overcome the hurdle of customers who only want a price quote. If you needed a root canal, would you pick the lowest priced dentist? Or would you want to know something about the dentist first?

When our company called for bids on the purchase of CD replicators, we initially looked for the best price on a specific model. Most of the companies we approached simply sent over a quotation (as we requested). However, one sales person fielded our call, listened to our request and then began asking questions about how we would be using the equipment.

Upon reflection, he verified that we were looking at the right model, and then explained his company's service policies, the level of expertise of the technicians and other after-the-sale advantages provided to clients. He

then sent over a fair quotation that reaffirmed all the other benefits in writing. His was not the lowest price, but he got the sale because he showed an interest in verifying our needs and fully presented the value he brought to the table.

Remember: Price is not the solitary issue in the mind of a customer. Take the time to focus on the customer's needs, provide the solution for the customer and show the value that your company brings to the transaction.

Another example: After 15 years, Sound Marketing switched long distance providers. We had knowingly paid a premium for AT&T from the get-go, so obviously price was not a determining factor for us. The reason for the switch had to do with service—specifically, policy and procedural changes relating to telephone conferencing. Before calling other providers, we offered AT&T every possible chance to keep our account. However, its finely-tuned bureaucracy rendered it incapable of doing so, and we requested price quotes from its competitors: Sprint, MCI and GTE.

MCI and GTE refused to send anyone to our office; they would only deal with us over the telephone. Dismayed at their lack of interest in my account, I tried a different tactic with Sprint. I went to its Web site and sent an e-mail requesting someone to contact us (preferably in person). Within an hour, a Sprint employee called to schedule a visit by one of their sales representatives. To my amazement, he asked if 3 p.m. that afternoon would be agreeable.

The Sprint representative called first to gain information about our company. When he arrived at our office, the rep quickly assessed our needs, and provided details on how to test the recording quality of their teleconferencing service. Before leaving, he verified that we understood and were satisfied with the teleconferencing quality and operational features. Two days later, he came by again with a written proposal/price quote. The proposal highlighted the unique benefits and services Sprint offered, and the last two pages detailed the pricing. Sprint is our new provider.

Price was a factor in our decision to go with Sprint—but not the deciding factor. Sprint's prices weren't the lowest, but they were competitive. The

deciding factor was their willingness to send a representative to our offices and the caliber of that representative.

Our choice proved to be even more beneficial. Our rep later called to say there was a new program that, based on our usage, could result in greater benefits and lower expenses. We scheduled an appointment and he introduced us to Sprint ION, which would give us a DSL line for the Internet and equalize monthly billing statements to reduce our overall long distance expense. And, he sold us on the features and benefits. Saving several hundred more dollars per month was just icing on the cake.

Since making the switch, we have had at least two dozen calls from AT&T, two from MCI and several from GTE. The three companies basically approach us with the same pitch—*We really want your business. How much are you paying per minute?* What this proves to me is that they just don't get it. They incorrectly assume our decision was based on price. Based on this misconception, they all predicate the conversation on price. They created the pricing monster, because our decision was based on changes to their teleconferencing services—not long distance rates.

Pricing in the Retail Market

If you still think price is the critical factor in purchasing decisions, consider one of the most basic commodities in our world—salt. Salt is salt. The only difference in the minds of some consumers is whether it is iodized or not. That being the case, why is the blue salt container sporting a little girl in a yellow dress with an umbrella a staple in most kitchens? Morton Salt—*when it rains it pours®*—is the market leader and sells at a higher price. It has established a value reputation that justifies a higher price in one of the most basic commodity industries.

In fact, I think every business owner should have a container of Morton Salt prominently displayed on his desk as a constant reminder that there's more to sales than price. Granted, that example is a pure commodity, not a service difference like the Sprint example, but it makes the point: Price is seldom the only deciding factor in a purchase.

Still not convinced? Then ask yourself why most people still buy name brands over the lower cost grocery and pharmaceutical generics. Price is not the issue. Quality, consistency, reputation, safety and service all impact the purchasing decision.

The retail side of the electronic world has created a myth that price is the primary issue. Too many retail Web sites assume pricing is the primary motivating force. I disagree. I don't buy on the Internet to save money; I buy for the convenience. If I hear about a new book, and I'm busy at work, I'll order it over the Internet. No muss, no fuss, and it'll be delivered to me the next day—that's convenience and price is not the issue.

On the other hand, if I'm in the mood for a good mystery and have some time on the weekend, I'll go to a bookstore where I can browse to my heart's content. The smells of print take me back to childhood memories of a library. I can feel the texture of the pages and the weight of the book. I can judge whether the print is comfortable for my aging eyesight. Ambience and pleasure are the critical factors in this case, not price.

The lament and excuse of every salesperson: Why didn't they buy? Our price is too high! Why did you lose the deal? The competition beat our price! Why, why, why? Price, price, price! Salespeople point fingers at the competition and the customer, yet continue to structure their presentations on price—not on service, value or relationship.

Ask Yourself

1) *Unexpected actions can bring solid results*

 ☐ Do you think customers have preconceived ideas about what you are going to do? If so, how can you use these preconceptions to your advantage?

 ☐ If someone expected you to "sell" them, how would they react to being given something instead?

 ☐ How can understanding the value in a customer relationship allow you to exploit this difference?

Relationship Aspect Marketing

- [] Could a non-salesperson set a better stage to make an eventual sale?
- [] How—specifically—would this work?
- [] Would an outside service function set the stage?

2) *Depict the extra value your company brings to the table.*

- [] Do you know what your unique differences are? In other words, what is the value that you offer in a relationship?
- [] Have your customers ever explained why they choose to do business with you? If not, can you ask them why?
- [] What do you do that your competition doesn't do?

3) *Price is no longer the issue, it's all about value.*

- [] Can you name the variables (aside from price) that comprise value for your company's product or service?
- [] How does this translate into—or shape—the value you offer in a customer relationship?
- [] Do factors such as quality, performance, guarantee and brand identity impact what your customers are willing to pay? How much? In what way?
- [] What circumstances would negate the price-to-value ratio?

4) *Consumers do expect competitive pricing.*

- [] Assume many of your customers have a good idea how much the goods and services you provide cost. Do you know where they get their information? The Internet? Consumer groups? Your competitors?
- [] Do you know what your competitors charge for comparable products and services?
- [] What percentage price mark-up are customers willing to accept, if you offer them superior service and quality products?

5) *Don't sell price when you can sell value.*

- [] What specifically differentiates you from your competition?

Chapter 24: Battling Over Price On the Internet

☐ Do you offer better product or personalized services?

☐ How frequently is your lowest price customer your highest maintenance customer?

☐ Have you ever attempted an informal test to see what kind of sales pitch draws in your customers?

☐ Do they respond to a price-only sales pitch?

☐ Or do they respond better to slightly higher prices, but with additional services?

☐ Do you pay personal visits to your customers?

☐ Do you ask them what they think of you? Questions you can ask include:

1) What do you expect from us?

2) Are you pleased with, or only satisfied with our products or service?

3) Do we respond to problems to your satisfaction?

4) Is there anything we aren't doing that we should be?

Relationship Aspect Marketing

Chapter 25:

How Effective Is Your Technology?

Merely surrounding good product with quality service at competitive rates is not enough for a company to survive. Today's consumer requires excellent products, superb service in every facet of an operation and competitive low prices. And all that still isn't enough! You must use technology to offer added value in the form of knowledge, information, expertise and instantaneous customer service. But what happens when technology comes up short?

Technology that Promises but Doesn't Deliver

Sound Marketing experienced a major technology snafu with GTE (our local phone company) and AT&T (our long distance carrier).

A contractual change with AT&T created a new account number for our billing, but began double billing us under the old account number—including major penalties for inactivity. Simultaneously, our local provider began billing us for local long distance charges that duplicated the same calls on our AT&T bill.

When I called AT&T, the biggest problem was dealing with their new voice prompts. I felt rather stupid yelling *help!* into the phone as the computer continued to talk away. I finally reached a human voice and this initial customer service agent remained on line with me until the correct supervisor got on the line to resolve the problem. However, the supervi-

sor told me that I also had to contact the local carrier so they could rectify their role in the problem as well.

Frustrated that AT&T couldn't handle the problem in its entirety, I attempted to contact GTE. I was disconnected every time I entered our phone number. The only way I could get through was to call residential accounts and ask to be transferred to commercial accounts.

Once there, I spent nearly an hour working through automated menus and inept customer service representatives. I finally gave up and went to their Web site and e-mailed them. Within a minute, I received a verification of their receipt of my message and a note saying that someone would contact me within a day or two.

Over the next six weeks, I received no response from GTE. And, when I e-mailed follow-up notes about their lack of response, the entire complaint file was turned over to the Web master as a technical problem.

The technology was working, it was the customer service area that was lacking. However, the Web master takes his complaints seriously and I have been deluged with reports on the various technical tests that show the Web site is working fine. In fact, six weeks later, I received a note informing me that they had just checked the dial-up phone number and it was working.

I never resolved the problem with GTE. Luckily, AT&T finally did issue a credit on the duplicitous charges and ironed out the problem with GTE.

Out of curiosity I sent GTE another complaint via its Web site months later, just to see if things had improved in its handling of electronic complaints. I didn't receive a response, but GTE certified receipt and sent a note saying that someone would contact me in a day or two. This didn't make me feel any better, since that was the response to my original problem some months before.

The company that uses technology to enhance caring service develops loyal clients who know that problems, inevitable as they are, can—and should—be handled in an appropriate and expeditious manner.

In my opinion, GTE has two very serious issues:

1) Its automated phone system does not work properly, and following the menu always resulted in disconnection. As the customer, I had to get creative to find a way to reach a human voice that could at least get me into the correct menu system. But once there, I was never able to wind my way through the maze to the right person.

2) Its Web site approach to customer service is totally ineffective. Its mere existence creates expectations of a timely reply. A slow reply, or in this case no reply, crashes all expectations with the bitter taste of disappointment and anger. Remember: Expectations unfulfilled should be read as exit signs by customers.

The Internet Is Speed, But Can It Keep Up?

I've mentioned that speed has become the newest customer entitlement. The world is speeding up. Faxes beat next day air, and e-mail beats them both. We are a society that has learned to eat fast food on the run. Speed is no longer a perceived benefit—it is an intrinsic entitlement.

When it comes to speed, even the Internet can be disappointing—despite easy access, ever more powerful search engines and the world's greatest accumulation of knowledge. And although recent studies show that the Internet has driven productivity, saving time, money and manpower, and has no competition for accessing research, business tools and communications, its results on the consumer side have been a bit spottier. Despite the success of some mail order businesses and, of course, Amazon.com, the retail side of the Internet is quite disappointing. Categorical searching is often effective, but most Web sites provide only general information, which requires you to contact the company.

To enable you to do this, the Web site may include a mailing address (that slows down the process a bit), a phone number (not much better than the Yellow Pages and usually requires dealing with an automated system) or a

link to an e-mail system. Although the e-mail inquiry can be sent speedily enough, the reply time often leaves a lot to be desired.

Business must back up that technology with performance. For a large company, that might mean a service center that is open 24 hours a day, seven days a week. For a smaller company, it simply requires an appointed person to field electronic inquires as they occur.

Sound Marketing's Web site includes e-mail response forms so customers can contact us for additional information. We check for new e-mail about once per hour during the business day. Web-originated requests for information are always handled as a priority. It's not perfect and it's not immediate, but I am continually amazed at the number of thank yous we receive for prompt service response. We consider it a simple courtesy, but the customers and prospects see it as an entitlement or added value.

Some Web sites offer automatic responses that usually say something like, *We have received your communication and will respond within one to two days.* This is totally reprehensible in the electronic world. When people log onto the Internet they expect immediate response, action or information. When I receive that type of response, I immediately pick up the phone and try to make contact the old-fashioned way.

Companies must learn that the Internet should first be focused on meeting the customer need, not on internal procedures that pre-empt customer expectations. Some businesses say customer expectations are too high— and that might be the case. But the reality is that the expectations exist and, therefore, businesses must adapt to them.

Remember: The customer is in the driver's seat. If you're on the Internet, your competition is not merely within your own industry. You are competing with every Internet presence that is doing things the right way.

Ask Yourself

1) *Customers don't resent problems, just the failure to resolve them.*

- ☐ Do you have a process in place to solve customer problems in a timely manner and follow up to make sure the customer is satisfied?

- ☐ Are your employees trained to respond to problems with patience and courtesy?

- ☐ Do you ask your customers what you can do to alleviate the inconvenience a problem has caused?

- ☐ Do your customers continue to purchase your products or services even after a problem has occurred? If not, what can you change to make sure they do?

2) *If you promise something, keep the promise.*

- ☐ Have you ever marketed or advertised skills or products you don't have?

- ☐ Do you have a system in place to obtain such skills or products once you've gotten the customer?

- ☐ Do you have a system in place for monitoring employee follow up with customers?

- ☐ How do you determine how much you can promise a potential customer, without creating unreasonable expectations?

3) *Internet solutions must solve problems, not create them.*

- ☐ Does your business back up expansive Internet promises with equal amounts of customer service?

- ☐ Does your Web site serve your customers' needs as well as sell your product or services?

Relationship Aspect Marketing

Chapter 26: The Continuing Evolution of Technology

In the preceding chapters, I offered several examples of the problems that result when technology promises more than it can deliver and when it develops faster than the average human can adapt. Sometimes the advances happen so fast that they seem to zoom by in a blur, leaving us in a wake of bewilderment. Often, by the time you figure it out, there's something new in its place.

Less than 10 years ago, most of us were just beginning to learn how to use e-mail and wondering what impact it might have on our business. At that time, most business e-mail addresses were of the CompuServe numerical variety or ended in aol.com. Within a year, everyone had to have a Web presence, which basically meant an electronic brochure and changing e-mail servers to use a domain name. Still, it was basic text-only technology.

Today, Web sites incorporate multimedia audio, video and graphics. Databases that literally think and adapt to the consumer are becoming commonplace. XML and Java are replacing HTML as the language of choice, allowing companies to better interact with each other. Interactivity is key because Web sites are becoming productivity centers that drive the inner workings of business as well as serve the consumer. This pace of change is akin to condensing five decades of television advancements into about six months.

The question is whether we can continue to enjoy all these technological advances, using them to our betterment at a speed which we can manage.

We must learn to assess and determine whether the advance is actually worthwhile to our operation. The mere existence of a given technology does not always justify its purpose. The inherent problem is that our expectations seem to keep up with the changes quite nicely, but a slower level of actual performance can quickly result in disillusionment.

Some Technology Still Manages to Wow Me

My growing disillusionment over so-called technological advances gave way to unbridled excitement as I was investigating AT&T's Web hosting services. An AT&T press release had alerted me to a technology that could add the element of a live, interactive human voice to a Web site. I started at att.com, and I proceeded through the Web site to its information on Easy World Wide Web—AT&T's Web hosting service. At the bottom of the page, I found a button that said, *Click here to talk to a service representative*. I did, and a new page came up asking for my telephone number. It also verified that the telephone line was available while I remained online. I clicked on *Call me*.

Within a split second my phone rang. I glanced at the screen, which told me to stay online. I picked up the phone to hear a computer voice asking me to hold for a moment to speak to an AT&T service representative. Less than 10 seconds later, a live person was on the line.

In utter amazement, I blurted out, "This is fantastic, I can't believe that this type of immediate response is really happening." The service rep chuckled and said, "You ain't seen nothing yet. Let me give you a demonstration of how AT&T's Interactive Answers Service works." I was taken through an exercise in which the rep pretended to be a cruise line and I was the prospective customer.

While he spoke to me over the phone, the rep took control of my computer screen. My screen jumped to a page on the cruise line facilities, and the rep asked if I would like information on the available cabins. I said *yes* and my screen flipped to three different cabins. "Which style interests you?" asked the phone voice and the screen flipped to detailed informa-

tion on the cabin I had indicated. The AT&T rep went on to explain that this interactive service is available to those companies who have AT&T host their Web sites.

This is what the Internet is all about—immediacy. But AT&T had made the service even more valuable by integrating the telephone connection to someone who can answer specific questions and take the order. Since my discovery, I've learned that there are a number of companies offering this type of interactive technology. (There's only one problem: This experience has raised my expectations and retail Web sites without this technology already seem antiquated.)

AT&T's public relations liaison identified a few of the first companies to use this tool: Mercedes-Benz of North America, Inc., Outrigger Hotels & Resorts and GEICO Direct Insurance. I decided to visit these companies' Web sites to see how their technology worked.

Accessing www.GEICO.com, I found an icon for a "free rate quote," which opened the door for their interactivity feature. Just like AT&T's demo, my phone rang within a second of entering my phone number and within 10 seconds I was talking with a licensed agent in their San Diego center. The agent told me that after I filled out the data capture forms, he would have a rate quote within five minutes and actually set me up with a policy within 10 minutes.

This agent is part of a team that handles Internet inquires, sponsors marketing (alliances) and fields questions from their significant base of clients in the military. Inquiries come in via the phone, as well as from GEICO's Web site.

Jess Reed, GEICO Direct's assistant vice president for Telecommunications, says that the Internet has significantly widened the range and reach of the people reached by his company's marketing efforts. Reed also says that GEICO is looking at ways to speed the process further by imbedding all necessary rating information into the Web-based system. "Our aim is to cut down the time for rate quotes from five minutes to 30 seconds," he says.

Relationship Aspect Marketing

Although vocal interaction via a Web site may be the ideal, it isn't perfect for everyone. Smaller companies may not be able to dedicate an employee to manning the phones, or afford to outsource it to a telemarketing firm. The next best method is live, online, real-time chatting.

Talk to Your Customers on the Internet

There are a number of programs on the market that offer low-cost way of chatting with visitors to your Web site. HumanClick is a perfect example of one of these programs. The program enables you to have real-time e-mail conversations, similar to visiting a chat room on the Internet (for more information go to www.humanclick.com.).

When logging on to the company Web site, you're invited to watch a short video presentation. It takes only a few minutes to download this 400K video, which is surprisingly self-explanatory. The program notifies you when a visitor hits your site and even sources it for you; for instance, the program tells you if the visitor found you from a search on Yahoo! The HumanClick icon lets visitors ask you questions, which you can answer in real time. It's similar to greeting someone who walks through the door of your business.

HumanClick acknowledges that you can't be present at all times to monitor live activity. So, you can switch the program to off-line. When you do this, the icon indicates that the visitor may leave a message, as opposed to speaking immediately with an employee. Later, you can activate the icon on their screen to invite the visitor to a conversation.

These technology advances in interactivity are prime examples of integrating customer focus into the electronic world. They allow you to handle specific issues one-on-one, providing a customized aspect to what would otherwise be generic mass-merchandising.

Other developments in multimedia are also proving to be valuable. Just a short time ago, the incorporation of video into a Web site was a costly venture. A company had to hire a production company to produce a video,

digitally format and compress it for the Internet, then mount a large file onto the Web site—with expenditures potentially hitting six figures.

Today, new versions of PowerPoint can be saved as Quicktime movies that can easily be incorporated into your Web site to provide more excitement in the distribution of information. Likewise, the MP3 compression technology for audio has enabled many more sites to offer visitors the ability to download audio files to play at a convenient time and personalize the information with a human voice.

Whichever type of interactivity or multimedia enhancement you choose, any effort you make to provide a personal touch, coupled with immediacy, will lift your Web site miles above the competition. It also positions you as a company that truly understands the expectations of its electronic customer.

Ask Yourself

1) *The human element personalizes electronic experiences.*

 ☐ Do you make your Web site so easy to use that even Internet novices are comfortable using it?

 ☐ Do you train your employees to use the technology your business relies on so that they can help customers with questions?

 ☐ Are you using technology to augment personal relationships with your customers? How are you accomplishing this?

 ☐ Do you spend time each week researching new ways to personalize your Web site and other technological performance?

2) *Internet users demand immediacy or they move on.*

 ☐ Can customers get to your site from the major Web browsers, without knowing your company's site address?

 ☐ How long does it take your Web site's home page to load?

 ☐ Does it load quickly enough?

 ☐ Have you asked customers what their experience has been?

Relationship Aspect Marketing

3) *When you save a customer time, you earn the right to serve them.*

☐ Does your business's technology measure up to your competition's?

☐ Have you lost customers because your technology wasn't as advanced?

☐ If so, is there anything you can do to stop this from happening?

Chapter 27:
Technology Predicts
Customer Behavior

Nearly 300 years ago, Reverend Thomas Bayes developed a theorem of probability. His Bayesian Formula utilized *all known data* to arrive at the best possible answer. However, most modern predictive technology is designed to assess a *specific number of variables* and arrive at the right answer—much like the human mind. For example, upon meeting someone, we very quickly assess about eight factors to determine the likelihood of developing a relationship with that person. Such factors include clothes, speech pattern, hairstyle, cleanliness and overall appearance. Based on this input, we make a quick decision as to whether we want to proceed.

Sometimes we're right, sometimes we're wrong.

Now imagine you could immediately access over 500 factors and compare those to a historical model of a successful relationship. Then, armed with this probability analysis, you could add your own judgment and arrive at a decision regarding the viability of pursuing the relationship.

Unfortunately, the human mind is not capable of such complex extrapolations. If it were, most divorce lawyers would be looking for work. Life would be much simpler as our personal and business judgments would be exponentially enhanced. As humans, this sort of analysis may be beyond our capabilities. Although, I have met one man who has the technology that can achieve all this and more.

Nigel Cooper of Bayes Corp., and his partner Jim Sewell, have combined the Bayesian Formula with information technology to create predictive engines that forecast probability for the insurance, financial, health care and marketing industries.

Although simple in concept, this is no ordinary predictive program. It all but thinks for itself. For example: An insurance company is trying to determine the potential of selling long-term disability insurance to a list of people in a given zip code and a key piece of information, such as age, is not available for input. Using a generic predictive program, the results would be unusable—if it would even give you a result.

The Bayes technology, however, is based on all available data. When a component such as age is missing, the program literally draws an inference based on other available information such as number of children, homeownership, etc. Furthermore, this predictive model can be continually changed based on new information. It deals with all known information, and then suggests the best possible answer under known parameters.

The potential is phenomenal. Telemarketers in sales centers could begin each day with a list of potential prospects newly prioritized according to the likelihood that they will make a purchase. According to Cooper, companies can dramatically increase sales productivity by 25 percent or more. The technology is already proving useful with clients in the insurance, financial and retail industries.

Applying This Model to Insurance

As a marketing specialist, I was intrigued to learn that 10 years ago Jim Sewell was one of the key people involved in the development of USAA Insurance's legendary target marketing models—which are still in use today and frequently emulated by others. USAA is a leader in cross marketing multiple products and services to its customers, and it has one of the highest customer retention rates in the industry.

Chapter 27: Technology Predicts Customer Behavior

One of the insurance industry's biggest disappointments of late is its inability to develop an effective model for purchasing insurance over the Internet. I'm not talking about purchasing complex commercial insurance or estate planning. I'm referring to personal auto and homeowner coverages. One of the greatest stumbling blocks is not the technological aspect of the Web sites, but actually underwriting the coverage.

According to Rick Morgan, publisher of the insurance industry newsletter on technology, *The Automated Agency Report*, "Until companies change their perspective on underwriting, insurance cannot be effectively sold on the Internet."

The problem: Underwriters jealously protect their turf as a science and an art that requires intuitive human analysis. I agree with them to a certain degree—but the process is too slow and arduous for the speed of the electronic consumer. The challenge is how to combine these aspects effectively.

Now imagine that someone fills out an online insurance application. Using the Bayes technology, within seconds the application is compared to the company's entire database of information in relation to the underwriting benchmarks of historically profitable policies and unacceptable risks. Seconds later, the underwriter's screen flashes with the application and the predictive analysis showing the probability of underwriting risk.

The program has not replaced the underwriter, but has provided critical data to support a decision. Underwriters, rather than feeling threatened by technology circumventing their "intuitive analysis of risks," would welcome this as a predictive tool based on their own underwriting benchmarks. Armed with this tool, the productivity and efficiency of underwriting can be dramatically improved to the point where decisions can be made fast enough to meet the needs of electronic consumers.

Underwriters can customize benchmark models to the individual underwriter. For instance, the program can be instructed to draw inferences only from prior underwriting decisions by a particular underwriter, or a particular division or a particular company. It has the potential to be an

invaluable resource tool, which would bring underwriting into the 21st Century without sacrificing the personal touch.

As for claims, increases in efficiency and productivity result in savings and expense control. Bayes Corp. has already installed programs to help major insurance companies identify potentially fraudulent claims, eliminate erroneous or duplicate claims payments, identify long-term disability claims likely to fall under Social Security and highlight policy/product upgrade opportunities.

Again, the program is not designed to replace the claims examiner, but to provide decision support. For instance, let's say the average examiner is handed a daily stack of 100 claims and out of that stack, the examiner selects 50 to audit. Imagine if those 100 were benchmarked against all known claims data and prioritized as potential candidates for subrogation or fraud. The examiner could simply audit the 50 most likely to produce financial benefit to the company, based on all known information. Now that's efficiency with results.

The predictive opportunities of this and other such programs are limitless and can be used to:

1) Position product marketing by the propensity of the prospect to purchase;

2) Telemarket based on purchase probabilities;

3) Cross-sell to existing customers;

4) Generate leads to support sales;

5) Prioritize customers for future value;

6) Identify customers needing product packages; and

7) Identify market niches according to purchasing behavior.

Predictive software may not apply—directly—to every business. But the news of computer systems and human analysis that these programs offer the insurance industry *is* something that customer service in other fields

can follow. As technology makes high-end information processing relatively cheap, more companies will be able to use these programs to identify and categorize customers within seconds of their call) or e-mail.

Ask Yourself

1) *Automation can enhance consumer knowledge profiles.*

 ☐ Do you use the Internet to capture information about your customers? What do you do with it?

 ☐ Does the information you glean sit on someone's desk or do you really put it to work?

 ☐ Does your database automation include a customer relationship management (CRM) program? Do you use it?

 ☐ Do the right people know how to use the program effectively?

 ☐ Do you have a database that can be accessed by all software programs used to make contact with your customers?

2) *Information is a valuable commodity in increasing sales.*

 ☐ What are the important factors to know about a customer?

 ☐ Do you target your advertising and sales efforts to existing customers based upon their known lifestyle needs? If not, why not?

 ☐ Would you buy software that could predict what your customer might buy ?

3) *Speed and adaptability are crucial in meeting expectations.*

 ☐ Are you able to adapt as quickly as you customers' needs change?

 ☐ Is it an easy transition or does the process take its toll on you and your employees?

 ☐ Does your automation mandate all information fit pre-existing parameters or can it adapt to exceptions?

 ☐ Are you meeting your customers' expectations consistently?

Relationship Aspect Marketing

CHAPTER 28:
KEEPING UP WITH KEEPING UP

Consumers have created an electronic stampede for change in the way business is done. The question we need to ask is whether we're caught up in the dust or running with the herd. The reality is that the models for e-commerce are changing so fast that most of us are choking on the dust.

Whether an industry adapts to a threat, or lifelong competitors join forces in purchasing alliances to reduce costs and increase efficiencies, the Internet changes the way business functions.

But the real challenge is trying to keep up with the changes.

While some of us are just becoming comfortable with standard e-mail, the medium is already mutating into e-mail with voice files and animated graphics. Most business people focus on keeping up with trends and technology within their own industry. They have a hard time keeping up with electronic industry as well. This inability can become frustrating and detrimental to a company's ability to stay in the loop.

The simple fact is that businesses must know what others are doing within the electronic medium. Your clients are aware, if only vaguely, what other companies are offering—and they are setting expectations based upon that awareness. The whole world is your competition. Manufacturers' Web sites are being compared to Amazon.com. And this sort of competition is not likely to end.

The following are a few suggestions for keeping up with technology that also take into consideration constraints on your time:

Relationship Aspect Marketing

1) Since magazines tend to pile up and collect dust, subscribe to the online synopsis of several key information sources, including: www.internetweek.com/newsletter, www.informationweek.com, www.interactiveweek.com, etc. Each site offers the latest news and trends within the electronic world. Learn what others are doing on the Internet or in automation and how that can apply to your business. Retailers, bankers and insurance professionals can also find some excellent daily newsletter resources from kpmg.com.

2) Spend at least one hour every week surfing the Internet (outside of your industry) to see what others are doing online and to observe new features on their Web sites.

3) Learn more about how sound and visuals are impacting the Internet. For instance, have you checked out the monthly MP3 files at mp3.com? Aside from the music, this compression technology allows any industry to easily and economically add voice segments to its Web sites.

 Also visit www.evoke.com to learn about voice e-mail and Internet conferencing capabilities; and www.humanclick.com, which lets your visitors initiate a live chat with you or allows you to invite them to a chat.

4) Spend at least one hour every week checking out Web sites within your industry. You can't compete with your peers, unless you have actually seen what they are doing. Your competitors compete for your customers, so it is crucial that you know what they are offering.

5) Attend conferences that focus on electronic issues and industry automation. Such events can help you assess where your industry is heading and how you can take advantage of the opportunities. If no such conference exists within your industry, look outside your industry for potential resources.

I've often said that your true competitors are not those within your own industry. Your true competitors are in the other industries, which are cre-

ating higher and higher levels of expectation among consumers. They are the ones who are raising the bar you must jump over to keep your clients happy. By increasing your level of awareness in the electronic arena, your company can position itself as creative and innovative and one that is able to think outside of the box.

Ask Yourself

1) *Blinders prevent you from seeing beyond your industry.*

 □ Are customer expectations strictly based on your industry or the world at large?

 □ How do you keep up to date with advances within your industry?

 □ Do you take advantage of seminars and meetings run by associations and trade groups?

 □ Do you ask questions—and listen to the answers—when you meet people within and outside your industry?

 □ Do you spend time each day on the Internet, researching how others in your industry are utilizing technology?

2) *Educate yourself on technological advances.*

 □ Is programming your VCR about as sophisticated as you get in your use of technology?

 □ Do you know why you bought the technology you have?

 □ Do you use technology efficiently?

 □ Do you understand technology's full potential?

 □ Do you reward employees who take extra time to learn how to utilize new technology?

3) *Web surfing is crucial to your survival.*

 □ Do your children know more about the Internet than you do?

 □ Do you know what your competitors' Web presence is?

Relationship Aspect Marketing

☐ When was the last time you visited the Web sites of your clients and your competitors?

CHAPTER 29:
USE THE TECHNOLOGY
YOU ALREADY HAVE

Technology is truly awesome. Every day we're bombarded with new, better, faster and upgraded equipment—computers, software, Web-enabled telephones and other wireless gadgets—to make our lives and our businesses more productive. We can't wait to get our hands on the next new toy. Yet how many of us actually use the technology we currently have to the full extent of its capabilities? I don't.

The editing of this book is a perfect example. Although I wrote *Relationship Aspect Marketing* on computer and electronically transmitted it to Silver Lake Publishing, I envisioned that the editing process would proceed as in the past.

In the past, the publisher print and bound a draft manuscript which goes to the editor. The editor, in turn, "marks up" the text on paper with pen or pencil and adds little post-it notes to mark areas that need additional work. The draft with the editor's notes is then express mailed to me. A few days later, manuscript in hand, I go back to the computer, enter the changes and send the revised manuscript back to the editor and publisher via e-mail.

This cycle is normally repeated two or three times before a final draft goes to print. The computer makes the task easier than the old typewriter or pen, but it is still fairly arduous and time-consuming. That is, until I discovered an editing program.

Valuable Tools at Your Fingertips

Thanks to my editor, the process was significantly more efficient through the use of Microsoft's Word editing program. Starting with the original electronic manuscript, my editor entered her changes using the program's tracking function.

Upon my receipt of the edited chapter—sent via e-mail—I opened the document to find all of her comments and corrections entered in red in the text. If I agreed with her changes, I highlighted them and clicked on *accept changes*. The text immediately transformed itself to the new version. If I needed to provide additional writing or add comments, my track would appear in blue. I then returned the document to my editor, and she accepted my changes or edited them further. The technology proved itself to be extremely efficient, cutting days off the editing process. Although this was not a new program, it was a tool that had been sitting unused within my computer. I never even realized it was there, much less understood the efficiency it offered. How many other such tools exist within the nooks and crannies of the software programs currently installed in my computer?

After working on the book, I mentioned this editing function to an attorney friend who is with a major corporation and his eyes lit up with excitement. Although he considers himself somewhat of a computer aficionado, he did not know that this editing function existed either, despite the fact that his company uses the same Microsoft Word software. Armed with this new information, he returned to the office.

I hear he is already saving his company serious money. Apparently, as many as six attorneys review a legal document before it is approved. This major company also edited the old-fashioned way: handwritten notations were given to a legal secretary who revised the document prior to each review. Using the editing function, the company has substantially reduced the number of hours dedicated to preparation of documents.

This is not a lone example of the underutilization of technology due to simple ignorance, either. I was asked by a client/friend to help prepare a PowerPoint presentation for a retirement party. (PowerPoint is the computer-generated slide show advancement that replaced the old overhead

transparencies.) He wanted the presentation to be a multimedia event with over a hundred photographs, background music and imbedded narration. Rather than using a remote control or the keyboard to advance individual slides, he wanted the program to run automatically so that each slide advanced according to preset timing. Everything went well until we got to the final assembly process. The program failed to play, despite meticulously following the directions in the operations manual.

I called Microsoft and began working through the difficulties with a very helpful PowerPoint technician. He explained that we were pushing the program's capabilities and directed me to the necessary solutions. "This stuff isn't in the manual," I blurted out to him. He chuckled, agreed and explained that you only learn how to push a technology's potential by trial and error.

His solutions worked, but not to my total satisfaction. The size of the presentation taxed the memory and performance limits of the laptop we were using. Although the visuals ran fine, the background sound occasionally skipped like a scratch on an old record. Remembering the technician's comment about trial and error, I tried something different the next day.

I removed the background sound from the presentation and recorded it onto a separate audio CD. I then embedded an instruction on the first page of the presentation to play the audio CD, which was in the CD drive of the laptop. It worked perfectly. The hard drive wasn't trying to play the presentation with a huge audio file attached; it merely played the visual program leaving the sound to the CD player.

I passed on my solution to the Microsoft technician who was appreciative and surprised that he hadn't thought of it. We all learn together: Sometimes we're students, sometimes we're teachers.

Train Your Employees to Use Technology

So, what does this mean to business and what sort of lessons can be applied? Allocate money for training and education in technology. Send

staff members to any of the thousands of hands-on training seminars conducted by software and computer manufacturers. Encourage employees to listen to the experts and trade experiences with other attendees.

If you're reticent to send employees off-site, consider inviting experts to the office to advise your employees and expand their technology know-how. You may be surprised at how in-house training can expand the capabilities of your company and your current technology. You may even be able to shelve the plans you have to upgrade computer and other electronic systems.

When Sound Marketing made the switch from analog production (tape) to digital (no tape), we were overwhelmed. Mastering the art of digital editing appeared to be an impossible task. It finally reached a point where I questioned the investment into digital technology, especially when we were so proficient in the old ways with tape, wax pencils and razor blades. There just wasn't enough time available to learn the new methods without drastically hurting our production output and disrupting our cash flow. A friend in the music business suggested that we bring in a tutor. As he explained, "Even though it may be new technology to you, we've been using it for quite a while in music. Why not get a really good digital music editor to help you?"

We took his advice and hired a man who had produced numerous hit albums to spend a day at our office. Our new consultant asked some questions about our business and then sat down and began working with one of our projects as we watched. Although we were beginning to appreciate how the technology worked, it still seemed that it took him longer to accomplish things digitally than we could achieve with tape.

I was considering this problem when, I suddenly realized that he approached it as an artist rather than a factory technician. Stopping him, I explained that we didn't need artistic perfection, but reasonable efficiency with acceptable standards of quality. With that understanding, he went on to spend the day helping us to understand the workings of the software and showed us numerous shortcuts that we utilize today. His price for the day seemed hefty at the time, but in hindsight it was the bargain of a life-

time. We haven't put razor blade to tape for over four years now and our production capabilities have increased tenfold—without the need to upgrade further.

Is Technology Limiting You?

Technology is a wonderful thing—and I don't know where I would be without it. However, I feel I must share a few words of caution about technology: Sometimes the corporate world inadvertently builds roadblocks into software that hinders the full use of its own technology.

When I was working on the retirement presentation, my client's company laptop served as the perfect example of policy hindering technology. After testing the PowerPoint program on my laptop, we loaded it onto the client's laptop. When we began running it, the program stopped after about five minutes. Since the program was on automatic play, the computer didn't sense any keyboard activity and put the laptop to sleep. I explained the problem to the client and told him to turn off the sleep function. He couldn't. It turns out that the corporation's software system that was loaded into every employee's laptop actually disabled the ability to turn off the sleep function. (Somebody had probably figured that the energy conservation aspect of putting idle computers to sleep would save money.)

That corporate programming decision rendered all of its laptops incapable of running automatic presentations unless someone stood by and periodically touched the mouse pad to prevent the computer from entering the sleep mode. There was absolutely no way to fix this on the spot. The only way to correct it was for the corporation to reprogram its system to provide the laptops with a sleep off function.

Does your company's software contain similar glitches? The unfortunate aspect is that in business we sometimes, knowingly or unknowingly, implement policies or procedures that actually prevent us from effectively using what we have.

So, as we drool over the future potential of new technology, let's not miss the potential of existing technology. Consider the following:

1) Encourage employees to attend hands-on workshops that can increase their knowledge of the various tools within existing programs.

2) Allow employees to experiment with the capabilities of the programs loaded on their computers.

3) Reward employees who find and share new ways to use the tools of technology.

4) Don't assume that the Operations Manual covers all of a software program's capabilities.

5) Bring in the experts. Utilize the training resources available from manufacturers, but don't stop there. Consider hiring an expert in a particular program to come in for a show-and-tell session with your employees.

Above all, don't fall into the trap that newer is always better. Don't upgrade until you're sure that you're using what you already have to its fullest extent.

Ask Yourself

1) *Most technology is significantly underutilized.*

 ☐ Are you familiar with everything your computer enables you to do?

 ☐ Do you know your software programs in their entirety? What else can they help you do to be more efficient?

2) *Shared experience is a priceless asset.*

 ☐ Are you willing to accept computer suggestions from outside sources?

 ☐ When you are overwhelmed with work, do you withdraw to your computer and sequester yourself from employees and colleagues?

□ Or, do you feel refreshed and motivated after interaction with colleagues and peers in your industry?

3) *Experimentation may look like a waste of time, but it can lead to productivity and efficiency.*

□ Do you spend at least a couple of hours a week simply playing with your computer, Internet or other electronic devices in hopes of better harnessing their capabilities?

□ Do your employees get out of the office to attend meetings and seminars so they can exchange information with others in the business community?

Relationship Aspect Marketing

Section Three: Employees Are Your Front Line To Your Customer

Next to using technology as a replacement for human interaction with the customer, the biggest mistake a company can make is to assume that business relationships only involve the sales and service functions—those which are directed obviously to the external customer.

Relationship aspect marketing thrives when it's integral to the totality of a company or institution.

The greatest relationship in the world between a sales person and a client can be damaged by a ruined delivery caused by a careless shipping department. A wonderful vendor relationship can be destroyed by an accounts payable clerk who delays paying an invoice and ducks phone calls. A current or potential business relationship can be irreparably harmed by an offhand comment made by a receptionist and overheard by a client. Relationship aspect marketing is a team effort that involves *everyone* in your business.

Relationships of any kind are two way streets. Treat one another with love and the relationship flourishes. Don't and the relationship withers and dies.

Business relationships usually reflect the eternal triangle composed of management, employees and customers. As the management treats the employees, so do the employees treat the customers.

Imagine a gruff manager who starts each day by belittling employees. Will those employees turn around and treat the customers with care and re-

spect? Probably not. A disgruntled employee will create disgruntled customers. Attitude flows outward from the center of any organization—as a manager, you have to make sure that attitude is good.

Cultivate Loyalty in Your Employees

The old command-and-control style of management has died, so it is time to bury it and move on. Today's employees, like today's consumers, are better educated and better informed than ever. They are not their parents, nor are they their grandparents. They generally do not plan on making a career with a single company and are less likely to overlook the small frustrations of a workplace.

While they are working for you, they want to feel that they are a valued member of the team, that their efforts are appreciated and that they are empowered to think for themselves. They will question direction until it is understood, often suggesting a better way to undertake a project. They will not blindly follow a leader who has not earned their respect.

Sounds a bit like your customers, doesn't it?

A company cannot pride itself on having strong relationships without focusing on its internal customers—the employees. Think of the matter this way: The employees are customers of *management*; the people who buy a company's products and services are customers of *the employees*.

Management's job description should be to nurture employees and support the development of strong relationships with external customers. The employees should feel cared for and supported—and turn their focus on the external customers.

This may sound a little flaky to some; but the alternative is worse. I once heard a business owner say that he wouldn't spend money to educate his employees just so the competition could steal them away. I could tell that he thought he was coming across as a hard-nosed, savvy pragmatist. He wasn't. One of the other people in the room asked if he was any better off with employees that no one else would *want* to steal. The business owner

was exposed as more woolly-headed than hard-nosed. There wasn't much more he could do than hang his head and shrug his shoulders.

The challenge for business is to provide such a stimulating and challenging environment that employees are loathe to leave.

When it comes to its people, a business must plan for the future but live in the moment. (Again, this is good advice for *any* relationship.) Employee turnover is always a reality of business; and companies should have plans that provide for it. However, a company cannot encourage solid relationships with employees on the assumption that they will leave tomorrow. It has to assume that a good work environment will attract good employees and make them want to stay.

Now, *a good work environment* doesn't have to mean foosball tables and beer bashes...and the other trappings of the dot.com fantasy. It involves things more basic and broad. Some critical components include:

1) Properly matching employees to job assignments;

2) Providing suitable training for the job being undertaken;

3) Offering potential for advancement;

4) Providing ongoing education and technical development;

5) Showing appreciation for performance;

6) Monitoring to identify and correct performance weaknesses;

7) Sharing the spotlight with the employees; and

8) Offering fair pay and useful benefits.

Consider these components carefully. Most managers respond quickly that they offer these things. But take some time to think about these issues—especially the ones near the top of the list. (And notice that money and benefits are at the bottom.) Making sure employees are matched to the right kind of job and given the support they need for their own professional development are hard-won accomplishments.

Relationship Aspect Marketing

You can also think about these issues in a more personal way. If you want your employees to develop relationships with your clients, it might be time to take an inventory of your relationships with your employees. Since knowledge of each other is key, ask yourself these questions:

- How well do you know your employees?
- Can you recall the names of their spouses and children? Do you know any of their interests outside of work?
- What are their birthday and anniversary dates?
- Are they experiencing any personal problems?
- How frequently do you take time to just chat with them about things other than business?

If you are one of the rare few that knew the answers to all those questions, turn the tables on yourself—because relationships are two-way streets.

- How well do your employees know you? Do you ever share personal triumphs and tragedies with them?
- Do they know the names of your spouse and children?
- Have you ever received a birthday card from any of them?

Relationships are built on sharing. Your job as a manager is to create an atmosphere in which they can share with you and you can share with them. Granted it is a fine line and I don't advise going out for drinks with them every night because you still have to perform your role as a boss. But by getting to know each other, you have made the foundation of your relationship a little more solid.

The bottom line is that management must create a relationship bond with the employees and empower them to properly serve the customers. Instilling this philosophy in all employees is an absolute must.

But actions speak louder than words. Management must back up the words by supplying the proper tools, support and empowerment neces-

sary for employees to then build comparable relationships with the customers.

You cannot tell a customer service representative that her primary purpose is to serve the customer, if her job performance is evaluated by how well she processes the paperwork. Her primary focus will soon become the processing of the paperwork and the customer will become an unwanted intrusion.

Satisfied employees, armed with the proper tools and support, will result in satisfied customers. As a team member, each employee will take a gentle pride in how well she can be of service to the consumer. Her focus will be as single-mindedly centered on the customer's happiness, as management's focus is centered upon hers.

Relationship Aspect Marketing

CHAPTER 30:
ONE EMPLOYEE CAN SAVE MANY PROBLEMS

This story begins on a bright and sunny Southern California day. I had called my dentist to advise him that I would be stopping by to have a crown re-cemented. However, I found that my dentist had moved without notifying me. I had to fill out new patient forms because the office could not find my file with x-rays and five years of treatment records. Finally, I was seen by one of the dentist's associates, who wanted me to make an appointment for a new patient work-up and x-rays before he discussed the problem tooth.

I left the office and called DentalNet (the dental division of BlueCross) for reassignment to another dental provider. However, the dentist was reluctant to see me. The dentist thought I wanted a new crown, which would not be covered by insurance since the original crown was less than five years old. After several more calls to DentalNet, the provider was convinced to see me. They re-cemented the crown and were so friendly during the appointment, I felt that I had found a new dentist and I wrote to compliment them. Boy was I wrong!

About 10 days later, the crown came off again. The dentist had expressed concern that it might not hold and I was aware that any further expense would probably come out of my pocket. Resigned, I stopped by the dental office to make an appointment to get it fixed.

This time the receptionist gave me about 10 percent of her attention, forcing me to repeat my name and the problem several times. She then turned

to another woman and asked her to work up a treatment plan so she could set an appointment. "No," was the reply. "I'll do it later and call him back." The woman then glanced at my file and said, "Oh wait a minute, this is that crown that isn't five years old, we don't want to get involved. Tell him to call DentalNet."

As they were already involved because they had touched the tooth 10 days earlier, I asked to see the doctor and was told that wasn't possible. I then asked for them to have the doctor call me and was told, "The doctor will *not* call you."

Enraged, I left and called DentalNet. Halfway through the problem with the service rep, I was disconnected. Calling back, I went through it all again with another service rep and was placed on hold for 15 minutes while she called the doctor's office. It was recommended that I choose another provider from a list of providers within my area. I asked for the name of the supervisor of claims service, and I was told that they couldn't give me that name. When I asked who could give me the name, I was told that her supervisor could but that she wasn't there. She then connected me to the supervisor's voice-mail and I requested that the supervisor call me in the morning.

Two days passed with no word from DentalNet. I wrote to DentalNet and the appropriate regulatory agencies involving dentists. I also faxed a request for a dentist to every dental provider in my area. I received no reply.

Everyone Needs a Hero

I was angry, frustrated and concerned about how I was going to get my tooth fixed. Then I received a call from Elizabeth Acevedo at DentalNet. She explained that she had received a call from a dentist asking about my records. When she pulled up my file on the computer, she saw the complaint and that DentalNet had faxed a provider list to me—but she saw no resolution. She explained that she was curious as to whether one of their

insureds was out there with a missing tooth and possibly in pain—so she was calling to follow up.

She reminded me that this wasn't her case, but asked me for details about what had happened. She was appalled at the situation and said, "Mr. Burke this never should have happened. It's late, but I work until 6:30 p.m. I'd like to take this up to our dental review board and perhaps check with the dentists involved. Could I call you back in an hour?"

An hour later, Elizabeth was back on the phone. She did not have a resolution for me, but she acknowledged that the dentists were cooperating with her and she needed a bit more time with the dental review board. She asked if I could give her until the morning to try to work something out. I was so elated, I told her that I was leaving everything in her more than capable hands.

The next morning Elizabeth called twice while I was recording an interview and my wife fielded the calls. As it turned out, Elizabeth had gotten me a direct referral from BlueCross to an endodontist, had actually scheduled the appointment for me and arranged to have a prescription called in for an antibiotic in case there was any infection in the tooth.

I called Elizabeth that day to thank her and she told me that she would call back on Friday to make sure everything went well with the procedure and to help me find a new provider. Because of Elizabeth's efforts I will remain a loyal BlueCross insured.

So, why is Elizabeth a perfect example of Relationship Aspect Marketing? The answer is simple. Her competency is augmented by a caring attitude towards people. Elizabeth is willing to risk investigation into areas that might not be of immediate concern, but that reflect on the overall reputation of her company. She involves the client and lives up to her word on follow-up contact. She does what she can to create a resolution. She never says she can't do something, she always says she'll try. She keeps the client updated on the status of her efforts.

Ask Yourself

1) *Empowered employees must be developed and nurtured.*

 ☐ Are you developing and empowering heroes among your staff?

 ☐ How can you empower frontline customer service staff to make decisions and take initiative to satisfy customer needs?

 ☐ Is this a written policy or a software function?

 ☐ Do you view employee mistakes—within a responsible limit—as educational opportunities?

2) *Rules must occasionally be broken.*

 ☐ How rigidly do you apply specific rules to your customer service staff? Is an unbroken rule better than an unhappy customer?

 ☐ Are your procedures ironclad rules or operational guidelines?

 ☐ Can you replace rigid rules with guidelines—without creating havoc in your customer service function?

3) *Care for the client must precede operational guidelines.*

 ☐ In the greater scheme of things, is a customer more important than a guideline?

 ☐ How much is a customer worth?

 ☐ How much would you budget to acquire that customer?

 ☐ How much would a guideline save?

 ☐ Is there a middle ground in your procedures that might allow for exceptions?

 ☐ How can you quantify when an exception applies?

 ☐ Would you fire an employee who made a mistake but retained a loyal client?

Chapter 31:
We're More Alike Than We Think

Even the best relationships—whether forged on personal time or at the office, face-to-face or in cyberspace—encounter rough patches. Just look at our sordid worldwide state of affairs. Getting along is tougher than it appears.

A friend who works at a local hospital shared an instructive story about the interaction between a new employee and a longtime employee. From day one, it was obvious that the two did not like one another. As a result of this initial dislike, each began to seek a basis for her feelings. They picked incessantly at each other's smallest peculiarities. In essence, they first pronounced each other guilty without cause and then proceeded to build their individual cases. For absolutely no reason, each employee expended a tremendous amount of mental energy on this relationship battlefield.

One day, by an unusual set of circumstances, the two were forced to work together and they realized that they were both on their first marriage, and their respective husbands had been married before. As the day wore on, this led them to confide in each other about dealing with their husband's ex-spouses. By the end of the day, they both decided that their husbands had shown remarkably bad judgment in their first marriages, but were extremely lucky in their second marriages.

There is no fairy tale ending here. These women did not become lifelong pals. However, after sharing some confidences and discovering some com-

mon aspects to their lives, they now appreciate each other, get along and, most important, work better together.

Encourage Good Working Relationships

This anecdote illustrates a simple fact: Preconceived prejudices, whatever the basis, prevent us from working together harmoniously. The more we get to know each other, the greater the chances of working together—productively.

It's a two-way street. This doesn't mean that you need to become bosom buddies with everyone in the workplace, nor is it necessary for your co-workers to become your primary social life outside of work. After all, there might be some truth in the old saying that "familiarity breeds contempt." However, when we seek out points of similarity, life becomes a little easier. Grudges and resentment take a lot more energy than fellowship.

This applies to the relationship between a business and its customers, too. Many businesses concentrate on gathering information about their customers—*the more we know about them, the better we'll do*, we tell ourselves. That's only half true. The other side of the equation is letting your customers get to know you. And the best way to let your customers get to know you is by letting them get to know your employees. The more opportunity to discern commonality, the greater the potential bond and the more likely customers remain customers.

Sounds simple, but it isn't as simple as it appears. Business owners and managers tend to portray their businesses as perfect. If that is the only image a client receives, it could spell trouble on a couple of fronts. First, how many of us really enjoy spending time with a "perfect" friend? Second, perfection can raise unbelievably high levels of expectation.

An example: About 20 years ago, at a time when I believed that image was everything, my friend Doug and I were returning from dinner when he confided that he had some concerns about our friendship. He perceived

my life to be perfect and that made him feel inferior. I was stunned. Yet, in hindsight, I understand what he was saying. I never shared any of my difficulties or problems with him—merely the good news. I was a bit of a braggart and I always made sure the outside looked good. I valued the friendship, so I tried to give him a more balanced view of things.

Most of us do not bond with others as a result of our successes; we bond as a result of our human frailties. When you bond with your customers, they are aware and accepting of your shortcomings. Their expectations are more reasonable because they know that you aren't perfect, you can make mistakes—just like them! They also know you will take the extra steps to make things right when you do make mistakes.

Ask Yourself

1) *Let your customers get to know you, as you get to know them.*

 ☐ Do your customers know you? (People like to do business with people that they know.)

 ☐ Is it more important for your customer to know you or for you to know your customer?

 ☐ How do you create the best perceived value among customers?

 ☐ Can you sketch a desired schedule for migrating a onetime customer to repeat status?

2) *Be honest and forthright in communications and acknowledge your shortcomings.*

 ☐ Have you ever empathized with a customer or client? What place does empathy have in a customer relationship?

 ☐ Can you use empathy to build trust or loyalty?

 ☐ Do you feel closer to someone who needs your help or to someone who is boasting about a success?

Relationship Aspect Marketing

- ☐ How can you admit to a problem so that customers help you resolve it?

- ☐ How can you pass this word along to sales and customer service staff?

3) *Customers bond with people—not companies.*

- ☐ Do your customers personally identify with the people in your business or the business itself?

- ☐ Is customer loyalty based on your relationship with customers, or is that loyalty solely based on company products and services?

- ☐ Where does a customer go in your business when he or she needs help?

- ☐ What kind of reception does the customer get when he or she makes this contact?

CHAPTER 32:

LOW-TECH SOLUTIONS FOR A HIGH-TECH WORLD

Solving problems quickly and decisively is one of the most important jobs of a business owner or manager; the ability to do this, well, can save time and money, boost employee morale, and, ultimately, keep customers. Sometimes you have to take a chance.

A former employer of mine, turned client, was experiencing problems with his employees. I'd like to share how we arrived at a very creative solution. You may not identify with the problem but, I hope, you'll see the value of using creative problem solving to change your businesses approach.

In the mid-1980s, National Coach Corporation, a shuttle bus manufacturer, was recovering from an automotive recession while simultaneously dealing with substantial growth issues. The company decided to make a concerted effort to maintain high visibility on a face-to-face basis with its clients. This meant that the sales division spent a lot more time on the road than usual. Although the sales executives were willing to put in the extra effort to make more money (more contact = more sales), employee morale had dropped to an all-time low. It seems that the spouses—mostly wives—were extremely agitated over the increased travel time and their complaints were taking a heavy toll on the sales personnel.

The problem: How do you fix a personal family issue that involves non-employees, occurs mostly in the home—not the workplace—and is caused by actions that are absolutely essential to corporate survival?

The CEO of this company was a direct, head-on type of executive. His first reaction was to tell the salespeople to handle it with their spouses. But the employees had already been trying to do that with no success. His second reaction was to bribe the spouses by holding the annual planning meeting at a resort—and inviting the spouses.

The employees felt that this might help, but weren't too sure that it would have a lasting effect with their spouses. The CEO thought that he should honestly address the issue during a speech at the planning meeting where the wives would be present. Everyone, however, was concerned about the effectiveness of this because the spouses looked at him as the enemy.

Good Ideas Come in All Shapes and Sizes

Our company was asked to create a message that would defuse this tensions. Upon our evaluation, we knew that if the message was going to have the intended impact, the messenger had to be acceptable. After much discussion about the appropriate messengers, we decided on a popular children's toy—a talking teddy bear that could be programmed to carry the needed message.

As each couple checked into the resort, the wife was presented with her personal teddy. When she pulled his string, the bear said, "Hi, I'm Teddy and we need to talk. The elves tell me that it's been a rough year on you, what with all that traveling your hubby has had to do for the company."

The bears may have been a little too cute for some, but the results far exceeded our expectations. The bears brought the resentment out into the open. By bringing the problem out of the closet and enabling people to share the pain, the pain was lessened dramatically. All of this gave the CEO the opportunity to talk about the extra travel, show the difference it was making for the company and explain that it would eventually drop back down to more acceptable levels.

Creativity Reaps Significant Rewards

Creative solutions produce results that are successful beyond your wildest imagination. Solutions don't need to be extravagant or complicated—some of the best plans are the simplest. For example: Jack Allen, the owner of a large insurance agency, told me how he found a creative way to break the ice with one of his clients during a phone call after a long break in communications.

Jack opened the conversation with some humor saying, "Gee you don't call, you don't write, you don't send flowers…do you still love me?" The client laughed, and in an instant the awkwardness was out of the way and the conversation flowed.

About an hour later, a delivery person arrived with a bouquet of flowers for Jack. The attached note read, "I may not call, I may not write, but I do send flowers." Both had found simple, but creative ways to solidify the relationship.

The point: Creativity reaps rewards. Whether it is a uniquely worded thank you, an unusual gift, unique packaging or a talking teddy bear, people react positively because they appreciate the effort that went into the idea. Don't let tradition stifle creativity when it comes to addressing problems; and always remember that humor is the essential ingredient in the cure for most problems.

Ask Yourself

1) *Creativity positively impacts image.*

 ☐ Do you use creativity to gain more and happier customers and vendors?

 ☐ Does your creativity impact your bottom line?

 ☐ How do your customers react?

 ☐ Do they let you know they appreciate your creative efforts?

Relationship Aspect Marketing

- ☐ Do they pay their bills more quickly as a result?
- ☐ Are they less demanding of you and more forgiving of your mistakes?
- ☐ Are your vendors more lenient with you when you get behind on a payment?
- ☐ Are they available more often when you try to reach them?

2) *Never underestimate the power of relationships.*

- ☐ Have you ever paid more for something because of a relationship you have with the provider?
- ☐ Do you think your customers will?

Chapter 33:

Happy Employees Make Happy Customers

Every owner of a business, no matter how enlightened, can relate to how profoundly employee problems and morale affect a company. Yet there are times when a business may have to demand more from its employees in order to survive. When that happens, employees will rise to the challenge—but there can still be difficulties.

Every year, billions of dollars are spent by business to attract and retain customers. On a daily basis, owners and managers shout, *whatever it takes, we need the business*! When a good customer makes a request, we bend over backward to fulfill it. But how quick are employers to treat their employees with the same consideration as a top client?

All too often, we forget that our first customer is our employee. How we treat them is exactly how they treat our clients.

Find Ways to Nurture Your Employees

If this concept is too philosophical for the pragmatists reading this book, I recommend you look to the extremely tight job market, coupled with the high costs of training and turnover, if you need more reasons to nurture your employees. Recent trends suggest that employee nurturing is catching on among the major corporations, which are offering incentives such as stock options, hiring bonuses, staying bonuses, on-site childcare, dry cleaning, parties and even on-site automotive repair.

Relationship Aspect Marketing

Most businesses can't afford such a large investment, but there are less expensive, technology-based ways to increase employee morale and job satisfaction, including:

1) Provide and allow Internet access for all employees. This is the communication tool of the present and future. Yet, many employers are still resistant to providing individual access.

2) Establish individual e-mail accounts. This costs virtually nothing and is a tremendous morale booster. Plus, most of your clients expect to be able to contact your people by e-mail.

3) Provide desktop computers for internal personnel and laptops for outside personnel. Your clients expect your outside people to have virtual offices. If you want to position yourself as a cutting-edge company, use every available tool.

4) Use company-wide e-mail to honor employee performance. Everyone likes to be recognized and this reinforces the company's commitment to the electronic world.

5) Honor an electronic employee of the month—the person who offered the best solution to a problem, the person who gained the most ground in learning a new technology, an in-house trainer or automation mentor. By acknowledging individual efforts to expand technological horizons, a company motivates employees to work harder and reaps unlimited benefits.

6) Establish an electronic suggestion box. This offers the younger, computer savvy members of your company an opportunity to expand your technological know-how. Many of these so-called novices were born with a computer keyboard in their hands and can offer you some excellent and creative ideas. Take advantage of the expertise they bring to your company.

7) Publish an electronic version of your employee handbook. This reinforces your commitment to automation and makes for easier access. It also enables the company to update the manual as laws change and corporate policies are amended.

8) Publish an electronic newsletter. Make it a joint-effort; solicit your employees to submit articles electronically. Seeing their

thoughts published is a tremendous boon to their self-esteem, and the fact that the company recognizes their expertise is a major motivator and morale booster. Additionally, advice or suggestions from one employee to another is a very powerful training technique that can increase productivity within the workplace.

9) Investigate computer-based training programs and classes to offer your employees. This is a highly-efficient and cost-effective method for both training and continuing education credits (that are required in some professions for maintenance of certifications or licensing). In addition to making your personnel more computer savvy, computer-based educational programs allow the employee to work at his own speed and helps control training expenses. Another advantage: The company isn't sending the employee off-site and incurring travel and lodging costs.

10) Put your employees in your contact management system. Use your database to remember birthdays, special events, anniversaries and other important moments in your employees' lives—just as you do for your clients.

These are just a few ideas to improve your relationships with your employees, while solidifying your organization's technological position. With a little bit of time and brainstorming, you can come up with many more ideas to stimulate your employees and enhance their work experience.

Ask Yourself

1) *Your employees are your primary customers.*

- ☐ Do you set up programs on a regular basis to train employees so they respond to the needs of your customers?

- ☐ Do your employees feel that they are valued partners in the success of your business?

Relationship Aspect Marketing

- ☐ Have you asked your employees for feedback on how management is doing?

- ☐ Do you have a suggestion box and respond quickly to employees' questions and concerns?

- ☐ Do you give your employees reasonable autonomy and the tools to handle problems on their own?

- ☐ Do you know your employees?

- ☐ Do you have more contact with your employees or your customers?

2) *Establish employee perks.*

- ☐ When was the last time you did something nice for all of your employees?

- ☐ Do you hire outside consultants, if necessary, to help employees use the technology you have?

3) *A happy workplace means less recruiting and more retention.*

- ☐ How much business do you lose when an employee leaves? Have you ever tracked it?

- ☐ Do your employees stay long enough for you to have a return on your investment? If not, why don't they?

- ☐ What exactly is the cost of lost business while a new employee is training?

- ☐ Is there any way to minimize these losses?

- ☐ Can you assign the new employee a buddy at work to answer questions and lend support for the first week or two?

CHAPTER 34:
TELECOMMUTERS POSE A
RELATIONSHIP PROBLEM

Telecommuting is a product of technology, and it is a mixed blessing. Everyone seems to feel strongly about telecommuting. The pros are pro and the cons are con with fairly few arguments in between. But how does telecommuting affect a company's business practices? How does telecommuting impact consumer relationships? How does it impact peer relationships? How does it impact managerial relationships? And how does it impact the telecommuter?

If telecommuting engenders a happier, more relaxed employee, customer relationships will blossom and flourish. But in order for that to happen, the company must first (excuse my repetition) recognize that the employee is the most important customer. Supporting and nourishing a telecommuter, however, may be a difficult task for management.

Communication Is Everything!

Open and consistent communication is critical to successful telecommuting. Unless there is continual dialog, management may feel that the out of sight employee is not giving 100 percent, and the employee may feel forgotten. Communication eases these worries and helps everyone adapt to the telecommuting process. Bosses must take heed; communication is not an outward monologue, it is the exchange of information—a dialogue. It is extremely easy, and common, for a telecommuter to become disconnected

from the company and eventually feel so disenfranchised that he quits. When this happens, the company is a four-time loser.

First, the company loses business and customers between the onset of the employee's personal frustration and the point of his departure. The unhappy employee causes a loss in revenue before he quits or is terminated. Second, the company loses its training and education investment in the employee. Third, the company incurs the cost of finding and training a replacement—which can be extremely costly in today's job market. Fourth, the company loses potential business during the new employee's orientation period. After all, no one hits the ground at full-speed in a new job.

Tips for Managing Telecommuters

To avoid incurring such losses, it is best to keep the telecommuter happy from the start. The following are guidelines for the successful management of a telecommuter:

1) Provide your telecommuter with the technology to successfully do his job—Internet access, external e-mail account, internal e-mail account if applicable, fax machine, scanner, telephone, pager and answering machine or service. If your telecommuter spends a considerable amount of time on the road, then it is wise to provide a laptop with a docking station at his home.

2) The Internet connection should be active 24-hours a day. A DSL line or cable modem is preferable to dial-ups when available. When using e-mail preferences, ensure that the employee activates e-mail notification so he knows immediately when someone is trying to reach him. If an employee has to wait hours for a response to an e-mail from an off-site employee because he hasn't checked his e-mail messages it is counterproductive.

3) If dial-up access is the only available option, then management should set specific times at which the employee checks e-mail. This eliminates the unknown waiting factor for replies.

4) When geographically convenient, telecommuters should attend at least one meeting per week at company offices to review current and upcoming projects and activities with their boss. Whenever possible, include other coworkers to make your telecommuter feel like a part of the team. This confirms that everyone is on the same page and work is being done properly. Additionally, this team meeting allows for an open group discussion about the direction of the work and any need for reassessment, adaptation or change.

5) Establish a monthly staff meeting of all telecommuters and internal workers in order to maintain relationships, and encourage peer support and personal comradery.

6) Encourage some chitchat among telecommuters and other employees, including both telephone and e-mail communication. Communication is critical for telecommuters to avoid feeling disenfranchised and shared information often increases overall productivity. full-time workers often exchange personal news and office gossip to relieve stress. At the same time, they share important work-related insights with each other. Inside the office or outside, this is not wasted time and energy.

7) Establish a telecommuter training program where new telecommuters spend several days at the residence of one or more established telecommuters. This encourages sharing beyond the basic aspects of the job. The novitiate may express fears and anxieties that can be assuaged by the veteran. And the veteran can pass on lessons learned that can help ease or eliminate some of the more common pitfalls encountered when working at home.

8) Build an internal chat line on the company Web site to allow interaction among all employees.

9) Consider video technology for conferencing between the telecommuter and the office, as well as with clients who also have the technology. Electronic video cameras are relatively inexpensive and provide a more intimate—and fruitful—working relationship.

10) Insist that supervisors and telecommuters have at least one phone conversation per day.

11) Consider an electronic suggestion box for telecommuters, as well as inside staff. Telecommuters have specific needs and suggestions that may apply to in-house staff as well; never underestimate the value of a good suggestion, no matter from whom it comes.

12) Provide the telecommuter with a modest budget for decorating her home office area. Work ambience is important, whether at home or in the office.

13) Expect the best. If management maintains the attitude that telecommuters are goofing off, it may become a self-fulfilling prophecy. Show them you have respect and confidence in them. You'll be surprised at the dedication these off-site employees offer you in return.

14) Develop guidelines, policies and procedures, and involve the telecommuters. Mutually-determined rules are more apt to be followed.

15) Don't let out of sight mean out of mind. Occasionally visit the employee at her home office to offer advice and encouragement and monitor work flow.

16) Encourage telecommuters to participate in all non-work functions—company picnics, sports activities, community relations and award banquets. It is essential that these employees feel part of your organization.

17) Acknowledge that your telecommuter can have a bad day just like your house staff. A simple word of encouragement or a willingness to listen to a problem can help turn his day around and put him back on track.

18) Don't let your telecommuter become isolated. Urge her to get out of the house periodically. A quick trip to a coffee shop, lunch out with a friend, client, coworker, or even a trip to the hairdresser or mall can do wonders for productivity. Most people need human contact and the lack of it can cause prob-

lems. Getting out of the house (on company time) is a valuable support tool. You may think I'm crazy for suggesting that an employee go to a hairdresser on company time; but telecommuters often work beyond normal quitting time and the emotional boost of getting out for an hour can significantly increase performance and productivity upon the return to work. Since we moved our offices into a wing of the house, I've been known to work in a bathing suit and take several swimming breaks during the day. The simple truth is that these mini-vacations increase both my mental and physical alertness, which enables me to get more work done each day.

19) Develop a consistent means of monitoring telecommuters and measuring performance, and be sure to review your findings with the employee on a regular basis.

Implementing suggestions such as these empowers employees to do their best and helps nourish their self-esteem. This allows them to do their job and serve clients with a sincere smile and a happy heart.

Ask Yourself

1) *Telecommuters must feel a part of the organization.*

 □ Are your telecommuters encouraged to participate in all staff events?

 □ What have you done for your telecommuters lately?

 □ Do you offer them the technological and other work-related support they need?

2) *Managing telecommuters requires ongoing communication.*

 □ How frequently do you visit off-site employees at their home offices?

 □ Do you ever call telecommuters just to see how they are?

Relationship Aspect Marketing

 ☐ When was the last time you complimented a telecommuter for good performance?

 ☐ Do you offer telecommuters incentives for good work practices?

 ☐ Do you encourage telecommuters to keep in touch by phone and e-mail with other telecommuters as well as with staff employees?

3) *Telecommuting can be beneficial to employee retention and recruiting.*

 ☐ Do potential recruits look at full or part-time telecommuting as a benefit?

 ☐ Has your company considered including telecommuting as a benefit to present and future employee?

 ☐ Have you ever lost an employee because he or she needed to spend more time with family?

 ☐ How can telecommuting assuage the family burdens of two working parents?

Section Four:
Branding and Other Marketing Concepts

Many companies falter when it comes to the final step in relationship aspect marketing. They focus on the customer's needs, wants and desires to build a good relationship. They properly utilize new and old technology to support and enhance that relationship. They expand relationships to include the employees, vendors and community. But—and it's a big *but*—they just can't seem to package it into a single message that can be easily communicated to the marketplace. They haven't managed to brand themselves.

Branding, like a relationship, is all encompassing. It is the promise that your company makes to your current and future customers. It is the meaning behind your name or your logo. It is what people think when your company enters their consciousness.

Traditionally, marketers tried to create connections with customers at various points and through various channels—point-of-sale promotions, local media ads (newspapers, bus stops, billboards), national media ads (TV., radio, sport stadiums), etc. These promotions were meant to generate sales. Branding was simply a welcomed side effect. In the Internet age, I think all that media has lost it importance. As a result, the side effect was to become key. One of the great things about information technology is that it allows you to focus on fewer marketing points. I think that if you concentrate on relationships and branding, you can market effectively. This means you don't have to buy as much advertising as you used to in

order to build business. Create the good relationships—and then you can afford to be selective about how you promote you brand.

These two elements—relationships and branding—can carry you to success.

If someone says "McDonald's," do you think of a fine restaurant? Of course not. You probably think in terms of speed or consistency. You know that the golden arches promise speedy delivery of a consistent product regardless of where you are. In Tokyo, Seattle or Rochester, you will be immediately served up a "Big Mac" that will taste and look exactly as you expect. That's good branding. And that's what this section is all about.

Too many retail businesses think of branding as the domain of the company that provides the products they sell. Maybe this is true if you're a State Farm insurance agent, but it's definitely not the case for most companies that carry products from numerous manufacturers. Service providers such as attorneys, doctors and insurance agents seldom envision branding as something that affects them—but it does.

Ask any insurance agent what makes his agency different or better and he'll generally answer, "service." Yet, if asked to explain what that means or why it makes them different, he generally can't provide an answer. As a result, many such industries are commoditizing themselves. Price is the only difference, because companies are not branding themselves by providing unique value to the consumer.

So, what is your brand or class of goods? What kind of company do your customers perceive you as being? How can you burn the imprint or brand of your company into the minds of your clients and prospects?

Achieving an Effective Brand

In order to achieve an effective brand, a number of components must be present and must compliment each other including: products, ancillary profit centers, uniqueness, positioning in the marketplace and clientele. Brand identity must encompass the uniqueness of an entire operation. A neighborhood hardware store, properly branded, is thought of as the place that

provides "the products you want with the educational expertise you need from people you trust."

Numerous businesses fall into the product trap—they brand themselves based solely on what they sell, not what they offer (expertise, inventory, selection, service after the sale, service during the sale, etc.). Your product does not make you unique, especially in today's world where the competition can surface overnight. *You* are your uniqueness. But how can you quantify that uniqueness and translate it into branding?

Look to your customers, and they will tell you. They know *why* they do business with you. Your job is to get them to tell you. When you understand their reasons for choosing you, then you can build your brand around those reasons.

The problem is, we already think we know what's important to our customers without asking them. Quite frequently we're wrong. Therefore, the first step in developing a brand is to find out why your best clients do business with you. Once you discover what makes them give you their money, you can build your brand on these critical factors. For example, if your customers say trust is a major factor, ask why. Did you earn their trust because you have special expertise in their business? Did you position yourself as a trusted advisor? Do you provide educational and training assistance? Do you always back up warranties or guarantees? You need to know the specifics.

If your customers say service is the reason they do business with you, ask them to specifically define the good service that impresses them. Is it your order processing system? Is it because you are available when they need you? Is it because you return their phone calls? Is it because of the caliber of your staff? Is it because you have the technology to meet their needs faster through the electronic world? You need to know the specifics.

Promises Kept Build Strong Relationships

In the 1970s and 1980s, the Big Three American automakers were under attack by the foreign imports. Profits and market share shrunk, as con-

sumers bought into the concept that Japanese vehicles were of superior quality. General Motors and Chrysler seemed to give up quietly under the onslaught and have never really regained their former positions of dominance and strength.

Ford, on the other hand, survived quite well and has considerably increased market share from earlier decades. Ford branded itself with a promise: Quality Is Job One. The company bought into it, the employees took pride in it and the product improved to the point that consumers were willing to buy Ford products again.

Branding is not your advertising, your marketing, your logo or your slogan. Branding is the thought that captures the essence of your corporate being. It is what *you* are all about.

And few, if any, companies can determine that without input from their customers. The consumers that are actually buying your product or service are the ultimate font of truth. They are the only ones who can tell you why they buy from you. Look to them for the golden nuggets of truth that define what makes you unique and valued. From those nuggets come your brand, your essence, your promise.

Once you have determined the uniqueness that constitutes your brand, it becomes an integral part of every relationship. That means that you have to communicate that brand concept through every means and method possible. Your corporate entity must live and breathe it constantly, because every promise entails consumer expectations about the delivery of that promise.

Unless everyone within your company is committed to delivering on that promise, expectations will be crushed and customers quickly lost. If every McDonald's franchise delivered a hamburger that tasted different, they might as well advertise as the five star dining establishment that they aren't. Consumers would rebel and McDonald's would become history for failure to live up to its promise of consistency.

Consider the many brands you know. Hertz Rental Cars has an attitude: We're #1 and proud of it. Sony stands for quality in electronic equipment.

Ben & Jerry's is environmentally conscious. WalMart represents low prices. Apple computers are on the cutting edge of design. Jeeps are rugged. Nordstrom's delivers exceptional service. Keebler elves make tasty cookies. Crest prevents cavities. J. D. Power and Associates means integrity. H&R Block does your taxes. Sprint's fiber optic lines are clear enough to hear a pin drop. Each of these companies has managed to discern its unique difference and build a brand around that.

The Message Must Be Consistent

Once you have identified your brand, that message has to be communicated on a consistent basis in every way possible. Advertising, regardless of the media, needs to be consistent with and complimentary to all other communications from your Web site to your telephone, your e-mail to your stationery. This communication needs to be inwardly directed as well as outwardly. In other words, your employees need to be 100 percent sold on your message as well as your customers.

Occasionally, I'll respond to a point of purchase advertisement of one sort or another. Once in a while, I'll call the company to gather more information or place an order and the telephone representative knows absolutely nothing about the special offer. If a company fails to communicate advertised specials to its sales representatives, I can only wonder how well it communicates branding concepts and other more esoteric messages to the employees.

Again, relationship aspect marketing is a team effort. Everyone has to be involved and everyone carries the message. If not, the consumer has a credibility gap that is difficult to overcome. And in today's fast-paced environment second chances are rarely given.

Your branding message has to be consistent. If your specialty is the expertise behind your service, then your Web site should reinforce that message by providing resource material based on your expertise that is beneficial to your clients. If, like Domino's Pizza, your brand promises speed, you must reply to voice mail messages and e-mail inquiries quickly or you

defeat your branded message. A company that carries a quality brand, cannot afford to have misprints and typos in its advertisements and other communications.

Choose wisely the forms of communication that enable you to broadcast your branding message. From mainstream advertising to the unconventional, communication has to be seen and heard to be appreciated. Creativity is essential in the packaging of your message.

Great messages are often lost amongst a 12-inch pile of mail. Package the message so that it stands out. Look for subtle ways such as notes on invoices, signatures on e-mail, slogans on your letterhead and information on your fax covers. Add promotional pieces to bulk up your mailings. Consider not-so-subtle ways such as marketing—via audio or video tapes, CDs and DVDs. Develop print and electronic newsletters that educate and inform your market. Actively pursue public relations exposure. Encourage employees to mention your company online—in chat rooms or postings or relevant Web sites. Brand building is a more general proposal than sales generations. You can build brands in all kinds of places.

Customers as Advocates

Today's consumer has a cluttered mind. It is continually being bombarded with messages, most of which are quickly discarded. I believe that the old truth of taking seven impressions to gain a foothold in someone's mind is no longer valid. I believe that today's world requires 12 or more impressions before any message begins to break through the clutter—and that assumes that the message is worthwhile. Likewise, the message has to be succinct and all-encompassing. Consumers are not going to remember a litany of products that a company offers, but they might remember a company name and a singular concept such as greatest selection, lowest price, most friendly, exceptional service, etc.

Once the message is heard and contact is made, the real work begins. This is the starting point of the relationship, which brings us back full circle to the art of getting to know each other during the courtship, the develop-

ment of the relationship, and the proper use of the tools at our disposal. Exceed the expectations of your customers so they become advocates for you.

Explore Different Kinds of Relationships

Customers and employees are the obvious, direct relationship aspects in most business equations. But relationship aspect marketing is not just about the employees and the clients; it also entails other business alliances. A relationship-oriented company also values the role of vendors, industry and civic associations. Consider them your extended family.

The egocentric selfishness of a two-year-old child, under proper guidance, eventually matures into a sharing and interactive role within the family and eventually the outside world. Businesses cannot afford to be self-seeking two-year-olds. There has to be a mutual give and take for the benefit of all parties.

In the futuristic novel, *The Truth Machine*, author James Halperin invents a world where no one can lie without detection. In one scenario from the book, two businesses are negotiating a deal together. Since no one can lie, each side literally opens his books to the other as to costs and overhead. Paraphrasing the book, Party A says, "Based on our costs, we can afford to sell this item for as little as $1.66 each and still make a fair profit."

Party B says, "Based on our projected distribution costs, we can afford to pay as much as $1.98 each and still make a fair profit."

They go on to split the difference and settle on a price of $1.82. Each side is interested in protecting its interests, but without injuring the interests of the other party. If only business were that fair in this world.

Too many companies try to squeeze additional profits by declaring war on their vendors. These companies are not creating relationships; they are taking hostages. Vendors are invaluable allies in the success of your business. Like your customers, they should be courted as vested partners.

Relationship Aspect Marketing

And like your customers, if you treat them well, they will treat you well.

The best vendor alliances tend to be a bit incestuous. It's hard to determine the line where one company ends and the other begins. The relationship enables each to jointly present a solid front to the world. Each cares deeply about the welfare of the other and proactively works toward the success of both. In this sense, even your vendors can help you build your brand.

In healthy relationships, each company is proud to proclaim the attributes of the other. Marketing themes can be built around the contribution each provides to the customer. Each promotes the other on its Web site with links and testimonials. Each refers business to the other. In this type of atmosphere, the problems that are bound to arise in any business are never faced alone. Your vendors are your partners and you are theirs.

On the other side of the relationship equation, look at the Firestone/Ford debacle. Firestone was a strategic partner of Ford, providing the tires for all of Ford's sports utility vehicles. In 1999 and 2000, several consumer advocacy groups publicized the fact that the Firestone SUV tires had design flaws that caused many to burst when driven at high speeds. A few people died in resulting accidents—and public opinion exploded against Firestone and Ford.

The strategic partners had all kinds of problems. It appears that each kept secrets from the other, and when the excrement hit the fan, there was no united front. Each went its own way pointing the finger at the other.

(I might mention that Ford appeared to be more proactively forthright with its customers and encountered substantially less criticism than Firestone, which—in my opinion—totally mishandled the crisis to its detriment.) Adversary relationships with employees, customers or vendors are of little or no benefit to anyone.

If you maintain membership in trade or industry associations, do you take an active role in them? Or do you sit back, reap the benefits and allow others to do the work? If you don't actively participate, you're cheating

yourself, your company and your employees out of the true benefits that arise from the lasting relationships and contacts made among those who do the work. Civic organizations are no different. Just about any entity with business or commercial relationships has a role—and interest—in keeping a good brand.

In either case, additional benefits can be reaped if you support employee participation in such groups as well. Again, your industry and your community are further examples of the extended family upon which relationship aspect marketing is based.

By now, it should be clear that relationship aspect marketing is the philosophy of doing business. It is based not just on words, but on the actions that back up the words. It is driven from the top down, but involves everyone within the company as well as outside alliances. The relationship aspect puzzle is comprised of numerous interlocking pieces that come together to create a single picture. It creates an environment where people want to do business with you.

Relationship Aspect Marketing

CHAPTER 35:
FOCUS ON THE
BASICS

Don't get too tricky—or techy—when you think about your brand. Stick to the basics of what you do. If you develop a strong brand, it can translate into all kinds of benefits for all kinds of business relationships. As I've mentioned before, this will usually relate to relationships with customers. But it can also relate to their relationships.

Many years ago, I received a valuable lesson in the fundamentals of branding and business from a source I've never forgotten.

When I was managing Hertz Car Sales, Bill was our combination sales manager/salesman for Hawaii. Hawaii is a problematic state for the car rental industry. It requires a lot of rental cars to handle the tourism, but the limited population base of residents makes it very difficult to sell the used vehicles. Most rental firms ship the old cars back to the mainland for disposal—an expensive proposition. But under Bill's watch, Hertz didn't have to. Bill always managed to sell the cars within our fleet, as needed. The joke was that he was building a reef off the coast from our old rental vehicles. Month in and month out, I would send Bill a note of congratulations on a job well done. I never had to worry about his projections or his sales. He literally required no management, so I just let him do his job and kept saying, "Thanks again, Bill!"

Convinced that he had some secret formula that could benefit all of our regional car sales managers, I invited Bill to speak at a national meeting of Hertz salespeople. Bill arrived for our meeting dressed garishly by cor-

porate standards. On the way to the meeting room Bill asked what he should talk about, and I told him to explain how he sold cars so successfully. I introduced him and sat back eagerly awaiting his words of wisdom. He said:

> Well, I try to make a lot of friends. In the evening I visit several restaurants and nightclubs and buy people an occasional dinner and a few drinks here and there. As I get to know them, I ask when they think they might be buying a car. When I get home I jot down what I learned and put an index card in my file for each potential car buyer and note the month and year they indicated they might be ready to purchase a car. Each month I call the people in my files for the upcoming month and check to see if they are on schedule to buy a car the next month. If they aren't, I re-file their card under a new date. If they are, we try to schedule a time to get together. And that's about it, thank you.

I was a bit embarrassed. I had scheduled Bill to talk for an hour. The audience wasn't quite sure how to react—and I'm not positive that they ever really understood the value of his message. After all, how could anything so important be so simple. Yet, in a few short minutes Bill had given us his entire strategy:

1) Prospect for customers;

2) Develop a database;

3) Build relationships;

4) Maintain contact (follow-up); and

5) Ask for the sale.

It seemed so simple…too simple. But there it was. And I suggest that Bill's plan should be the basic plan of action for most sales professionals today. Technology merely affords us computerized databases in lieu of index card files, and e-mail and contact management software, in place of a walk around the corner to the local pub.

Stick to the Basics

But there was something more to Bill's success. He operated with a very strong—and positive—sense of the company he represented. This gave him a confidence that other store managers didn't have. I learned this lesson a few months after Bill's short talk. I was sitting in my New York office one day when Bill called and asked if he could talk to me. When he arrived, he confided that he had a problem.

Avis had made him an offer—a three-year contract for more money than he was making with us, plus a signing bonus. The money was considerably more than we were paying, and I didn't think human resources would be able to match the offer.

"That's quite a deal they're offering, are you thinking of taking it?" I asked. Bill's answer shocked me and gave me considerable insight into what motivates people.

Bill answered, "Of course I'm not going to take it, Jack, but they were so nice I was hoping that you could help me write a letter that won't offend them when I say I'm not interested."

"No problem," I quickly and happily replied with relief. "But what made you decide not to take their offer?" I asked.

"Two reasons actually," Bill explained. "One is that you're always so appreciative of my work and I really like that. Plus, why should I work for #2, when I'm already working for #1?"

Relationships go a long way with your customers, but they also go a long way with your employees! Not everyone is motivated solely by money; many find more value in appreciation. Employees take great pleasure in being part of a winning team. Maybe it's self-esteem, maybe it's ego, but people (right or wrong) draw some of their identity from the company with which they work and the job they do. Everyone wants to be #1, whether in sports or the military, business or social settings. What young ballplayer doesn't dream of making it to the Yankees? Wouldn't a young college student prefer to work at Disneyland rather than a more nonde-

script amusement park? When you're associated with #1, you feel like a winner, too. And perhaps the greatest perk in the world is feeling like a winner.

Throughout this book, I have attempted to show that technology, used improperly or given too much importance, can erode the basic foundation of good business principles. If we lose sight of the basic tenets of business, technology only leads us to failure.

Some of the basic tenets of good business practices include:

- A welcoming voice on the telephone;
- E-mail messages that show respect with proper etiquette;
- Web sites that cater to the needs of the customer (rather than the ego of the company);
- Showing appreciation for the business that your customers place with you;
- Acknowledging and meeting customer expectations for speed, service and value;
- Maintaining continual communications; and
- Viewing problems as opportunities to provide service above and beyond the call of duty.

These are the basics that drive a business. Technology does not drive a business. It is merely a tool that enables us to conduct business better, faster and easier. Build your brand around the basics of your business.

Ask Yourself

1) *Take care of the basics and the basics will take care of you.*

 ☐ What are the basics that make the foundation of your business?

- ☐ What is your strategy for success?

- ☐ Do you practice the basics of your craft for at least one hour every day?

- ☐ Do you read the business books you purchase, or are they bookshelf decorations within your office?

- ☐ How frequently do you attend seminars and workshops to hone your skills?

- ☐ Do you practice your presentation before sales meetings?

- ☐ Do you spend time listening to positive input from tape cassettes when driving?

2) *Relationships are the cornerstone of every business.*

- ☐ Do you spend time each day talking with your employees and your customers?

- ☐ Have you ever written a letter of appreciation to a client—or an employee?

- ☐ Do you know and remember personal dates that are important to employees and clients, such as birthdays, anniversaries, etc.

- ☐ Do you know the names of your employees' spouses and children?

Relationship Aspect Marketing

Chapter 36:
A Brand Is a Moving Target

Every company, like the economy and the marketplace, goes through periods of expansion and contraction. Sometimes these ups and downs are determined by the market economy, other times they are dictated by corporate complacency due to continued success or longevity. Many times companies simply lose their focus.

Branding, marketing and advertising efforts tell the public what a business is and what it does. Doing this well is essential to the survival of a business—no matter in which stage a business is. The problem is that many business owners and managers think that if they perform these three functions well, success is theirs. In fact, too few businesses put as much effort into the business's performance *after* they've landed the customer as they do into getting the customer in the first place. And performance determines whether customers stay with you or go with the competition—and once they move on it's almost impossible to get them back.

Many businesses perceive marketing as being static. But this is not true. Branding, marketing and advertising efforts must continually evolve. In today's world, failure to adapt means you will be left behind. Successful companies realize that change is a constant in everything they do.

I remember the excitement of visiting a five and ten cent store such as Woolworths as a child. I freely roamed narrow, overcrowded aisles bulging with inexpensive items designed to serve the homemaker and light the desires of youngsters. That model worked for a long time—that is, until

the era of the large discount retailers. People were astonished when such companies as K-Mart began mass merchandizing in large uncluttered stores filled with discounted items of every imaginable category—and, they were hooked.

Today those original K-Mart stores pale in comparison to such mega-stores as Walmart, Target, Price Club and CostCo. Although K-Mart attempted to capitalize on this super-center mentality by building newer, bigger stores, the company was hampered on several fronts—most important, K-Mart's image (or brand) had already suffered. Although the new K-Mart super stores were bright and roomy, the public perception was crowded aisles in facilities that were worn around the edges. There really wasn't much difference between K-Mart and the other stores in the way of products, but K-Mart was losing in the image department. K-Mart shouted "low prices," but Walmart concentrated on a image of friendly employees and excellent service as well.

The Three Ss: Service, Service, Service

K-Mart's turnaround began in 1996 under the direction of CEO Floyd Hall. Hall's willingness to embrace change and reinvigorate marketing brought about a dramatic improvement in the company's net income. When he retired several years later, he had effectively laid the foundation for K-Mart to prosper. His successor, Charles Conaway, the former president & COO of CVS, the drug store chain, committed the company to making customer service K-Mart's priority. And it's more than just lip service; the commitment is backed up by ongoing monitoring and developing of an employee incentive program, which is tied to customer service.

Today's K-Mart knows that customer service means more than just serving the customers who shop at its stores. It means bringing the company to the customer by whatever means and methods the customer demands, including various forms of brick and mortar facilities ranging from the traditional to supercenters, small convenience stores, and, of course, the Internet.

K-Mart acknowledged that attempts to be the low price leader did not work. Walmart was just too good at the game. Thus, K-Mart committed to making convenience, service and national brand selection at competitive prices its hallmark for today and beyond.

Focusing on the customer, this formidable marketer has developed multiple marketing fronts, each of which is undergoing a continual process of updates and change. These multiple marketing approaches include:

1) **Database Marketing**. Currently, K-Mart has a database of over 100 million households, enabling it to niche market to target audiences within their consumer family. Recent trends in relational database programs (such as the predictive modeling of Bayes Corporation discussed in a previous chapter and new refinements in customer relationship management software) should provide substantial refinements to further customize the company's target marketing.

2) **Web site**. Bluelight.com, K-Mart's Web site, is reminiscent of the old "blue plate special" of Depression-era diners. K-Mart knows that its customer base is primarily at the lower end of the income bracket, which also means less Internet accessibility. Rather than just putting its wares onto a Web site, K-Mart actually provides its customers with free Internet access. Twenty dollars per month for AOL may not seem like much, but it deters lower income shoppers. Granted the customer needs a computer but the Internet access is free. With over two million subscribers to date, this could turn out to be a major factor in K-Mart's virtual shopping carts.

3) **Groceries**. The consuming public wants to save precious time with one-stop shopping convenience. To that end, the company has implemented the Pantry in all of its traditional K-Marts and larger Big K's. The Pantry offers nearly 6,000 grocery items, and efforts are already underway to market the benefits of convenience and further specialize the products carried according to the demographic and geographic market demands. This will enable each store to stock items in accordance with the demands of its locale.

4) **Convenience**. Built on the Pantry concept, the company is testing a convenience store concept (*a la* 7-11)—K-Mart Express—that will sell gasoline. The initial testing will be conducted in the company's home state of Michigan, with plans for adding up to 100 stores across the country. With improved branding, this concept could make K-Mart a significant national player in the convenience/gasoline marketplace.

5) **Bigger Stores**. Dwarfing all other K-Mart facilities, the expansion of this megastore concept (Super K) was interrupted due to prior cash problems. The company now plans to renew the expansion efforts and bring this mega K-Mart concept to new areas by opening some 75 new stores in the coming years. Currently, there are just over 100 Super Ks in 21 states.

6) **Traditional Marketing.** Sticking to the old adage, *if it ain't broke, don't fix it*, K-Mart continues to use circular marketing to draw traffic to its facilities. At present they distribute about 72 million circulars per week offering product selection in accordance with seasonal marketing.

K-Mart is determined to stick around and be the leader in its industry. The company is embracing change by focusing on its customer. Will it work? Only time will tell, but my guess is that it will and K-Mart will continue as a major and profitable retailer—that is, as long as it remains committed to the customer. K-Mart is an example of a company faced with the necessity of change. Its dilemma was simple: change or perish.

Another challenge: ensuring that your customers and potential clients are aware of the many services and products you provide. Many businesses are undergoing convergence. Banks are selling insurance; insurance agents are serving as stock brokers; supermarkets are offering dry cleaning and banking; and hardware stores are selling telephone services. Clients want more and you should be giving them more.

You have to package your business as a full-service, multifaceted provider to your clients. If you can't do that, you may not be around to worry about branding. Many people argue that adding ancillary services and

products dilutes your brand. That is only true if your brand is built around a product— which is why the chapter started out warning against that common misconception. If an insurance agency has branded itself as a place to buy insurance, moving into other financial services will be difficult and disruptive to the branded identity. Yet if that same agency has branded itself as a trusted, knowledgeable advisor in financial management, that brand carries over to the management of risk (property insurance), attainment of financial goals (banking and investment), future security (long-term care products, retirement funds) and so on. The brand is not built on the product, but on the identity of the company. This concept may seem subtle to some, but it is an important one.

Once you've determined the direction to take in the development of your brand, make certain that you heed these three critical factors:

1) Meet or exceed all expectations that your brand creates. Truth in marketing, verified by performance, is the cornerstone of your future success.

2) Create a template for your brand. Every message, every marketing exposure, every advertisement should be captured within the template.

3) Ensure that your brand is in a constant state of renewal. Customer perceptions change quickly. Your brand must align itself with those changing perceptions as they impact your business. This doesn't mean completely changing your brand, but contracting and expanding to the dictates of your market.

Create a Top-of-Mind Branded Identity

When I was a child, our family insurance agent used to visit monthly to collect premiums from my parents. He was more than an insurance salesman; he was a friend, a consultant and an advisor. If my parents were considering buying a refrigerator, they asked him what he thought first. In arranging finances for my college, they sought out his advice. And when I

needed insurance for life, home, car and health, I automatically went to him. He had branded himself a trusted expert, not the seller of insurance.

Like that insurance agent, businesses need to create that type of top-of-mind, branded identity. Businesses have to position themselves as the first string for anything related to a specific product or service they offer. This means we have to use that brand template to disperse our message through every traditional medium from the phone to snail mail, and through every new medium from the Internet to e-mail, and be ready to make use of every future medium. Branding, in turn, will build business, increase customer retention and build profits. It also makes it easier for loyal customers to recommend you to their friends.

I like to think of branding as a "30 second elevator speech." If you were on an elevator with another person for a 30-second ride, could you explain what your company offers and why it is of value to your clients? Merely seeing your company name should instantly bring to mind your product and service, its unique aspect and the offerings and benefits that you provide your customers.

Ask Yourself

1) *Change should be a part of a company's growth strategy.*

 ☐ Do you have the courage to dump your old business strategies, even if they have worked well for years, and adopt new ones?

 ☐ How much money are you willing to risk to do this?

 ☐ How much time are you willing to devote?

 ☐ Have you fully researched the changes you hope to make?

 ☐ How will these changes impact your customers?

 ☐ Have you asked your customers whether they welcome these changes?

2) *Sometimes desperation is the primary catalyst for change.*

Chapter 36: A Brand Is a Moving Target

- ☐ Are you the type of manager who is always "putting out fires," or do you proactively seek out ways to prevent those fires in advance?

- ☐ Are you from the "If it ain't broke, don't fix it" school of management? Do you only act when something is already broken? Consider how this behavior impacts your day-to-day routine, employee morale and customer confidence.

- ☐ If you only act out of desperation, ask yourself: At what point am I desperate enough to act?

3) *Change should be led by what the customer needs, not what the company wants.*

- ☐ Have you ever invited a few of your customers to lunch to discuss how they think you are doing?

- ☐ Have you ever asked a customer to attend a business planning session?

4) *Meld the facets of your business into a single identity.*

- ☐ Do you think of WalMart as a hardware store, a clothing store, a jewelry store, a record store, a grocery store...or all of the above?

- ☐ Have you create a central theme that conveys what you do?

- ☐ Is your name synonymous with your product?

5) *All of your marketing and advertising efforts should be consistent.*

- ☐ How do you advertise? Are you consistent when you do?

- ☐ If you take out newspaper ads, do you ask that your add be placed in the same location each week so potential customers always know where to find you?

- ☐ Is your company's name the first that comes to mind when they think of the kinds of products and services you offer?

- ☐ Do you have an identifying symbol—like the McDonald's arches—that conjures your company name?

Relationship Aspect Marketing

6) *A brand is always evolving.*

- ☐ Do you constantly research changing customer patterns in order to adapt to them?

- ☐ Where do you get your information? Do you pay for it? Conduct customer surveys? Read trade magazines? Surf the Web?

- ☐ Do you know how to expand your brand without losing your customers in the process?

- ☐ Do your customers know what your brand is?

Chapter 37:

The Internet—Resource or Retailer?

As the public first discovered the Internet, it generally perceived the new medium as an unlimited repository of information and a new and faster way to communicate without buying postage. In short order, everyone from Wall Street to the corner store envisioned the Internet as the ultimate place for retailing.

If you have something to sell, you better figure out a way to sell it over the Internet or you'll go out of business—at least according to the vociferous proponents of this new world. Or, if you can't figure out a way to sell your product or service over the Internet, then at least establish a brochure presence.

The bigger question of how you use the Internet relates to the brand you are choosing for your business. In short, the question is: Will you make your Internet presence about a retail transaction or about offering information that leads to a sale through traditional channels?

In the 1990s, small to large investors solidified such prevailing thoughts by pouring obscene amounts of money into any company whose name ended in "dot com." Proven business models that mandated profits as a measure of a company's worth were no longer considered valid. *Potential* became the new king, and profits were a questionable projection for future growth. And, the stock market gyrations that greeted the new millennium have shaken some, but not all, of the new market believers.

As millions of investment dollars continue to pour into potential retail sites, the two original goals for the Internet—viable information resource and communications medium—continue to grow exponentially.

The Future of Business on the Internet

Although many have made millions on investments in Internet retail, I do not buy into the idea that this is the true future of the Internet. I believe that retail will eventually find its place, and it won't be the most significant element. In fact, I maintain that the Internet of the future will meld information and communication for business-to-business commerce.

In a previous chapter, I mentioned the impact Jack Welch's vision of the Internet has had on General Electric's efforts to streamline purchasing, reduce costs and cut expenses. Furthermore, as XML and Java languages allow for standardization among industries, the Internet is becoming a tremendously successful way for businesses to interact with all of their vendors. It's not so much the placing of orders, but making the entire business relationship literally seamless. Orders are placed automatically predicated on electronically monitored inventory stock levels; shipments are tracked from moment-to-moment; claims are serviced; and invoices are processed and paid without pen touching paper. This is a huge opportunity for businesses of all shapes and sizes.

Through the Internet, business has the potential to become more productive, more cost-effective and better at serving the consumer. The best example of an industry that has a lot to gain in the future Internet economy, is one of the most competitive industries—automotive.

Lifelong competitors Ford, General Motors and Daimler-Chrysler have finally found common ground on the Internet. These rivals are coming together with the formation of a centralized electronic exchange that will support electronic procurement, planning, fulfillment and collaboration. By combining their purchase power in this way, vendors can cut costs while maintaining profits—enabling the manufacturers to pass the savings on to the customers with higher quality, greater innovation and lower prices.

In a similar vein, Sears Roebuck has joined the French retailer Carrefour and Oracle to establish a centralized electronic exchange to coordinate over $80 billion in purchasing conducted by their combined 50,000 suppliers, distributors and partners. The goal is to control costs and reduce expenses. Everyone wins in this scenario. Lower prices for the customers, higher profits for the company and bigger dividends for the stockholders.

Interestingly, recent studies say that nearly 50 percent of the American public currently invests in the stock market. This gives more credence to the belief that what's good for business is good for the economy and good for the people.

The significant coverage of these alliances by the business media will certainly drive many other companies and industries to enter into comparable electronic alliances. And even without the media exposure, the competitive forces of the marketplace will drive these cost-cutting alliances. The ensuing increase in productivity, purchasing power and interoperability should quickly turn into consumer benefits in quality, price and support. Those who don't acknowledge the advantages of such productivity efficiencies may find themselves out of business.

Direct-to-Consumer Commerce

The Internet has moved beyond simple business-to-business commerce and is also serving as a model for business-to-consumer commerce. Standardization efforts—such as XML, which provides a common language platform for the Internet, will enable smaller businesses to join larger alliances to increase productivity, while using their Web sites as multi-tasking hubs for better serving their clients. Language standardization will also ensure that each company speaks the same language in terms of databases.

If all goes well, all businesses will have the technology to interact with their vendors as well as their customers. But for this to happen, companies must make customer focus their priority. So, where is your focus? What

do your customers want? How do they want it? These are the important questions.

A perfect example of such customer focus is an encounter I had with a large insurance brokerage. Brokerages are in the middle of the distribution chain in insurance. Like an insurance agency, they sell policies on behalf of an insurance company. However, they are large enough that the insurance company often uses them as the reseller of coverages to smaller agencies or as the distributor of exclusive programs. At this particular brokerage, upper management had determined, by polling themselves, that they needed their Web site to offer insureds the ability to track claims as they were processed through the system. And, it initially sounded like a neat idea. However, upon reflection, some serious questions surfaced that made me wonder:

1) Would the claimant understand the claims process well enough to know what the status tracking means? Probably not. No matter how user-friendly the system interface is, the intricacies of the actual claims process are difficult for a layman to understand.

2) Since claims are processed by the insurance company, not the brokerage, could the broker respond to a concern that surfaced while the client was tracking the claim? Not directly. The broker would have to check with the company or explain the status shown on the Internet to the client. In either case, there is no efficiency whatsoever for the broker. And the client who has spent time accessing a Web site, must call the broker for an explanation. So it's double the work for broker and client, with no advantage to either.

3) Might the insured think that it was the broker's responsibility to stay on top of the claim for the client? Probably. (And this is not a responsibility the broker can—or likes—to accept. After all, insurance is nothing more than the sale of a promise, so most insurance professionals like to be involved in the delivery of that promise if it becomes necessary.)

4) Would such a tracking system have meaning for the client? I asked some people who had been impacted by the Northridge earthquake what they thought. The unanimous reply was that they weren't necessarily interested in the various stages of the claim process—they were interested in when they would get the money. And they added that they'd rather call their agent and ask that question than try to figure out some electronic tracking system.

This leads to a logical conclusion. Advances—such as tracking—on the Internet, can be applied to some companies and not others—i.e. Internet technology should be used only when it adds value. The brokerage in the example above should ask insurance companies to institute systems that will enable it to track a claim in process. Then, when the client calls with the big question, "Where's my money?" the broker can quickly access the information to answer the question.

Another idea currently circulating in the insurance industry is that agencies, brokerages and companies need to have claims reporting capabilities on their Web sites. That way, if someone's house burns down or car is wrecked at 3 a.m. he can go to the appropriate Web site and input the initial information for starting a claim. I don't know about you, but if my house burns down at 3 a.m., I'm not going to look for a computer terminal—I'm going to wake up my agent with a phone call. You see, I want human contact in an emergency. I want others to feel my pain and console me, particularly those who are earning a living off my premium payments.

In the end, the Internet may work best as a tool in this process. But the process itself (and the company's brand) isn't about the Internet…it's about the customer relationship.

Ask Yourself

1) *There's more to e-commerce than retail.*

 ☐ Do you think of the Internet primarily as a resource or a shopping mall?

Relationship Aspect Marketing

- ☐ Are there ways your company can use the Internet as a source of information?

- ☐ Are you using the Internet as a vehicle to better serve your customers?

- ☐ Are you using the Internet to expand your customer base? If so, how?

2) *Your great ideas may have nothing in common with what customers want.*

- ☐ McDonald's has tried again and again to expand into new areas—away from its signature hamburger and fries menu. Most of its ideas have failed. Do you know why?

- ☐ Why have you failed to expand into new business areas?

- ☐ Do you research what your customers want before you spend a lot of money giving them something you think they want?

3) *Controling costs and increasing efficiency position a company to better serve its customers.*

- ☐ How can you reduce costs and increase efficiency? Will such actions make your company more competitive?

- ☐ What steps would you have to take right now to achieve this?

- ☐ Do you have the courage to take the necessary steps?

- ☐ Are you willing to align with competitors to streamline purchasing and decrease costs?

- ☐ What if such an alliance meant you might have to give up some trade secrets?

CHAPTER 38:

FEAR OF CHANGE IS A CONUNDRUM

If you are like most reasonably successful business people, you may react badly to the notion of altering your existing marketing efforts to shift to a program that rests mostly on two points—building customer relationships and then opportunistically building brand recognition. If you're an established operation, you may think this program sounds like a smaller outfit's approach. But try not to think that way. Business, customer relations and marketing are all changing. Be part of that change.

Earlier in this book, I spoke about fear—specifically, my fear of building a company Web site. I conquered that fear, but there were more fears waiting in the wings to fill the void.

Fear of change is a big one for me, and for many other successful business people as well. Most of the material in this book, as in life, is about change. Change is inevitable and in today's world, it is an absolute necessity to survival. Yet, despite its constancy in our lives, change still evokes fear. And fear creates resistance.

There's an old story about a barber with a shop in the Pittsburgh airport in the late 1960s. He had a successful business that catered only to men and he swore he would never change his operation to a unisex salon, though others in the business were already changing. He resisted that change, went out of business and was replaced by a unisex salon. The point is, resistance to change can be deadly.

Accept Criticism, It's Free Advice

I experienced this same resistance when some of the world's top image consultants critiqued me during a convention workshop. I willingly accepted recommendations that more stylish glasses with lenses that didn't have bifocal lines would make me look younger, and that trousers with pleated fronts would make me look more fit. But I bristled when it was suggested that I shave off a 27-year-old mustache. "Never!" I said emphatically. I was sticking to my own personal brand.

One day I recounted this story to a good friend, and he commented, "Isn't change a bitch!" His words hit me like a bolt of lightening. It wasn't the mustache to which I was attached, I was attached to an old habit. When I realized that change was the issue, not the mustache, I shaved it off—and the compliments have been unbelievable. I am surprised at how many people (particularly women) have told me since I shaved it off that they don't particularly care for mustaches; and everyone comments that I look 10 years younger without it. My resistance to change had led me to ignore the sage advice of the world's top professionals in the image field.

In fact, the leader of the seminar commented that a study he had undertaken in Australia indicated that the majority of female business executives put less trust in a man with facial hair. The women surveyed felt that men with beards and mustaches were hiding behind them and inferred that such men were more than likely hiding something. This was an aspect of my personal brand I hadn't even considered.

Does fear paralyze your ability to change? Are you holding on to past ways of doing things for no reason...other than habit? Do you resist change even against expert advice? Does your resistance jeopardize your business or sabotage your personal relationships? If you answered yes to any of these questions, consider rethinking your behavior. You'll be glad you did. And you'll be one step closer to implementing relationship aspect marketing in your business.

Our Failure to Change Is the Problem

Making any headway in shifting your sense of fear? Let's try the rational and logical approach taught to me by my Jesuit educators. All fear stems from losing something we have or not getting something we want. If you find yourself fearful of change—losing something you have, or not getting something you want—you have entered a philosopher's worst nightmare.

I've heard fear described as False Evidence Appearing Real. This phrase perfectly describes how fear manifests itself in my own behavior patterns. Out of fear, my mind projects a predetermined outcome to a difficult situation that prevents me from taking action. Yet once I take the action and conquer the fear, I usually find that my mental projections had no basis in reality. That's why the experts tell us that we have to walk through our fear to conquer it.

If change is truly inevitable and necessary to survival, our fears should be based on *failure to change*, rather than *change itself*. If we fail to change, we may lose our business, a valued client or a special relationship. Likewise, if we fail to change, we may not achieve the goals that we have set, either in our personal or professional lives.

Therefore, our fear of change is a true oxymoron. We fear the wrong thing. Fear the fear, not the change. In this spirit, I urge you to exercise your change muscle. Pick anything—from a bad habit to a petty annoyance—and make a decision to change it. Commit to achieving the change, acknowledging that you may fall short at times. And that's okay, as long as you pick yourself up and continue.

You need to embrace change. It's a clarifying process—as I discovered when I got the feedback on my moustache. Most importantly, embracing change is an essential part of considering—and building—your brand.

Ask Yourself

1) *Embrace the change, don't fear it.*

 ☐ Do you consider change to be a problem or an opportunity?

Relationship Aspect Marketing

☐ Do you avoid handling problems when it means you may have to change an existing policy?

☐ When a customer informs you that his needs are not being met and suggests a possible solution, do you argue with him and tell him that his suggestion is beyond the scope of the services you offer?

☐ Or, do you take his suggestion as an opportunity to expand the services you offer and begin work on implementing the change?

2) *The ability to change requires practice.*

☐ Do you spend time strengthening your change muscle? That is, do you take the time to *think* about changing something?

☐ Do you ask for the opinions of others—and use them to promote change?

☐ Do you let your employees and customers know that you are open to new ways of doing things?

3) *Those who don't change, lose.*

☐ Do you think you will continue to thrive without change?

☐ Do you wait until you're about to lose before implementing change?

Conclusion:
Flexibility, Failure and Humanity

This book is a series of insights and anecdotes from my experiences and those of other business owners and employees I have met. In order to develop a realistic picture of consumer and employee relationships in an information-based economy, I chose some stories that deal with what people typically call *successes* and others that, at first glance, they might call *failures*. Of course, business owners and managers strive for success in their endeavors. However, I would like to end this book with a discussion of the important role that failure (or, more precisely, the *risk* of failure) plays in business and life. It is often the touchstone of success.

You might hesitate to follow the advice of this book: Build your business around relationships with customers, vendors and employees. It may not be the way you've done things before. It might sound costly, in terms of both human and financial resources. And, like any change, it may seem to threaten failure.

For most businesses, though, it's worth some risk of failure to humanize technology. The upside—in terms of repeat business, revenue growth and overall profit—is huge.

I know how hard risk of failure is to embrace. As I've mentioned before in this book, our fear of failure often leads to a greater failure—the failure to learn and grow. The result is that mistakes are repeated over and over again…all in the name of avoiding failure.

Relationship Aspect Marketing

Any institution—government, not-for-profit or ordinary business—can fall into this trap.

An example: In California's past, the state mental health care system was rife with abuse. It was very easy to have a spouse, business partner or child "committed" upon the testimony of a single psychiatrist. As in many states, the mental hospitals were filled to the ceilings with forgotten patients. The system was a failure, so the laws were changed to protect the rights and the treatment of the mentally ill. However, the system that replaced it is also a failure. Sadly, most of the people in decision-making positions are too concerned about administrative or political failure to learn from the system's mistakes.

I know about these problems first-hand. One of my daughters suffers from schizophrenia and has been hospitalized numerous times, always involuntarily. Each time we have a hearing to review her situation, the doctors recommend long-term treatment as a road to recovery. However, to safeguard her rights, she is assigned a public defender for these hearings.

The legal system pits a doctor against a public defender before a judge. The public defender argues that forced hospitalization is a violation of her rights and that my daughter seems fine. Since my daughter appears functional—with hospital-provided medication—and does not appear violent, the judge often agrees and lets her go.

The mental health care system focuses on legal rights instead of treating illness. This prevents short-term, political failure. But the system virtually ensures that people like my daughter will not get the treatment they need—and miss out on the chance to live somewhat normal lives.

Instead, my daughter continues to be hospitalized on a short-term basis and then released into a world she can't navigate on her own…only to repeat the same cycle over and over again. The true insanity lies in the system itself; the wrong people keep making the wrong decisions for the wrong reasons. No one seems to be willing to see the *status quo* for what it is (a large failure born of avoiding small failures). At some point, a visionary reformer will take some calculated political risks and restructure the entire system.

Business often falls into the same pattern; but one of capitalism's great strengths is that it empowers visionaries to make changes. GE's Jack Welch almost ignored the Internet because he didn't understand it. It was only after his wife introduced him to a chat room that he began to get an inkling of the possibilities. The more he learned about the new technology, the greater his excitement and his vision for its potential. As I've mentioned earlier, his use of the Internet within GE is already becoming legend—and will be studied in detail by our future MBAs.

How can you apply these lessons to your operation? Take a pragmatic and objective look at the direction you are heading with technology. Don't base your future on the continuation of current and past mistakes. Let go of the idea that *there is too much invested to give up now.* Think, instead, in terms of *the first loss being the least loss.*

Defending an indefensible position can cost you the battle and perhaps the war. Don't let your *system* steal your future.

Remain Flexible, Admit Mistakes

Great leaders are willing to acknowledge mistakes, change accordingly and proceed.

I had the privilege of producing an audio book for the dean of leadership, Warren Bennis, the founding chairman of the Leadership Institute at the University of Southern California, who has written best-selling books on leadership and management over the past four decades. The audio book was to be based on his book, *Managing People Is Like Herding Cats.* Normally, in such projects we would have written the audio adaptation for recording, as the spoken word is not the same as the printed word. In this case, the publisher had supplied the script for recording.

Warren has been a long-time hero of mine. When we first met to record the script, I tried to act casual, so as not to appear the fawning fan I am. After a few minutes of chitchat, he began recording the script. About a half-hour into the recording, I stopped him and said, "Warren, we have to talk."

Relationship Aspect Marketing

The problem as I saw it: The first half-hour of the tape was way too negative. It was a laundry list of everything that is wrong with society and business when it comes to leadership. Any listener would have been ready to commit suicide by that point—not to mention ready to press the eject button on his tape machine. As I gingerly tried to approach the subject in a compassionate way, Warren quickly said, "I agree, this is terrible. What can we do about it?"

It was a weekend; we could not contact the publisher for advice. So Warren and I looked at each other, chuckled a bit, rolled up our sleeves and spent a couple hours reworking the script to be more positive. When we finished, Warren went back into the recording booth. By the end of the day, the recording was completed and a new audio book was born. The program came out so well that there wasn't a single change made by the publisher when it was reviewed. And, Warren requested that I produce any future audio versions of his works.

Warren and I spent a considerable amount of time talking about past mistakes that we had made. He told me that, after spending a lifetime in higher education, he'd concluded that the system was on the wrong track. Once, he had vehemently pushed students to march through undergrad and obtain the coveted MBA; more recently, he had changed his thinking.

He now thought that there should be more emphasis on the liberal arts, and expanding one's mind and horizons with great art and literature. He even took this one step further, musing that perhaps, upon attaining a bachelor's degree, graduates should be required to enter the work world for a couple years before admission to a grad school.

Warren Bennis is a living example that life is all about change and that a person's willingness to admit mistakes and embrace change is perhaps a sign of greatness. It's interesting that his next book, published in 1999, was titled *Old Dogs, New Tricks*.

Bennis not only researches and analyzes leadership, he is leadership personified. Confronted with a problem, he doesn't look back or justify and defend the past, and he doesn't take criticism personally. He rolls up his

sleeves and begins working on a solution. How many of us are as quick to admit a problem and change direction?

Technology, particularly e-commerce, is the most dynamic playing field that business has ever seen. As such, we are bound to make mistakes and venture down dead-end roads. The secret of success is having the flexibility to change direction quickly and without regret.

Once you've recognized the need for change, you need to buckle down and decide how to proceed.

Walmart is also a perfect example of a company that has been willing to change direction. In October 2000, Walmart did the seemingly unthinkable—it shut down its Web site. Prior to the shutdown, Walmart announced its intentions to take its Web site off-line for a period of time (which turned out to be three weeks) in order to make changes in accordance with customer feedback. The company actually listened to the customers who felt the site was cumbersome, ineffective and not very user-friendly.

Much like a brick and mortar facility that is closed down for remodeling, Walmart closed the site for a total revamping because it wasn't meeting the customers' expectations. Walmart's Web site has since re-opened for business. The site is designed to make the customers feel welcome. It doesn't concentrate on being glitzy, but on simplicity and organization. It is easy to use, which is what the customers want. In fact, it is a virtual recreation of an actual Walmart store.

How Technology Got Us Here

The combination of advances in computer and communications technology that, taken together, make up the Internet is revolutionizing the way people interact. But mixing text, audio and video elements, the medium will change—is already changing—the fundamentals of how people deal with one another. But will it change the way people *treat* one another? Or want to be treated? I don't think so. That's why I believe in relationship aspect marketing.

Relationship Aspect Marketing

For most of the 19th and 20th centuries, the emphasis of technological advance was on replacing human labor with machine labor—automation. In the early years of the Internet revolution, the temptation has been to think of this as one more step on the path of automation. Some people talked in terms of replacing human assets with machines; there would be no more people in phone centers, only computer systems. Some companies even acted on this talk (and some venture capitalists funded it). The results have generally been disastrous.

There's a simple explanation for this. The Internet, like any technology, is a tool. It's like a magic pencil that can write with sounds and pictures, as well as words. But pencils—even magic ones—don't write by themselves. If the person holding the pencil has no idea of what he's trying to say, the results will be bad.

But, if the person holding the pencil knows what she wants to say to her customers, vendors and employees, she can use the magic to communicate so effectively that she'll surprise even herself.

This magic may take a few lessons to master. In business we often make mistakes; the trick is to accept them, learn from them and correct them. The key is being flexible enough to change direction. If humility is the state of being educated, we need to meter our corporate pride with a sense of humility…and a focus on humanity.

Let us forever remain students in a technological world. Technology is a tool for achieving success—provided that you remember that the customer is the ultimate destination. Use technology wisely with a personal touch and you will master relationship aspect marketing.

APPENDICES

Relationship Aspect Marketing

Appendix One:
Assessing Your Electronic Aptitude

The following questions are designed to help you think critically about your company's current computer automation status in relation to client and business relationships. Questions such as these can form the agenda for a management meeting. Circulate them before, and then compare answers in the meeting.

As you review each question, ask yourself:

1) Does this issue benefit our **clients**?

2) Does this issue benefit our **employees**?

3) Does this issue benefit our **vendors/suppliers**?

4) Should we **change** any of these answers? If an answer is *no*, should we do something to make it *yes*?

5) If several issues need action, how should we **prioritize**?

General Questions

☐ Do we have a company Web site? Yes ___ No ___

☐ Do all of our employees have Internet access and individual e-mail accounts? Yes ___ No ___

☐ Can we accept and place orders electronically online?

 Yes ___ No ___

☐ Do we have a customer relations management (CRM) automation system designed for our specific industry?

 Yes ___ No ___

☐ What percentage of our client communication is via e-mail, fax, phone?

e-mail ___% fax ___% phone ___%

Relationship Aspect Marketing

☐ What percentage of our vendor communication is via e-mail, fax, phone?

e-mail ____% fax ____% phone ____%

☐ Do all of our outside employees have laptop computers and Internet access? Yes ___ No ___

☐ Do employee business cards provide Web address, e-mail address, telephone number, fax number and pager number?

Yes ___ No ___

Sales & Marketing Questions

☐ Does our Web site provide product information, pricing and ordering procedures? Yes ___ No ___

☐ Does our Web site provide articles or information of value to our clients or prospects? Yes ___ No ___

☐ How frequently is our Web site updated?

daily ___ weekly ___ monthly ___ sometimes ___

☐ Do we distribute a printed or electronic newsletter to clients or prospects? Yes ___ No ___

☐ Do we have a standard corporate signature for all e-mail messages that has detailed contact information as well as product or service offerings? Yes ___ No ___

☐ Does our fax cover sheet offer additional information about our company? Yes ___ No ___

☐ How quickly and easily can a client contact his or her sales representative?

in minutes ___ in hours ___ in days ___

☐ Do we survey your clients to learn their needs, wants and expectations? If so, what kind of response do we get?

Yes ___ No ___

☐ If we don't use a customized CRM program, are client accounts automated and accessible? Yes ___ No ___

☐ Do we promote our clients on our Web site, newsletter, advertisements or other forms of communication?

Yes ___ No ___

Back Office Questions

☐ Is our billing system automated? Is it part of a CRM program? Is it part of an accounting program?

Yes ___ No ___ CRM ___ Accounting ___ Other ___

☐ Are invoices personalized for cross-marketing of products or services and customer appreciation? Yes ___ No ___

☐ Does our staff have the ability to access customer files quickly during telephone conversations? Yes ___ No ___

☐ Do we have an automated telephone system, menu and voice mail messaging? How easy is it for a caller to bypass this system and speak with an actual person?

Yes ___ No ___ one-button bypass ___ difficult ___

☐ Do we have written company procedures for telephone courtesy and call return? Yes ___ No ___

☐ Do we have written company procedures for Internet use and e-mail etiquette? Yes ___ No ___

Relationship Aspect Marketing

- ☐ Have our clients been formally introduced to the office staff with whom they do business? Yes ___ No ___

- ☐ Do we promote our office personnel on our Web site, in our newsletters or through our other communications with customers and the industry? Yes ___ No ___

- ☐ How frequently do we meet with our office staff to discuss problems relating to automation procedures, telephone call flow, duplicate effort and overall workload?

 daily ___ weekly ___ monthly ___ sometimes ___

- ☐ Do we have an appointed technology expert to oversee electronic and automation issues that impact the way customers and vendors communicate with us? Yes ___ No ___

Appendix Two:
Surveying Your Customers and Employees

Even if you use an outside consultant or firm to produce your customer service surveys, you should still do your own informal surveying whenever the opportunity presents itself. Have a standard way of asking everyone—from an employee over the water cooler to a valued client over lunch—two things:

> 1) how he or she views you and your company; and

> 2) what you can do to serve him or her better.

The following are a few examples of specific questions that can get at the two main points you're after.

1) Why do you choose to do business with (or work for) us rather than our competitors? _____

2) What do we do right? _____

3) What do we do wrong? _____

4) What can we do today to improve the service we provide?

5) Based on your plans for future change, what can we do in the future to support your growth? _____

Relationship Aspect Marketing

These informal questions also can be put into an electronic format to be distributed by e-mail, placed on your Web site or printed for a traditional mailing. As opposed to detailed surveys designed for analytic review, these informal approaches should be designed to elicit *feedback*. You're looking for people to answer in their own words.

Among other things, this process can help you tailor your marketing efforts to prospects that have similar needs to your best clients.

Appendix Three:
Telephone Response Testing

How well does your company process phone calls? Every business owner and manager should know this answer. Here's a simple test. Ask a friend to call your company and ask for someone in sales (or any department you choose). Have the friend answer the following questions.

Telephone Response

1) How many times did the phone ring before it was answered?

2) How long was it before someone picked up the phone after you were transferred?

3) Was the call transferred to the correct department or person?

Yes ___ No ___

4) Were employees friendly and helpful? Yes ___ No ___

Automated Answering Systems

5) Was the automated process simple and quick?

Yes ___ No ___

6) Were you routed to the correct person/department?

Yes ___ No ___

7) Were the directions easy to understand? If not, why?

Yes ___ No ___ Why? _____

8) Were you given an option to connect with a live person?

Yes ___ No ___

Voice Mail

9) Did the message state clearly whose desk you'd reached and what that person does—so you could be sure you'd reached the right place? Yes ___ No ___

10) Did the message give any indication of when to expect a call back? Yes ___ No ___

11) Were you given alternate names or numbers in case of an emergency? Yes ___ No ___

12) How long before the call was returned?

13) When you were called back, did the person have the information or result that you needed? Yes ___ No ___

Thoughts on answers to these questions:

Telephone response should be quick. When a person calls from the outside, the system should pick up in two to three rings; anything over five is unacceptable. In terms of hold waiting, under 30 seconds is optimal. Anything over 60 seconds is troubling; anything over 90 seconds is unacceptable. You will lose customers if you make them wait for more than two minutes to speak with someone.

Automated answering systems are a necessary evil of business these days. Rather than ranting about businesses' overdependence on these systems, I'll limit myself to saying that any answer other than yes to the questions about the systems is unacceptable.

The key to voice mail messages is: Be courteous to the person leaving the message. Convey as much customer-support information as you can in a short time. Every employee's voice mail should state clearly who the person is and what function he or she serves. A message of when to expect a call back is common courtesy.

Appendix Four:
Ten Tips for a Better Web Site

This book contains many suggestions relating to Web site design and the philosophy behind those suggestions. Whether you are planning to implement your very first Web site or ready to upgrade your existing site, the following suggestions can help make your site a little more user-friendly and, therefore, more effective.

1) **Keep your home page simple**. The more graphics and special effects, the longer it takes for the page to load. Although the greater speed and bandwidth of DSL lines and cable eliminate this difficulty, most people still use the much slower dial-up modems.

2) **Keep navigation simple**. Clearly identify the specific sections: About the Company; Products; Services; Press Room; News; Articles; Contact Us. Every page should have a hyperlink to return to the Home Page.

3) **Update, update, update**. Unless your Web site's information changes constantly, people have no reason or need to return to your site.

4) **Avoid brochure speak**. Your Web site should provide detailed, but succinct, reasons why a visitor should do business with you. Avoid making it look like an advertisement.

5) **Provide added value**. Articles and basic information that benefit your clients and prospects should be an integral part of your Web site. If you publish a newsletter, incorporate an electronic version. Offer them data that can help their business prosper.

6) Enable visitors to **contact you quickly**. Incorporate all contact information on your site. Have e-mail hyperlinks and respond to e-mails on a timely basis. Consider interactive telephone contact services for immediate access to a human voice.

7) Provide an electronic **employee directory**. List employees by name and job description, and include their e-mail addresses with their direct phone lines or extensions.

8) **Promote your employees**. People do business with people. Provide each employee with his own Web page. The advantages: clients can connect with your employees on a personal level, which enhances relationship building; employee morale is increased because everyone feels important within your organization; and if employees manage their own pages, it becomes a training tool to enhance their electronic performance.

9) **Promote your clients**. Offer a connections page where your clients, vendors and friends can network using hyperlinks to each other's Web sites. In return, ask these same people to place hyperlinks to your Web site on their sites.

10) Consider adding **audio and video**. Advances in compression technology make such optional enhancements much easier to implement. Once past the homepage, offering the surfing consumer a video product demonstration or an audio presentation featuring the business owner's commitment to quality and service can set your company apart from the others.

Appendix Five:
Ten Tips for Building Web Traffic

Too many businesses create a Web site, sit back and wait for people to find it. This is absurd. If you printed a brochure would you wait for people to come and ask for a copy—or would you make every effort to get it into the hands of potential clients? Your Web site is no different. Market it via every possible means. Here are some suggestions:

1) Include your **Web site address** on business cards, stationery and fax cover sheets, printed advertisements, radio or television commercials, brochures and handouts, order forms, invoices, statements, automated answering system and as a hyperlink within the signature on your e-mail.

2) Send **press releases** announcing the Web site, and, periodically, about new updated material you have added to the site.

3) Promote a simple **contest** on your Web site. For instance, an easy e-mail quiz with five questions about material on your Web site. Each week or month you conduct a drawing from the correct respondents and give the winner a prize.

4) Provide and promote a **community bulletin board**. Every time you advertise an event within your community, people will visit your site.

5) Create **hyperlink alliances**. It's the old "I'll scratch your back, if…." Offer to provide hyperlinks on your site for businesses with whom you deal, and ask that they put a hyperlink to your site on their Web site.

6) **Market by e-mail**. Each time you update your site, send a short e-mail to your entire electronic database announcing the new article, product or service with a direct hyperlink to your site within the e-mail message.

7) **Advertise**. Aside from including Web information in your normal ads, consider traditional and electronic advertisements that promote Web traffic, like the billboard that only states your URL, www.yourdomain.com. Or develop an electronic banner hyperlink that you can place on other Web sites and portals like Yahoo! Some companies can prioritize your site on the various search engines so that it is among the top 20 identified in search results.

8) **Invite criticism**. Ask people within your marketplace to visit and critique your site. Update and change accordingly.

9) Invite others to **write articles** to be presented on your site. This builds traffic and adds value to business relationships. Those who write such articles send their friends and business contacts to see it.

10) Feature a **client or vendor of the month**. Trust me, the company or person you select will notify friends…and promote your site!

Appendix Six:
Planning for Company-Wide E-Mail

Once you've decided to invest in a company-wide e-mail or an Internet-based communications system, you have to lay the groundwork before you can implement it. Here are a few suggestions to consider when it comes to planning your Internet future.

1) Establish a **planning team** staffed with employees from various company departments, such as finance, sales, marketing, service, production, fulfillment, shipping and technology.

2) The planning team should be headed by the **corporate leader**, who provides the grand vision and sets the overall goals for the company. As a visionary, the leader embraces input from everyone on the team and sets the tone, character and passion that drives the whole team.

3) The planning team should select a **technology leader** or champion who is invested and knowledgeable in internal automation, as well as Internet technology. (Although many companies have separated these two functions, the reality is that the two come together. We're already seeing browser interfacing with most management systems and programs for seamless interfacing with intranet and Internet activity.)

4) Consider a **consumer advocate** for your planning team; this person should not be an employee. Many companies feel that customer service management can represent the customer—they can't, due to vested self-interest. Ask one of your most valued clients to participate as a member of your e-planning team or board.

5) Nurture **communication and understanding** among team members and departments. Technology must understand sales, marketing, service, financial, production and shipping issues. Likewise, every department must stay apprised of developing technology.

6) Encourage **online competitive research**, and don't limit it to your own industry. Researching companies considered role models within a specific area of operation can pay big dividends. Find out what benchmark companies do, how they do it and determine what's applicable to your operation.

7) **Solicit and accept input** from all employees. The planning team should be an evaluation funnel for input from all sources. Let everyone at your company know that you're planning a new communications medium—and invite suggestions. Some of your most technologically proficient employees are the newest ones at the bottom of the ladder. Remember, today's youth grew up in a digital world and technology is inculcated into every facet of their lives. Take advantage of their expertise.

Appendix Seven:
Establishing Effective E-Mail Policy

Once you have selected the hardware and software systems that you will use for Internet-based communication within your company, you have to establish the policies that will define how employees can use the systems. The following issues are among the most common that companies face.

1) **Personal versus company use**. Most people agree that the use of the Internet at work should be restricted to company business. Yet others point out that even personal Web use is educational and can help employees become more comfortable with technology and resources. Company policy in reference to Internet use is likely to vary. The important issue is not what policy you adopt, but how that policy is communicated to employees. Some of the key questions to address before issuing any Internet guidelines are:

 - Should access to the Internet be available to all employees?

 - Should management provide individual passwords or codes for access? If so, what would be the process of gaining approval for such access?

 - What are the penalties for violation of the guidelines?

2) **Privacy issues**. An offshoot of the personal vs. company use issue is how much privacy employees can expect for the e-mails they send or receive. Generally speaking, they should expect none; the company should reserve the right to review any communication that comes across its computer system (even if that communication comes through an employee's personal e-mail account or instant message service on an outside system). Of course, Internet privacy is an evolving legal topic; you should consult with your legal counsel about the details of privacy policies.

3) **Communications standards**. All communication impacts the image of a company. The company is within its rights to prohibit any use of obscene, vulgar or slanderous language in e-mails. Beyond these prohibitions, basic letter writing skills can help protect a business's image. Among these skills: the use of a salutation, spelling and grammar checks, proper closings, etc. Other safeguards may be necessary, such as policies that prohibit contacting the media without involving public relations personnel, divulging of trade secrets, criticizing the competition—or the company itself or anything that might expose the company to undue risk.

4) **Use of copyrighted material**. Copyright issues range from illegal distribution of software in violation of licensing agreements to copying and distributing copyrighted material found on the Internet. That last matter is one of growing importance, as more people get online and are confused by some Internet sites' apparent *laissez-faire* approach to copyrights. Using a copyrighted picture of Brad Pitt in a brochure (even if it's only for internal use) can result in a legal problem. Consult with the company attorney or risk manager to determine what laws apply—but make these laws known to your employees. Pleading ignorance won't help when and if someone uses copyrighted material improperly.

5) **Viruses**. Ensure that the company has adequate software to detect viruses. Require all employees to use detection procedures for any e-mail attachment or file download. And keep employees informed of new, active viruses.

6) **Mandating severe penalties**. Certain e-mail activities should result in severe penalties, including: electronic distributing harassing or defaming messages of a sexual, religious, racial or disability-related nature. Most companies adopt a *zero-tolerance policy* toward these activities—one incident can lead to termination. Other similar (though less severely-penalized) activities may include use of company equipment for purposes of hacking, sending chain letters, electronic stalking, downloading or exchanging pornography or misrepresenting one's identity.

7) **Free time**. Today's tight employment market calls for new recruiting tactics. To entice talented employees who have grown up in the digital world, some companies use their computer technology as an added inducement. Employees are allotted specific non-work hours (early morning, evenings, weekends) when they can use the computers for writing new programs, playing games and other high-tech endeavors.

These suggestions serve as a starting point. Each company has its own unique needs and concerns. One more general suggestion: Make sure your e-mail use policies are consistent with other workplace policies—especially those having to do with anti-discrimination issues.

Management should consult with its legal team, review the team recommendations and come together for finalization. Once the guidelines are finalized, conduct implementation meetings so that all employees feel they have a stake and a say in how the new guidelines are carried out.

Remember: The first line of any company is its employees. How you treat your employees dictates how they will treat your clients and prospective customers.

Relationship Aspect Marketing

Appendix Eight:
Privacy and Copyright Use Statements

Two of the biggest issues that impact e-mail or other Internet-based communications tools (including instant messaging, chat room exchanges, etc.) are the privacy that employees using company systems can expect and the ramifications of using copyrighted material. The following are two sample statements on these issues that you might choose to include in your employee manual or related policy publications. As ever, check with your legal counsel for specific advice before using these statements.

Privacy Policy

Internet-based electronic communications (including e-mail, instant messaging, chat-room exchanges, etc.) can be an effective way for employees to communicate with each other—and with customers, suppliers and other business partners. The Company encourages progressive use of these communications tools. Furthermore, the Company recognizes that these communications tools often incorporate information and even personal exchanges; for this reason, the Company allows employees using these communications tools reasonable discretion in how they communicate through them. However, the Company reserves the right to monitor, access, record and review any form of electronic communication exchanged through any Company-owned hardware (including computers, personal digital assistant, digital communication devices, etc.) or software systems (including e-mail or communications software accessed from non-owned hardware). This reservation of right applies to all forms of communication crossing Company hardware or software, including those that any party to such communication might consider personal or private. All Company employees accept and acknowledge that they waive any claim of a right to privacy with regard to communications exchanged across Company hardware or software systems.

Relationship Aspect Marketing

Copyright Use Policy

The Company respects the right of any copyright or trademark owner to enforce his or her ownership of properly protected intellectual property. Therefore, any employee accessing information, data, images, sounds, software or other content in public or private marketplaces or exchanges will make a reasonable effort to determine the copyright, trademark or other protected status of that content when accessing it. Furthermore, any employee incorporating content acquired from outside sources into Company systems, publications, documents or communications (whether for internal or external use) will establish the copyright or trademark status of that content and secure any necessary agreements, licenses or other permissions required to reproduce it.

Appendix Nine:
E-Mail Etiquette Guidelines

E-mail has surpassed traditional mail (or *snail mail* as it is commonly called) as the most common form of communication. Despite this, we still need some work when it comes to proper e-mail etiquette. Below are some suggestions that may help you avoid the embarrassment of badly concocted e-mail correspondence.

1) **Use proper grammar**. Bad grammar damages your image in the mind of your recipient. E-mail is no different from a letter and mistakes *are* noticed.

2) Use an **opening salutation and a traditional closing**, just as you would in a traditional letter.

3) Maintain a pleasant tone, but **keep it to the point**. The electronic world values brevity.

4) **Don't joke** or engage in humor, unless you're on personal terms with the recipient. Sarcasm and humor do not translate well via e-mail; this is why people often resort to sideways pictographs like :-) or :-(to explain their attempts at or reactions to humor.

5) **Don't send large attachments** without gaining prior approval. Huge attachments are aggravating and time-consuming. Always ask if it is okay to send the attachment or if there is a better time to send it.

6) **Don't forward** jokes and other similar e-mail. Business people value their time and many immediately delete e-mails with a subject line that begins with "FW:" If you feel that the material is of value to someone, type in a new and appropriate subject line and add a brief, personalized note before forwarding it.

7) **Answer your e-mail promptly**. The electronic world is predicated on speed and convenience. Time is of the essence.

8) **Design and use a signature**. Most e-mail programs enable you to create a standard signature added to the bottom of the e-mail you send. Design one that provides complete contact information, including phone and fax.

9) **Use the subject line**. Briefly let the recipient know what your message is about.

10) **Don't begin your first sentence** in the subject line. Beginning a sentence in the subject line and continuing it in the body of the message is confusing and preempts the effect of a salutation.

11) **Don't e-mail in haste or anger**. Just like snail mail, once you send a message you can't retrieve it. If in doubt, wait 24 hours before sending an angry e-mail.

Appendix Ten:
Using Electronic Signatures

All major e-mail programs (such as Eudora, Netscape Messenger and Outlook Express) offer standardized signatures for e-mail. These signatures aren't handwritten names—they are brief, standard lines of contact information that you can attach automatically to all outgoing e-mails. Some programs allow you to have more than one signature; you can select specific ones for formal or informal e-mails...or the program can select different signatures randomly to add variety to your correspondence.

Signatures should:

1) provide complete contact information;

2) promote your services; and

3) hyperlink to your Web site.

Update your signatures as necessary to convey new information to your clients and prospects.

Here are three examples of signatures that I use:

Sound Marketing is a full service audio and video production and duplication facility specializing in unique corporate and governmental marketing and communications. Visit our Web site at www.soundmarketing.com for complete details on all our services, including our new CD-replication equipment.

Jack Burke's newest book, *Relationship Aspect Marketing* has just been released by Silver Lake Publishing. Visit www.relationshipaspect.com for more information.

Sound Marketing, Inc.
1454 Calle Alamo - Thousand Oaks, CA 91360
North America Toll-Free: 1-800-451-8273
Local: (805) 241-8122 - Fax: (805) 241-8522
Jack Burke: jack@soundmarketing.com

Relationship Aspect Marketing

Appendix Eleven:
Using Fax Signatures

The cover sheet for your faxes can be much more than just an address label. Use your cover sheet to promote your business.

An example:

Date_____

ABC COMPANY, Inc.

Cover + _____ Pages

A Fax Message from Sound Marketing, Inc.
Vox: 1-800-451-8273 - Fax: (805) 241-8522
www.soundmarketing.com - www.relationshipaspect.com

To:_____

From:_____

Message:

Your Full-Service Audio & Video Production & Duplication Center
Audio Marketing Tapes • Custom Audio & Video Productions
Telephone Messages-on-Hold • Convention Recording Services
**** ASK ABOUT MP3 SOUND FILES & CD REPLICATION ****

CHECK OUT JACK BURKE'S BOOKS
Relationship Aspect Marketing • Creating Customer Connections • Best of Class
Jack Burke is also available for speaking and consulting engagements.

SOUND MARKETING, INC.
1454 Calle Alamo - Thousand Oaks, CA 91360
1-800-451-TAPE • Local (805) 241-8122 • Fax (805) 241-8522
www.soundmarketing.com • www.relationshipaspect.com
Jack Burke: jack@soundmarketing.com
Jo Ann Burke: joann@soundmarketing.com

Relationship Aspect Marketing

Appendix Twelve:
Easy Ways to Nurture Your Employees

Employee nurturing is catching on. Major corporations are now offering incentives such as stock options, hiring bonuses, staying bonuses, on-site childcare, dry cleaning, parties and even on-site automotive repair.

Most businesses can't afford such a large investment, but there are less expensive, technology-based ways to increase employee morale and job satisfaction. Here are 10 things you might consider doing.

1) Provide **Internet access** for all employees.

2) Establish **individual e-mail accounts**. Allow clients to contact your employees by e-mail.

3) Provide desktop **computers** for internal personnel and laptops for outside personnel.

4) Use company-wide e-mail to **honor employee performance**.

5) Honor an **electronic employee of the month**—the person who offered the best solution to a problem, the person who gained the most ground in learning a new technology, an in-house trainer or automation mentor. Acknowledge individual efforts to expand technological horizons; this motivates employees to work harder and reaps unlimited benefits.

6) Establish an **electronic suggestion box**. This offers your more computer-savvy employees an opportunity to expand your technological know-how. Take advantage of their expertise.

7) Publish an **electronic version of your employee handbook**. This enables the company to more easily update the manual as laws change and corporate policies are amended.

8) Publish an **electronic newsletter**. Make it a joint-effort; solicit your employees to submit articles electronically.

Relationship Aspect Marketing

9) Offer computer-based **training programs** and classes. This is a highly-efficient and cost-effective method for both training and the continuing education credits that are required in some professions for maintenance of certifications or licensing. Advantages: makes your personnel more computer savvy; allows the employee to work at her own speed; helps control training expenses; and minimizes travel and lodging costs of sending employees off-site.

10) Put your **employees in your contact management system**. Use your database to remember birthdays, special events, anniversaries and other important dates in your employees' lives— just as you do for your clients.

These are just a few ideas to improve your relationships with your employees, while solidifying your organization's position technologically. With a little bit of time, you can come up with many more ideas to stimulate your employees and enhance their work experience.

Appendix Thirteen:
Show Your Customers What They Mean to You

Successful business owners know that customers go back to those places where they are made to feel comfortable and appreciated.

Consider these questions:

1) How often do you express your appreciation to your customers?

2) How do you express that appreciation—letters, calls, e-mails, gifts, cards, visits, business referrals, testimonials?

3) Do you promptly apologize when things go awry?

4) *How* do you apologize? Do you accept full responsibility?

5) Do you allow yourself to act from your heart, rather than your wallet?

6) Do you know when your customers are experiencing problems?

7) When you know a customer is experiencing difficulties in his or her personal life, do you take the time and make the effort to offer assistance, commiserate or send condolences?

8) Do you like your customers? If not, is the problem with them or you? If it's with them, why do you do business with them?

9) Do you listen to your customers and react appropriately?

10) Do you view your customers as you hope that they view you?

These are hard questions. They reflect simple human emotions that are often overlooked in the business world. Yet if business boils down to one person interacting with another, it should incorporate the most basic of human needs. The human touch is a remarkable tool in building long-term, mutually beneficial relationships.

Relationship Aspect Marketing

Appendix Fourteen:
Tips for Managing Telecommuters

Employee turnover is extremely costly to a company, especially in today's tight employment market. Telecommuters add another facet to this problem. To avoid incurring heavy losses in time and money, it is best to keep the telecommuter happy from the start. The following are suggestions for the successful management of a telecommuter.

1) Provide your telecommuter with the **technology necessary** to do his or her job successfully—Internet access, external e-mail account, internal e-mail account, if applicable, fax machine, scanner, telephone, pager and answering machine or service. If your telecommuter spends a considerable amount of time on the road, provide a laptop with a docking station at home.

2) The Internet connection should be **active 24 hours a day**. When available, a DSL line or cable modem is preferable to dial-up connections. When using e-mail preferences, ensure that the employee activates e-mail notification so he knows when someone is trying to reach him. Among the goals of new technology is to save time and increase productivity; having to wait hours for a response to an e-mail is counterproductive.

3) If dial-up access is the only available option, management should **set specific times** at which the employee checks e-mail. This eliminates waiting for replies.

4) When geographically convenient, telecommuters should attend at least **one meeting per week** at company offices to review current and upcoming projects and activities with their boss. Whenever possible, include coworkers to make your telecommuter feel like a part of the team. This allows project managers, for instance, to confirm that everyone is on the same page. The meeting also allows for an open group discussion about the direction of the work and any need for reassessment, adaptation or change.

5) Establish a **monthly staff meeting** of all telecommuters and internal workers in order to maintain relationships, and encourage peer support and personal camaraderie.

6) **Encourage interaction** among telecommuters and other employees, including both telephone and e-mail communication. This connection is critical so telecommuters do not feel disenfranchised. The sharing of information among coworkers relieves stress, opens the door to insights and overall increases productivity.

7) Establish a **telecommuter training program** in which new telecommuters spend several days at the residence of one or more established telecommuters. This encourages sharing; the novitiate can express fears and anxieties that can be assuaged by the veteran and the veteran can help ease or eliminate some of the more common pitfalls.

8) Establish an **internal chat room** as part of the company Web site to allow interaction among all employees.

9) Use **video technology** for conferencing between the telecommuter and the office, as well as with clients who also have the necessary technology.

10) Insist that supervisors and telecommuters have at least **one phone conversation per day**.

11) Consider an **electronic suggestion box** for telecommuters, as well as inside staff. Telecommuters have specific needs and suggestions that may apply to in-house staff as well; never underestimate the value of a good suggestion, no matter from whom it comes.

12) Provide the telecommuter with a **modest budget**. Work ambience is important, whether at home or in the office.

13) Expect the best. Show telecommuters that you have **respect and confidence** in them. You'll be pleasantly surprised at the dedication these off-site employees offer you in return.

14) Develop **guidelines, policies and procedures** for telecommuting, and involve the telecommuters. Mutually-determined rules are more apt to be followed.

15) Don't let out-of-sight mean out-of-mind. Occasionally **visit the employee** at his or her home office to offer advice and encouragement and monitor work flow.

16) Encourage telecommuters to participate in all **non-work functions**—company picnics, sports activities, community relations and award banquets. Again, it is essential that these employees are made to feel like a part of the organization.

17) Acknowledge that telecommuters can have a bad day, too. Sometimes a simple word of **encouragement** or a willingness to listen to a problem can turn someone's day around and put the person back on track.

18) **Don't let your telecommuter become isolated**. Urge him or her to get out of the house periodically. A quick trip to a coffee shop, lunch out with a friend, client, coworker or boss can do wonders for productivity. Most people need human contact; a little time out can increase both mental and physical alertness, which enables employees to get more work done each day.

19) Develop a consistent means of monitoring telecommuters and **measuring performance**. Review your findings with the employee on a regular basis.

Relationship Aspect Marketing

Appendix Fifteen:
Designing and Using Your Web Page

After much research and countless conversations with business owners and Web experts, I've come up with a few suggestions about Web sites that may be of benefit.

1) Design a *Contact Us* directory which lists the name, title and e-mail hyperlink for **each employee**. This, of course, assumes that each employee has his own personal e-mail. Again, connect employees to the Internet. Connectivity is the true value of the Internet and the means by which companies can improve productivity. Failure to connect your employees, both internally and externally, is a great disservice to your business.

2) Provide a constantly changing, **value-added enticement**. Give people a reason to return to your site. The easiest way: offer articles that contain pertinent information for your market. If you don't want to create the material yourself, many publications will allow you to reproduce their material as long as credit is given. You can also offer free tools that anyone can use, i.e. a template, worksheet, etc.

3) Develop a *Meet Our Friends* page that hyperlinks to the **Web sites of clients**, vendors and friends. This should be negotiated to a mutual benefit; that is, your clients, vendors and friends should have hyperlinks to you.

4) Expand the *Meet Our Friends* concept with **value-added discounts**. Ask your clients if they would be willing to offer a special discount to your other clients and employees.

5) Offer *Personal Pages* for **your employees**. This is not as difficult—or expensive—as it sounds. Each employee has the responsibility for his own page. Your employees will urge others to see their pages—which will drive more traffic to your site.

6) Design a *Virtual Library* of **training and educational materials**. Inventory what you have available in print, audio and video, then list it under your virtual library. Clients can e-mail their request and borrow the material on a first-come, first-serve basis.

7) **Have contests**. This is a fun way to get your clients and prospects familiar with what your site offers.

8) **Publish your newsletters**. If you send out periodic newsletters, post them on your Web site. This is a great way to expand your readership—cheaply.

9) Establish a *Community Bulletin Board*. From owners to receptionists, employees are usually pretty involved **within their community**. Offer charities and other such organizations free space to publicize their events on your Web site. They'll appreciate the gesture and will drive more traffic to your site.

10) Add a **Web site signature** to all your e-mail. Most e-mail programs allow you to customize a closing signature for all outgoing e-mail. Close every e-mail with a hyperlink to your Web site.

11) But above all, don't let Web-phobia lead you to pay more to build a site than necessary. Try to **build it on your own** (even if on your own means the combined efforts of staff). You'll be more confident when other technological issues arise.

Once you have your site up-and-running, minimize the cost of advertising. Think of creative ways to get exposure for free. A few suggestions:

- Send **press releases** about your Web site to your local media and trade magazines on a regular basis. Provide them with a synopsis of new features, articles or benefits on the site.

- **Network, network, network**. Everyone with a Web site is looking for ways to build traffic. Talk with clients, friends, industry peers and acquaintances about "rubbing each other's back." I'll promote your site, if you'll promote mine, etc.

- Incorporate your **Web site's URL into the graphics** of your company logo and make it available for posting on other Web sites when co-promoting each other.

- Create **e-mail newsletters** to send to clients and prospects. Rather than posting an entire article, compose a brief synopsis with a hyperlink to your Web site for the complete story.

- Promote your **Web address** on everything—business cards, stationery, fax cover sheets, packing materials, etc.

Relationship Aspect Marketing

Appendix Sixteen:
Customer Feedback Letter

The following is a template for acknowledging customer feedback, expressing your thanks and setting expectations. A letter of this type should be sent immediately upon receiving feedback—good or bad—from a customer. And it should be sent in the medium (e-mail, snail mail, etc.) that it was initially offered.

Dear Mrs. Jones,

As a company dedicated to serving our customers to the best of our ability, we would like to thank you for the valuable information you have brought to our attention. We know that the needs, wants and desires of our customers change. Therefore, we appreciate feedback in the form of criticism or suggestions, so that we may always improve our service to you—our customer. We believe that a healthy relationship is based upon open dialog and communication. This is the foundation of our business.

We will review your comments and recommendations in our regular management meeting, and strive to incorporate them into our future goals and practices.

Again, thank you for taking the time to help us serve you better. You will receive a phone call or letter updating you on actions we have taken as a result of your suggestions.

Sincerely,

Jane Smith, Director of Customer Service

Relationship Aspect Marketing

Appendix Seventeen:
Customer Feedback Report

Employees are your link to your customers. Every day, they receive input from customers—whether praise or criticism. Conversely, management seldom hears from customers—unless a major mistake has been made. The form below is one way for management to collect input to better understand the needs of the customer and respond to these needs. Every employee—from telephone receptionists to sales personnel to service staff—should make note of the answers to the following questions.

1) At the time of contact was the customer pleased or displeased...and how extremely of either?

2) What did the customer like about our service or product?

3) What did the customer dislike about our service or product?

4) If there was a problem, how was it resolved?

5) Did the customer suggest anything we should do in the future? If so, what was the suggestion?

6) Did the customer suggest anything we should not be doing? If so, what should we stop?

7) Were there any other comments? If so, what were they?

8) Do you have any other thoughts or conclusions about what happened?

Signed by: _____

Date: _____

Appendix Eighteen:
Internal Job Evaluation Form

Customer service has a tough job. They often spend their days handling complaints and that means they're spending a lot of time with unhappy people. When this happens, employees perceive customers to be an unwanted intrusion in their day—rather than the reason they have a job. Compounding this problem is that the employee's understanding of his job description does not match the employer's understanding. To avoid misunderstandings, ask each employee to evaluate his role in the company, using a simple form like the one below.

1) What do you perceive as your primary job responsibility or purpose?

2) Does your supervisor effectively reinforce this as your primary responsibility? Yes ___ No ___

3) Is your performance review weighted to that respect?

Yes ___ No ___

4) What gets in the way of you doing your job to the best of your ability? _____

5) What helps you to do your job to the best of your ability?

6) Do you have all the tools and technology necessary to perform your job? Yes ___ No ___

7) What else do you feel you need?

8) Are there work duties that duplicate one another? If so, what are they? How could the duplication be resolved?

9) What do you like best about your job?

10) List three things that would enable you to do your job better and enjoy it more (in order of importance).

1. _____

2. _____

3. _____

Index

Relationship Aspect Marketing